D1230969

THINGS
GREAT AND
SMALL

John E. Simmons

Collections Management Policies

AMERICAN ASSOCIATION OF MUSEUMS | AAM**100**

Design: Kirsten Ankers

On the cover: Installation by Rosamond Purcell for "Two Rooms," Santa Monica Museum of Art, 2003, and based on collection of Ole Worm as seen in the frontsipiece to his museum catalogue, 1655. Photo by Dennis Purcell.

Library of Congress Cataloging-in-Publication Data

Simmons, John E.
 Things great and small : collections management policies / By John E. Simmons.
 p. cm.
 Includes bibliographical references and index.
 ISBN-13: 978-1-933253-03-9
 ISBN-10: 1-933253-03-7
 1. Museums--Collection management--United States. 2. Museums--United States--Planning.
 3. Museums--United States--Management. I. Title.

 AM133.S56 2006
 069.50973--dc22

 2006003672

TABLE OF CONTENTS

ACKNOWLEDGEMENTS

One of the things I like best about the museum profession is the spirit of cooperation among museum people all over the world. It is simply not possible to take on a topic as big as collections management policy without extensive assistance from colleagues and friends.

Although the names of everyone who has offered me information, advice, and admonishment on the subject of collections management policies cannot be listed here, you know who you are. I want to express particular gratitude to Rebecca Phipps, Sally Shelton, and Steve Williams for their input and countless discussions of policy issues. Much of the material in this book was developed while teaching collections management, and I thank the students in my classes and workshops for their contributions and inspiration. A special word of thanks goes to Heather Berry for compiling a useful set of policy information to get this project started, to Ann Gonzalez for researching sample policies and obtaining permissions, to Jane Lusaka for editing the manuscript, and to Margaret L. Mazzullo, Julie Katz, Jane MacKnight, and Rebecca A. Buck of the AAM Registrars Committee who devoted considerable time and effort to improving the text.

Lastly, I owe a huge debt of gratitude to Elizabeth Merritt for proposing that I take on this project, for her intellectual input and support throughout, and for her persistence and persnickety attention to detail—of such are great editors made.

Sakaerat Environmental Research Station, Pak Thong Chai, Thailand, July 2005

CONSIDERING COLLECTIONS MANAGEMENT POLICY

"Without clear direction, poor decisions are bound to be made, and for a museum, many such 'mistakes' have no easy solutions. The best approach is prevention, and today an almost essential preventive measure is the adoption and implementation of a collection management policy."

—Malaro (1998)

"So much of what we call management consists in making it difficult for people to work."

—Peter Drucker

What distinguishes a museum from other educational, scientific, and aesthetic organizations is its relationship with its collections. Steven H. Miller noted some years ago that "Museums exist because of an assumption that physical objects have value." In *Museums, Objects and Collections,* Susan M. Pearce wrote that "The point of collections and museums...revolves around the possession of 'real things' and... essentially this is what gives museums their unique role." That unique role is further delineated by the field's standard definitions of a museum. To be accredited by AAM, for example, an institution must use and interpret objects or a site for the public presentation of programs and exhibits, and "have a formal and appropriate program of documentation, care, and use of collections and/or objects." The legislation authorizing the Institute of Museum and Library Services defines a museum as an institution that "... owns or utilizes tangible objects, cares for them, and exhibits them to the public on a regular basis."

Museums include some institutions that do not own, care for, or use collections to which these definitions do not apply, but most museums hold collections in trust for the public. The public, in turn, holds museum governing authorities accountable for:

- maintaining the highest legal, ethical, and professional standards;
- establishing policies that guide the institution's operation;
- and delegating specific responsibilities to staff, volunteers, and consultants through those policies.

What Is a Museum Collection?

The difference between an accumulation and a collection is that a collection is organized in some way. More precisely, a collection is a group of things that has been gathered and arranged in some order—in other words, a collection is a set of things (Simmons and Muñoz-Saba, 2003). Nicholson and

Williams (2002) have identified several characteristics of museum collections that differentiate them from other collections:

1. Museum collections consist of more than one object.

2. The objects have order and organization.

3. The objects are valued by people.

4. The objects are collected with the intent to preserve them over time.

5. The collections serve the institutional mission and goals.

6. The integrity of each object and its associated information are paramount to the museum.

7. The collections are maintained in adherence to professional standards.

What Is Museum Collections Management?

Collections management is everything that is done to take care of collections, develop the collections, and make the collections available for use. Pearce (1983) has identified three fundamental concepts that a collections management policy addresses:

1. The collections management policy describes a relationship among the museum and its collections, its authorities and staff, and the outside world.

2. The trajectory of this relationship is set by the sum of the previous relationships among these three parties, all of which have to be taken into account whenever decisions are made.

3. These relationships are in a constant state of interaction. The policy regulates activities in the present and the future, but it takes its character from what has happened in the past.

What Is a Collections Management Policy?

Although it is often referred to as a single document, in practice the collections management policy is actually a set of policies that address various aspects of collections management, including acquisition, accession, registration, cataloging, control, security, and storage, as well as the museum's other collections-related activities. Together, these policies clarify who is responsible for managing the collections.

Collections management policies must be written to meet the needs of each individual museum, its collections, and how they are used. A policy is created only to accomplish a specific goal or address a particular issue; for this reason, the set of policies included in the collections management policy vary somewhat from one museum to another. The individual policies that make up the overall collections management policy are interrelated and address many other museum functions (table 2.1 shows how collections management policies relate to other museum policies). For example, the ethics policy governs the professional actions of all staff in the museum in addition to addressing collections management issues. The access and use policy affects exhibition and educational programs as well as how the collections are managed.

It is a good idea to review and revise each policy on a regular basis. A collections management policy, like any other policy, is useless if it is outdated, ignored, too complex to be followed, too simplistic to be useful, or does not serve the museum's mission. By enacting and enforcing good collections management policies, the museum's governing authority meets its legal and ethical obligations to protect and provide public access to the collections. Good policies help the museum achieve its mission and demonstrate its commitment to professional standards and practices.

What Do Collections Management Policies Do?

Collections management policies govern what a museum does to care for and grow its collections and make them available to the public. Through these policies, the governing authority establishes the museum's guidelines and professional standards for collections stewardship and gives the staff the authority to implement the policies. Collections management policies are accompanied by collections management *procedures*—the detailed instructions that specify how the staff should apply the policies in their day-to-day activities.

In *A Legal Primer for Managing Museum Collections*, Marie Malaro notes that the collections management policy explains how the museum "goes about its busi-

ness." It does this by ensuring that the museum fulfills its obligations to protect, manage, provide access to, and maintain intellectual control over its collections and their associated records. The collections management policy ensures that collections are acquired legally and ethically; are appropriate to and advance the museum's mission; and are properly managed, housed, secured, conserved, documented, and used.

Collections Management Policy or Policies?

At times, the phrase "collections management policy" refers to a single policy document that addresses all of the appropriate collections management issues for the institution; at other times it refers to a series of separate policy documents that address each topic individually. How the document is structured—as one comprehensive policy or as several related policies—is determined by each institution. In this book, the phrase *collections management policy* is used to refer to all of the policies that guide collections management in the institution; the words *policy* or *policies* are used to refer to the separate topics (e.g., the loan policy is part of the collections management policy).

Policy, Procedure, or Plan?

Although policies and procedures often are discussed together, it is important to understand the differences between the two documents (see table 1.1).

- *Policies* clearly establish the standards that regulate the museum's activities. They identify what needs to be done and provide a framework to help staff make decisions. Policy statements are approved by the governing authority.
- *Procedures* tell the staff how to do things and provide the mechanism and details for implementing the policy. Procedures are a series of succinct and unambiguous action steps that are developed at the staff level. They do not have to be approved by the governing authority.

Policies and procedures are separate documents that make clear what is policy and what is procedure. Because the governing authority does not have to approve revisions of procedures, maintaining separate documents makes it easier for the staff to adjust the procedures as necessary to carry out the policy.

With increasing frequency, museums are creating a third type of document—called a *collections plan*—to shape the content of their collections. This plan guides the ongoing process of deciding the museum's collections-related activities. It establishes a vision for the collections that will best serve the museum's mission, compares the existing collections to that vision, and maps out how the museum will achieve these ideal collections (Gardner and Merritt, 2004). The criteria for a collections plan are summarized in table 1.2. Although collecting is central to the mission of museums (and significant resources are devoted to acquiring and caring for collections), collections planning in museums is still rare. A good collections plan helps a museum remain true to its mission without amassing a lot of junk; without it, the museum's collecting activities will lack control.

Traditionally, collections management policies have outlined some of the criteria that determine whether an object will be accessioned or deaccessioned, (such as the standards for provenance, condition, or authenticity). As such, there is a potential for overlap between the collections management policy and the collections plan. Some museums direct readers of the policy to the plan for more information, and vice versa; others include the same information in both documents.

To determine how the collections management policy and the collections plan should address collections needs, consider the nature of each of these documents. The *collections management policy* establishes general guidelines and principles that regulate the activities of the organization. These policies are not inherently time-limited, though they may change as the museum or the standards of the field evolve. A *collections plan* is the ongoing process of deciding the museum's specific activities. It specifies what will be accomplished in a given period, why, by whom, and with what resources. For more information about collections planning, see the list of resources in appendix D.

Determining the Content

Collections management policies are based on the museum's mission and a statement of purpose that reflects its legal status, bylaws, and capabilities. Many institutions choose to include an introductory statement in their policy document that affirms the museum's fiduciary responsibilities to manage the collections properly. The collections management policy comprises a set of detailed policies that focus on:

- descriptions of the museum's collections and collection-related goals
- acquisition, accessioning and deaccessioning criteria
- outgoing and incoming loans
- management of non-accessioned objects in the custody of the museum
- care of the collections
- documentation and record-keeping systems
- insurance and risk management
- collection inventories
- reproduction, copyright, and other legal and ethical issues related to the collections
- access to the collections
- review and revision of the collections management policies

The policy must incorporate an understanding of the basic principles of collections management. There are some fundamental commonalities among all collections, whether they contain furniture, paintings, or fossils (e.g., all collections must be organized and protected from deterioration). These commonalities can be summarized in six basic principles of collections management:

1. Each acquisition entering the museum is properly documented.

2. Collections are stabilized for long-term preservation and housed in a proper storage environment.

3. Each individual collection element is put in its specific place in the collections storage array.

4. The collections are inventoried and monitored regularly.

5. The collections storage environment is monitored regularly.

6. All collection-related activities and monitoring are documented.

Because the collections management policy helps the museum's staff carry out their responsibilities, it also:

- defines the areas of staff responsibility;
- delegates decision-making authority to the appropriate individuals or committees;
- identifies who has the authority to make exemptions to the policies, if necessary;
- directs the staff to maintain complete, written records regarding all collection-related decisions and activities.

Finally, the collections management policy addresses any issues that might have a substantial impact on the museum's collections, operations, staff, or visitors (see table 1.3). It reflects the best professional standards; is sensible, logical, and written in clear prose; and kept in a handbook that can be accessed easily. The goal is to provide the governing authority, staff, and public with the opportunity to learn about (and help enforce) the museum's guidelines and standards for collections stewardship.

How to Use this Publication

This book is designed to help museums write policies that meet professional and legal standards for collections management. This chapter discusses why collections management policies are important. Chapter 2 explains how to write policies. Chapters 3 through 19 discuss specific topics addressed in collections management policies, and chapter 20 discusses the interface between theory and practice. Each chapter begins with an introduction of the policy topic, which is followed by a discussion, tables that can help the museum develop a policy, and sample policy sections illustrating how some accredited museums have addressed these issues. The chapters cover related legal or regulatory requirements, outline choices for museums within each policy area, and discuss the relevant standards of the field.

The appendices provide additional information to aid policy development. Appendix A is a glossary of useful terminology. Appendix B introduces AAM's *Code of*

Ethics for Museums and *The Accreditation Commission's Expectations Regarding Collections Stewardship.* Appendix C reviews the laws and regulations affecting collections management in museums. Appendix D includes basic references for policy and procedure development and a list of other resources.

Although this book aims to encompass the various ways in which museums operate—including how standards and best practices vary between disciplines—the museum field is extremely diverse. Each museum should develop policies that are appropriate for its particular collections and circumstances. Good museum policies will be influenced by the museum's history, community, audiences, governing structure, tradition, and internal and external politics. No one template is appropriate for all museums.

References

American Association of Museums. 2005. *A Higher Standard: Museum Accreditation Program Standards.* American Association of Museums, Washington, D.C., 40 pp.

Campbell, N.J. 1998. *Writing Effective Policies and Procedures: A Step-by-Step Resource for Clear Communication.* American Management Association, New York, xiii + 397 pp.

Cato, P.S., and S.L. Williams. 1998. Guidelines for developing policies for the management and care of natural history collections. *Collection Forum* 9(2):84-107.

Gardner, J.B., and E. Merritt. 2002. Collections planning: pinning down a strategy. *Museum News* 81(4):30-33, 60-61.

Gardner, J.B., and E. Merritt. 2004. *The AAM Guide to Collections Planning.* American Association of Museums, Washington, D.C., viii + 93 pp.

Malaro, M.C. 1994. *Museum Governance.* Smithsonian Institution Press, Washington, D.C., and London, viii + 183 pp.

Malaro, M.C. 1998. *A Legal Primer on Managing Museum Collections.* Second edition. Smithsonian Institution Press, Washington, D.C., xx + 507 pp.

Miller, S. 1985. Selling items from museum collections. *The International Journal of Museum Management and Curatorship* 4:289-294

Museum Services Act 20 USC § 968(4).

Nicholson, E.G. and S.L. Williams. 2002. Developing a working definition for the museum collection. *Inside Line* (Texas Association of Museums), fall 2002, pp. 1-4.

Nicks, J. 1999. Collections management. In Lord, G.D. and B. Lord (editors). *The Manual of Museum Planning*, pp. 109-123. Second edition. AltaMira Press, Walnut Creek, CA., xvii + 462 pp.

Pearce, S.M. 1993. *Museums, Objects and Collections: A Cultural Study.* Smithsonian Institution Press, Washington, D.C., 312 pp.

Simmons, J.E. and Y. Muñoz-Saba. 2003. The theoretical bases of collections management. *Collection Forum* 18(1-2):1-37.

TABLE 1.1. **Policy or procedure?**

CONCEPT	POLICY	PROCEDURE
Principles	General guideline that regulates the museum's activities	Detailed method for performing an action
	Standard for exercising good judgment	Steps for implementing a standard as a professional practice
	Guideline for decision-making	Protocol to follow when implementing the policy
Functions	Who, what, why	How
Synonyms	Rule, standard, philosophy, guideline	Instruction, protocol, steps
Purpose	Regulates, directs, controls actions or conduct, sets criteria	Explains how to implement the policy
Nature and Scope	Broad philosophical statement; justification for decisions	Succinct directions for accomplishing a specific task
Content	What the rule is; why the rule exists; justification for the rule	Action steps necessary for implementing the rule
	When it applies	Conditions for action; alternatives
	Whom it covers	Procedural function
	Enforcement	Warnings; cautions
	Responsibility	Consequences
	How to get help or interpretation	Direction

TABLE 1.2. **Contents of a collections plan.**

CRITERIA	DESCRIPTION
Intellectual Framework	The underlying conceptual structure that focuses the museum's collecting. Built around the mission and the needs of the users, and often organized around interpretive themes that guide exhibits, programming, and research as well as collecting. Specific enough to guide decision-making.
Strengths	What is in the collection, and what will continue to be collected because of its importance to the museum's mission. Can include a statement of the collection's local, regional, national, or international status.
Limits	What will not or will no longer be collected or accessioned because it is outside the scope of the collection, because it does not relate to the museum's mission or intellectual framework, or because it appears to be illegally or unethically obtained.
Needs	What the museum would like to add to its collections in the near and long-term future.
Gaps	Materials that are important to the museum's mission but are currently underrepresented in the collections.
Overlaps	Materials considered to be overrepresented in the collections, or that are well-represented in the collections of peer institutions.
Resources	A plan to develop the financial, physical, and staff resources that will enable the museum to achieve its collecting goals.

TABLE 1.3. **Issues addressed by collections management policies.**

GENERAL AREA OF CONCERN	SPECIFIC ISSUES THAT MAY BE ADDRESSED
General	Museum mission
	Institutional code of ethics
Administrative	Governance
	Fiscal responsibility
	Allocation and use of resources
	Public image
	Accountability
	Investment
Personnel	Health and safety
	Staff relations
	Human resources/personnel management
	Working environment
	Ethics
Collections	Scope of collections
	Objects in custody
	Acquisition and accession
	Documentation
	Collections care
	Collections access
	Collections use
	Deaccession and disposal
	Risk management
Interpretation	Exhibits
	Programs
	Research
Legal issues and liabilities	Insurance
	Security
	Intellectual property rights
	Copyright
	Cultural property

COMPILING COLLECTIONS MANAGEMENT POLICIES

❝The process of developing a set of policies is as important as the resulting document.❞
—Cato and Williams (1998)

❝A committee is a cul-de-sac down which ideas are lured and then quietly strangled.❞
—Barnett Cocks

❝Good things, when short, are twice as good.❞
—Baltasar Gracián

The best way to prepare the collections management policy is to assemble a writing team that solicits input from all sectors of the museum staff, particularly those responsible for caring for and using the collections (Cato and Williams, 1993). In most institutions, the governing authority approves and has the ultimate responsibility for the policies. Staff participation is critical for preparing policies that everyone is committed to and understands.

Policy development can be a time-consuming process, but approaching the issues from a variety of perspectives will pay off in the long run. Staff will understand how the policies help prepare the museum for a successful future and fulfill its role as an integral part of society (Dietrich et al., 1997). Furthermore, the team approach fosters innovation and creativity, support for the museum's mission, and the production of a more useful policy, and builds *esprit de corps* among the staff. The process is most effective when there is full staff involvement at every stage: initial draft, review, revision, and recommendation to the governing authority for approval.

There is another reason to include the entire museum staff in the policy development process: the collections management policy is one of the overall institutional policies that guide the museum in fulfilling its public trust responsibilities. Input from colleagues helps ensure that the collections management policy complements and supports the institution's other policies as efficiently and effectively as possible. (Table 2.1 shows the relationship between collections management policies and other museum policies.) Other staff members can help the writing team reduce ambiguity and ensure that the policy addresses real issues and accomplishes specific goals.

Although the temptation to do so may be strong, it is not a good idea to use another institution's collections management policy document as a template when preparing your own. There are several compelling reasons why this does not work well, including:

- It is easy to miss nuances in the way a policy is written; those nuances can make the difference in how well the policy works for your institution.
- If you copy another policy document, your museum's staff will have little involvement in preparing your museum's policy; this will limit the staff input and support that a collections management policy needs.
- Another institution's policy could include unnecessary, contradictory, or incorrect information.
- Using another institution's policy as a template might lead you to miss critical issues specific to your museum.

Describing Collection Components

When writing policies, it is important to use terminology that best describes your collection. Several different words commonly are used to describe the components of collections, but not all of these words are used correctly. The words usually used to describe what is in collections are *object, artifact,* and *specimen*. The particular word that is best to use depends on the type of museum and the type of collections. For example, biological collections generally are said to contain specimens; anthropology collections contain artifacts; and art and history collections contain objects. It is important to understand that each of these words has limitations; to write an effective policy statement, use terminology that is as clear as possible. Some institutions will prefer a more inclusive term, such as *element* or *object*, to a word with a more limited meaning, such as *artifact*, or an inappropriate word, such as *item*. Table 2.2 provides more information about selecting the most appropriate word(s) for your institution's collections management policy.

Writing and Implementing Collections Management Policies

Each museum will want to establish its own process for writing and implementing collections management policies. Here is one recommended approach:

Step One: Assemble the writing team. Select a team that has a manageable number of participants yet represents a variety of perspectives within the institution, including administration, collections, conservation, governance,

public programs, research, and security. Include the staff who implement the procedures.

A museum with a small staff might choose to form an outside advisory committee to assist with policy development. Such a committee could be composed of museum staff members, volunteers, and board members as well as colleagues from other institutions who are willing to provide their input and expertise.

Step Two: Policy development. Team members discuss each policy from the viewpoints of the different museum functions relating to collections, with the institution's mission statement providing focus and direction. Start by reviewing the literature on the topic and consulting with colleagues at other museums. Use the mission statement and the scope of the collections statement to develop broad, institution-wide collections management policies. Then develop specific policies to address particular institutional issues. For each area of concern, describe the particular museum function and then write a succinct policy statement to address it.

Step Three: Standards review. Review the policies to ensure that they are based on current legal, ethical, and professional standards and adhere to the museum's code of ethics. If your institution doesn't yet have a code of ethics, it is a good idea to write one before finishing the collections management policy (see chapter 17, "Ethics").

Step Four: Staff feedback. Ask other staff members to comment on successive drafts of the policies. Some museums, particularly smaller institutions, find it helpful to ask a professional colleague in another museum to review the document. Once you have received feedback, revise the policy as necessary.

Step Five: Governance endorsement. Following staff review and revision, present the policies to the museum's governing authority for approval. Be prepared to explain and defend each policy as well as to incorporate the governing authority's suggestions.

Step Six: Procedure development. Once the collections management policies have been approved by the governing authority, prepare a set of procedures for imple-

menting each policy. The procedures provide direct guidance to the museum staff but because they implement the board-approved policies, they do not have to be approved by the governing authority. For more information on collection-related procedures, see *The New Museum Registration Methods* (Buck and Gilmore, 1998).

Step Seven: Implementation. The completed collections management policy (and corresponding procedures) are presented to the staff and the governing authority, and implemented and carried out by the staff.

Step Eight: Periodic review and revision. Ideally, policies and their related procedures will evolve as the museum grows and thrives. With continued input from the staff, the policies and procedures will be revised, supplemented, or eliminated (see chapter 19, "Policy Review and Revision"). Procedures might need revision more often than do policies.

For policies to be effective, they must be understood and accepted by everyone at the museum. This means educating the staff, governing authority, and volunteers about the purpose of the policies, the distinction between policies and procedures, and how the procedures put the policies into action.

References

Buck, R.A. and J.A. Gilmore (editors). 1998. *The New Museum Registration Methods.* American Association of Museums, Washington, D.C. xvii + 427 pp.

Cato, P.S. and S.L. Williams. 1993. Guidelines for developing policies for the management and care of natural history collections. *Collection Forum* 9(2):84-107.

Cato, P.S. and S.L. Williams. 1998. Collection management policies. In Buck, R.A. and J.A. Gilmore (editors). 1998. *The New Museum Registration Methods,* pp. 221-223. American Association of Museums, Washington, D.C. xvii + 427 pp.

Dietrich, B., R. Etherington, and T. Laurenson. 1997. Policy writing: a blueprint for the future. *Museum International* 49(1):46-48.

Simmons, J.E. and Y. Muñoz-Saba. 2003. The theoretical bases of collections management. *Collection Forum* 18(1-2):1-37.

Williams, S.L. 2005. Policy theory and application for museums. *Collection Forum* 19(1-2):32-44.

TABLE 2.1. **Relationship of collections management policies to overall museum policies (based on Cato and Williams, 1993).**

CATEGORY	POLICY	PURPOSE
Introduction	*Purpose of policies*	Explains the purpose of the policies and procedures document.
		Establishes the importance of complying with the policies.
		Clarifies the consequences of non-compliance with policies.
	Institutional mission	Articulates the museum's mission statement or statement of purpose.
	Statement of authority	Establishes the responsibility for approval of policies and procedures.
		Provides a decision-making structure and hierarchy.
Personnel	*Personnel*	Governs the responsibilities and management of personnel in the museum.
Professional conduct	*Ethics*	Identifies the code of ethics adopted by the museum.
	Legal issues	Affirms the importance of respecting laws and regulations in professional activities and actions.
		Affirms the importance of respecting laws and regulations in private activities and actions.
Fiscal management	*Fiscal policies*	Ensures the proper fiscal management of the institution.
Policy review and revision	*Review and revision*	Establishes procedures for regular review and revision of policies, procedures, and compliance enforcement.
Collections management policies	*Scope of collections*	Provides a brief historic overview of the development of the collections.
		Defines the scope and limits of the collections.
		Describes the contents of the collections.
		Explains how the collections serve the museum's mission or purpose.
	Acquisition and Accessions	Identifies who has the authority to accept accessions.
		Recognizes the acceptable means of acquiring collections.
		Outlines restrictions on appraisals.
		Provides guidelines for growth of collections.
		Establishes the priorities for acquisition of collections.
		Defines the criteria for accessions.
		Defines the conditions of acceptance of accessions.
		Mandates required documentation for accessions.
	Deaccession and disposal	Identifies the authority to make deaccession and disposal decisions.
		Defines the criteria for deaccession and disposal.
		Establishes acceptable methods for disposal.
		Explains how the proceeds gained from deaccessioning can be used.
		Provides guidelines for donor notification of deaccession decisions.
	Loans	Regulates loans to the institution.
		Regulates loans from the institution.
		Provides guidelines for handling unclaimed loans.

	Objects in custody	Establishes who has the authority to receive objects.	
		Mandates documentation requirements for objects in custody.	
		Provides guidelines for handling objects found in the collections.	
	Documentation	Establishes who is responsible for documenting museum collections and functions.	
		Establishes who is responsible for archiving records.	
		Mandates required backup system(s) for records.	
	Collections care	Establishes a preventive conservation approach to collections care.	
		Mandates minimum standards for the collection's exhibition and storage environments.	
		Mandates minimum standards for monitoring the collection's exhibition and storage environments.	
		Mandates minimum standards and intervals for collections inventories.	
	Access and use	Establishes who has the authority to approve collections access and use.	
		Provides for denial of requests for access and use.	
		Mandates responsibility for monitoring collections access and use.	
Collections management policies, (continued)		Regulates access and use of the collections.	Educational access and use.
			Exhibition access and use.
			Research and scholarly access and use.
			Commercial access and use.
	Risk management	Provides process for identifying and reducing risks to collections.	
		Ensures appropriate insurance coverage for collections.	
		Establishes integrated pest management in the collections.	
		Provides for disaster planning and recovery.	
		Mandates security requirements.	
		Addresses health and safety concerns.	
	Intellectual property	Provides guidelines for copyright issues.	
		Provides guidelines for fair use.	
		Provides guidelines for addressing intellectual property rights.	
	Cultural property	Provides guidelines for repatriation decisions and processes.	
		Establishes a system for monitoring compliance with laws and regulations governing cultural property.	
		Provides guidelines for handling culturally sensitive collections.	
		Provides guidelines for handling sacred collections.	
	Categories of collections	Describes the content and use of each type of collection in the museum.	
	Stewardship	Establishes cataloging systems and collection-marking standards.	
	Prioritization and resource allocation	Provides criteria for allocating collections care resources.	
	Repository agreements	Provides guidelines for establishing and implementing repository contracts.	
	Off-site storage	Mandates minimal collections care and environment standards for off-site collections storage.	
	Digitization	Provides guidelines and standards for transfer and production of collections information in digital formats.	
Addenda	Glossary	Defines terminology specific to the policies and procedures.	
	Sources	Provides a list of documents, model policies, and literature used to develop policies and procedures.	

TABLE 2.2. **Terminology used to describe the components of museum collections.**

TERM	DEFINITION AND COMMENTS
Artifact	Something made by or modified by human beings.
Element	A constituent part of a whole, a member of a set; all collections are sets of things (Simmons and Muñoz-Saba, 2003).
Item	A statement or maxim; a saying with a particular bearing; a unit included in an enumeration or sum total. Inappropriate for use in discussing collections.
Material	Relating to, consisting of, or derived from matter (e.g., fossil material).
Object	Something placed before the eyes; something capable of being seen, touched, or otherwise sensed; a material thing.
Specimen	A representative part of a whole, or a means of discovering or finding out; an experiment, a pattern, or model.
Thing	A spatial entity, an inanimate object.
Work/work of art	Something produced by creative effort; an artistic production.

CHAPTER 3

INTRODUCTORY SECTIONS

> *… 'the collections' are an immensely complex body of evidence…. This accumulation of material and meaning must be translated into practical museum policies if it's to be kept from disintegration, and these are what we call collection management policies.*
> —Pearce (1992)

Policies include information that helps users understand the choices the organization has made. Typically the collections management policy begins with a summation of such fundamental information, including the museum's:

- mission
- vision
- history
- legal organization (e.g., such governing documents as the museum's charter or its enabling legislation, and its tax-exempt status)
- commitment to collections stewardship responsibilities
- purpose for the collections management policy

Mission and Vision

As AAM's *Accreditation Commission's Expectations Regarding Institutional Mission Statements* explains, "an accreditable museum has a clear sense of mission and organizes its governing authority, staff, financial resources, collections, public programs, and activities to meet its formally stated mission." Collections management policies often begin with the mission statement as a way of emphasizing its central role in guiding collections activities; many include a vision statement (a description of the museum's future aims) and an explanation of how it guides the mission and collections plan.

History

A synopsis of the museum's history helps users understand its mission, audience, and history of collecting and collections care. Sometimes a museum's collections philosophy and approach to collections stewardship have been influenced greatly by its founder or parent organization. Other museums have collections care challenges that arise from mergers of disparate collections or earlier changes in mission.

Legal Status

A museum's organization and legal status affects some collections management policies. Museums are organized as either public or private institutions. Public museums are created by a federal, state, county, or city government and are subject to governmental control. Public museums have various legal constraints regarding funding, policies, programs, liability, and how they are managed, depending on the government they serve. Private museums are created by private individuals and organized as either for-profit or nonprofit institutions; most are nonprofit, tax-exempt institutions. A public nonprofit museum is subject to some governmental regulations, but is managed by a board of trustees and operated by a director (Lind et al., 2002). A private museum may be organized as a trust, a corporation, or an association.

- **A trust** is an arrangement in which the management of a trust property is the obligation of the trustees, who manage it for the benefit of the trust's beneficiaries. The trustees have a legal obligation and the authority to manage the trust property properly. The powers of the trustees are described in the trust instrument.

- **A corporation** is a separate, legal entity created by and operated under the laws of a particular state. Corporations can acquire and own property. The directors of a corporation do not have the same legal responsibilities as the trustees of a trust, and have a more limited liability than trustees. Most museums in the United States are incorporated as nonprofit corporations.

- **An association** is an entity that has not filed for corporate status. Legally speaking, there is no "there," there—just a group of people who have come together with a common purpose (in this case, running a museum). Associations cannot receive or hold property, and the members of the association are individually liable for both their own actions and the actions of the other association members. It is very difficult to count the number of museums that are operated in this way, because there is no formal record of them with the IRS or other government agencies. Some museums, especially those run

entirely by volunteers, operate in this manner for a time before filing for incorporation.

Some museums function under a joint governance arrangement, in which the collections management responsibilities are shared or are assigned to separate governing entities. For example: a county historical society owns the building housing the museum, while the county government owns the collections, which are managed by the historical society museum staff. In this case, the collections management policy addresses who is responsible for the care of the collections, for accessioning and deaccessioning decisions, and so forth. Most institutions in these situations operate under the terms of a written document called a Memorandum of Understanding (MOU) or a Memorandum of Agreement (MOA). Because the MOU or MOA is critical for determining how the collections are cared for, the collections management policies should reflect its terms.

Other institutions house multiple collections that they do not own. For example, a city art museum may house, manage, and/or exhibit collections owned by the city government, the local historical society, and the municipal library. A comprehensive collections management policy could cover all of these collections, or it might be necessary to prepare a separate collections management policy for each one.

More information on the legal organization of museums and the implications for the museum governance structure and collections can be found in Lind *et al.* (2002) and Malaro (1994, 1998).

Commitment to Collections Stewardship

"Stewardship is the careful, sound, and responsible management of that which is entrusted to your care," states *The Accreditation Commission's Expectations Regarding Collections Stewardship.* There are certain organizational characteristics that lead to good stewardship. The staff and members of the governing authority are familiar with the collections, the significance of the collections, the relationship of the collections to the museum's mission, and their own stewardship responsibilities. The appropriate staff are involved in decisions affecting

stewardship (i.e., financial planning, acquisitions, collection building, and collections use all include input from the collections care staff).

Collections management policies sometimes include an overarching statement of commitment to collections stewardship that highlights the value the museum places on this part of its mission.

Purpose of Collections Management Policies

Some museums include a statement describing the policy's purpose—the role that collections management plays in the museum and how it helps the museum achieve its mission.

References

American Association of Museums. 2001. *The Accreditation Commission's Expectations Regarding Institutional Mission Statements* and *The Accreditation Commission's Expectations Regarding Collections Stewardship,* American Association of Museums, Washington, D.C.; www.aam-us.org.

Lind, R.C., R.M. Jarvis, and M.E. Phelan. 2002. *Art and Museum Law. Cases and Materials.* Carolina Academic Press, Durham, N.C., xxiv + 718 pages.

Malaro, M.C. 1994. *Museum Governance.* Smithsonian Institution Press, Washington, D.C. and London, viii + 183 pp.

Malaro, M.C. 1998. *A Legal Primer on Managing Museum Collections.* Second edition. Smithsonian Institution Press, Washington, D.C., xx + 507 pp.

SAMPLE POLICIES

Bloedel Reserve Plant Collections Policy, 1997

Introduction

The purpose of this policy document is to identify how the plant collections of the Bloedel Reserve will be managed. The policy is intended to serve as a guide to the development, documentation, maintenance/management of the plant collections as a means to achieve the overall mission of The Reserve….

Background*

In order to fully understand this policy, it is necessary to have a clear understanding of the mission (Purpose) of The Reserve and, to some extent, its limited history. At the time of drafting of this document, The Reserve, as an institution, is only 27 years old. Of these years, 16 (1970-1986) involved a close relationship with the University of Washington whose educational needs were partially accommodated by the earliest Statements of Purpose, and eleven years (post 1986) of operation as a totally privately held organization.

One of the most recent expressions of our purpose suggests that Prentice Bloedel "… intended the primary purpose of The Reserve to be an emotional experience where people may find refreshment and tranquility in the presence of natural beauty evidenced by the preservation of trees, shrubs and wildflowers native to the Northwest, and by the woods, fields and streams which are their natural environment. Because the impression of raw nature is often one of chaos and confusion, he believed one's enjoyment of natural beauty may be enhanced by carefully introducing some organization into the primitive confusion, provided that organization did not destroy a sense of naturalness. The Reserve as a whole should be an example of man working harmoniously with nature—where man's power to manage is used cautiously and wisely."

(sections with additional history omitted)

In summary then, management of The Bloedel Reserve plant collection must reflect and understanding of and a commitment to:

a. the role of native versus exotic plants within our landscape displays;

b. the very limited research roles, if any, of our plantings or acquisitions;

c. our stewardship responsibilities;

d. the highest standards of facility (including landscape) maintenance.

(*section edited for brevity; for full introduction see sample document available from the AAM Information Center)

Old Cowtown Museum Collection Management Policy, 2000

Statement of Purpose

Old Cowtown Museum is an educational institution dedicated to preserving and presenting the history of Wichita and Sedgwick County, Kansas from 1865–1880. This mission is accomplished by: operating an open-air living history museum; preserving historic structures; collecting applicable archival material; publishing papers and written records; collecting, conserving, exhibiting, and interpreting appropriate artifacts and reproductions; developing and presenting a variety of educational programs for school and the general public; and placing local history into a regional, national, and international context.

The purpose of this collections policy is to establish procedures and criteria for the acquisition, exhibition, preservation and management of Museum collections. The collections policy will identify the duties and responsibilities of the collections staff, the Museum staff in general, and the Museum's governing bodies.

The Museum recognizes that living history methods are an integral part of collections management consideration. It is the Museum's responsibility to balance preservation and conservation needs with the educational and interpretive use of the collections. This policy's function is to outline procedures and set criteria by which the Collections Manager can determine how best to meet these needs.

Laumeier Sculpture Park
Collections Management Guidelines

Laumeier Sculpture Park History

In 1968, Mrs. Matilda Laumeier bequeathed the first 72 acres of the future Laumeier Sculpture Park, along with a large stone house, c. 1917, to St. Louis County Parks in memory of her husband. She stipulated that the land in suburban St. Louis County, 12 miles from downtown St. Louis, be used for passive recreation. The Henry H. Laumeier Park opened in 1972.

In 1976, Laumeier received 40 large outdoor sculptures by the nationally known sculptor and St. Louis native, Ernest Trova. The gift included examples of the artist's work, dating from the period 1969-76, and was given with the provision that Laumeier be developed as a sculpture park and gallery. Through discussions with the director of St. Louis County Parks and leaders in the business, arts and academic community, the concept of Laumeier Sculpture Park emerged. The St. Louis County Council approved the idea of a sculpture park and Laumeier Sculpture Park opened in July 1976.

In 1978, the former Laumeier stone residence was renovated to create exhibition galleries and administrative offices. Remodeling and updating has continued over the years to increase gallery area and provides spaces for a museum shop, library and curatorial work and storage areas. Additional land has been added to the Park over the years and today Laumeier has 98 acres….

Gallery exhibitions are developed in conjunction with the permanent or long-term exhibition of large-scale and site-specific sculptures outside in the park, or to present innovations in contemporary sculpture. Laumeier develops an exhibit of an artist's drawings, maquettes, small sculpture, photographs or related work to place the sculpture in the park in context and present a broader scope of the artist's oeuvre.

San Diego Natural History Museum
Collections Policy, 1997

Mission and Goals Statement, adopted by the Board of the San Diego Society of Natural History, 3 August 1992

Mission

To interpret the natural world through research, education, and exhibits; to promote understanding of the evolution and biodiversity of San Diego and Baja California; and to inspire in all people respect for the environment.

Purpose

- To emphasize this unique and diverse region while maintaining a global perspective;
- To collect and preserve scientific specimens for research and as a continuous record of the changing world for future generations;
- To serve as a center for the scientific study of biological diversity and evolution;
- To provide dynamic leadership in natural history and environmental education through exhibits, publications, and environmental programs, striving to make this outreach relevant to all the people of the San Diego area;
- To foster cooperative efforts in natural history research and education throughout our region and the world.

Our Vision

The San Diego Natural History Museum will be the premier collections-based environmental education and natural history research resource in our region. We will provide programs that are timely, user-friendly, and relevant to the real-life needs of the diverse populations of the San Diego/Baja California region today and tomorrow.

Our Niches

- Collections-based science education and research
- Timely environmental information relating natural history to present-day environmental and cultural issues

- Comprehensive teacher training and science curriculum development for schools
- Dynamic national and international natural history exhibitions
- Science literacy for the broad range of our constituents
- Diverse offerings of family educational opportunities
- Accessible regional environmental research with in-depth collections, computerized central data-base, natural science library, and diverse natural history research interests
- Biodiversity research of international significance
- Creative collaborations with the business community as well as other natural history, educational, and environmental organizations
- Entrepreneurial business plans to provide financial support for programs of research and education

Our Challenge

- The real products of this Museum have always been research and collections, exhibitions, and education programs. This plan calls for strengthening of each by addressing the pressing environmental, educational, and social needs of our constituents.

This will be accomplished by:

- Building a strong, economically viable, and influential organization capable of implementing the action plans contained herein.
- Establishing "The Center for Environmental Education" and developing and implementing a national model for Museum outreach.
- Establishing "The Environmental Research Resource Center" to provide ready access to our scientific collections and research library and provide for the long term support of research, collections, and scientific publications.
- Creating a continuous three-year schedule of socially responsible and inspirational exhibitions designed to inform our citizens and visitors.
- Addressing the short-term facilities needed for successful implementation of new programs and planning the facilities required for the Natural History Museum of the future.

Collections Policy of the North Carolina Maritime Museum, June 2001

I. General

A. Museum's Statement of Purpose:

The North Carolina Maritime Museum documents, collects, preserves, and researches the maritime history—and its corollary natural history—of coastal North Carolina for the purpose of interpreting this history through educational services and exhibits for our contemporary society, and passing intact its material culture to future generations.

Museum of New Mexico Collections Policy, 2002

Stewardship of the Collections

The collections are the enduring assets that distinguish the Museum from other cultural and educational institutions. The collections hold the heritage of many communities in perpetual trust and connect the Museum to the art, culture, and history of the peoples of New Mexico and the world community. The Museum directs its efforts and resources to preserve collections that reflect the values, tastes and conventions of New Mexico's diverse communities.

The Museum of New Mexico serves primarily as the repository for artistic, cultural, educational and historic collections that relate to the state's cultural heritage. The collections of the Museum are entrusted to the governing authority of the Regents who are appointed by the Governor of the State of New Mexico. The Regents determine the Museum's mission and set policy for accomplishing the Museum's objectives.

The Museum's stewardship of the collections entails the highest trust and the presumption of permanence, care, documentation and accessibility. However, as situations and policies change, it is sometimes necessary to move an item from one accessioned collection to another, to alter the status of an object within the collections, to deaccession an object from the collections, or to exchange items between institutions.

The Museum attributes importance, meaning, and value to its collections through educational programs, exhibitions, public forums, published documents, and scholarly research. The meanings of collections change through time and may reveal the attitudes of the original makers, meanings held by the people who first used an object, the knowledge of collectors, and the understandings of scholars who study the objects. Finally, the types of objects collected reflect the changing attitudes of the Museum itself.

Strong Museum
Collections Management Manual, 2004

Strong Museum Mission Statement, March 27, 2003

As an educational institution focused on American cultural history, Strong Museum explores play in order to encourage learning, creativity, and discovery.

The museum accomplishes this through exhibitions, programs, publications, and other activities that engage, entertain, and enlighten diverse audiences, especially families, children, and educators.

To support these activities, the museum collects, preserves, and researches historic objects, manuscripts, and other materials that reflect and document the importance of play, particularly as it reflects and illuminates the American experience and with special emphasis on toys and other artifacts related to play.

What this mission statement says about Strong Museum:

- Strong Museum is a museum about the importance of play, particularly its cultural history, and especially how that cultural history helps people understand the American experience (see note below).
- Strong Museum focuses on children, parents, and educators in particular.
- Strong Museum wants all its audiences to understand that play has a critical role in learning, creativity, and discovery.

- In teaching about play and about American cultural history, Strong Museum develops and implements programs that involve learning through play.
- Strong Museum collects historical artifacts that shed light on the importance of play and how it reflects and illuminates American cultural history, but the museum's most important collections, and therefore its primary collecting interests, are toys and other artifacts related to play.
- Strong Museum is not bound by geography. Like all good museums, its service starts and is greatest in its immediate surrounds, but its collections and its interpretive message are of wider import.

How the cultural history of play illuminates the American experience:

The cultural history of play illuminates the American experience in the following ways, among others. Exploring the cultural history of play helps us understand who we are—how we choose to entertain ourselves, how we learn, how we relate to each other, how we see and present ourselves, what we laugh at and therefore what we dismiss or fear, how we pass along our principles and standards, how we mark change, and how we court risk. Studying the cultural history of play allows us to see basic processes, fundamental influences, and growing and waning ideas and trends that light up our national view of ourselves. Understanding the history of play shows what amused us and when, thereby revealing human leanings and common inclinations across culture and time. It shows our changing sense of fair play and underscores our notions of who will be accepted and who will be excluded. It reveals our feelings, the way we "construct" our identity, and how we represent the world's challenges. Play shows how we separate and how we congregate by age group, gender, ethnicity, preference, and class. Knowing how we play, what games we choose, and whom we play with traces connections between individual and group, group and culture, and self and society.

CHAPTER 4

AUTHORITY

The statement of authority identifies who is responsible for making collections management decisions and implementing collection-related policies. It identifies the individuals or groups involved and summarizes their roles regarding the collections.

- *Governing authority (e.g., board of trustees, board of regents, city council, commission).* Often museums within larger parent organizations, such as a state government or a university, outline the chain of authority from the governing authority to the institution's director, identifying the position that deals with the museum on behalf of the governing authority (e.g., provost, cultural affairs director). The role of the governing authority in setting policy and overseeing the management of the collections is clarified in the statement of authority.

- *Director, chief executive officer, or administrator.* The day-to-day management of the museum is delegated to the director, who bears the responsibility for the implementation of the policy. In some museums, the director, rather than the governing authority, has final approval over such management issues as acquisitions, loans, and deaccessions.

- *Staff.* The director delegates to staff the authority to implement the collections management policy. This section emphasizes staff's responsibility for collections care duties, and specifies certain duties given to particular staff members, such as the curator or registrar. Staff usually have the authority and responsibility to make day-to-day decisions

> ⊚ **WHEN POLICY MEETS REALITY**
>
> The Hancock Shaker Village came under fire in 2003 for using its collection of Shaker artifacts as security for a $475,000 bank loan to cover operating expenses. The museum's actions were challenged on both legal and ethical grounds, according to news reports in the Berkshire Eagle.

regarding recordkeeping, storage, care, internal use of collections, and physical arrangements for loans. In some museums, staff have final approval over acquisitions and loans.

Some collections management policies describe the assignment of specific responsibilities, such as acquisitions, deaccessions, loans, etc., in relevant sections. The authority statement often identifies collection-related committees that the governing authority has established, describing:

- how the committees were established
- the number of members and method of appointment, including which staff positions serve on committees
- the specific mission and responsibility of each committee
- the operating parameters of the committees (e.g., quorums, frequency of meeting, methods of voting, etc.)
- the documents and policies that guide the committee's actions
- which staff work with the committee, and in what way

If more than one committee exists, the policy clarifies their respective duties and how they interact. Collections committees often are given authority to:

- approve or deny proposals regarding acquisitions, particularly purchases of collections objects, deaccessions and disposal, loans, and exchanges
- review the collections management policy and recommend changes
- bring issues concerning the collection to the attention of the governing authority

Some committees are advisory only, such as those composed of outside experts or community representatives who are not members of the governing authority. Depending on their charge, they will present their recommendations to staff, the director, or the governing authority.

References

American Association of Museums. 2005. *The Accreditation Commission's Expectations Regarding Delegation of Authority,* American Association of Museums. http://www.aam-us.org/museumresources/accred/standards.cfm

SAMPLE POLICIES

Currier Museum of Art
Collections Management Policy, 1997

[name change effective 2005; formerly Currier Gallery of Art]

Authority

The Currier Gallery of Art is a privately funded, not-for-profit organization.

Board of Trustees

The Currier Gallery of Art is governed by a sixteen-member Board of Trustees drawn from the community for their expertise, interest and service. The Board, led by the President, is charged with the general management, control and direction of all Gallery business affairs and of its trust and undertakings and has full power to make investments and all sales and transfers of real estate and property belonging to the Gallery. The Board is responsible for approving Gallery goals and policies and for raising funds and approving the annual budget. Additionally, the Board shall assist in the development of collection through its oversight of the Gallery's acquisitions, deaccessioning and approval of loans. All acquisitions, whether a gift or purchase, must be approved by the Board before entering the collection and all deaccessions and methods of disposal must be approved before removal from the collection. Similarly the Board approves all loans from the collection.

Director of the Currier Gallery of Art

The Director of the Gallery works directly with the President of the Board of Trustees and other Board members in managing the operations of the Gallery. Overall responsibility for the management of the Gallery's collection lies with the Director who is guided by the policies and procedures outlined in this document. The Director shall delegate specific responsibilities to appropriate members of the staff in managing the collections.

Staff

As with the Director, the staff too shall be guided in their collections-related work by these policies and procedures. The prime directive for the Director and staff is the protection and preservation of the collections. The immediate responsibility for the physical care of all collections lies with the Curator who balances the need for conservation and maintenance of each object with the need for public access, research and special exhibition needs, staff research, and funding. The Registrar is responsible for insuring the physical well-being of the collections through proper risk management and for creating and maintaining detailed collection records.

Collections Policy of the North Carolina Maritime Museum, 2001

Staff Responsibilities

1. The Director is the final authority on all decisions affecting the collection. He will abide by the dictates required by the State of North Carolina, the North Carolina Department of Cultural Resources and the American Association of Museum's Code of Ethics. He shall delegate various authorities and responsibilities to the Curators, Collection Manager, and Registrar concerning the Collection as deemed necessary.

2. The Collection Manager has decision-making authority and responsibilities vested by the Director. The Manager shall advise the Director and the Curators in decisions affecting the collection.

3. The Registrar has decision-making authority and responsibilities vested by the Director. The Registrar shall advise the Director and Curators in decisions affecting the Collection.

4. The Curators have decision-making authority and responsibilities vested in them by the Director. They shall serve in an advisory role to the Director in decisions affecting the Collection. They shall receive advice from the Registrar and Manager on matters concerning the Collection.

5. A Collections Committee consisting of the Director, Curator of History and Technology, Curator of Education, Collection Manager, Registrar, and one board member from the Museum's Friends Organization will meet monthly to:

- Approve objects for donation,
- Designate placement in the Permanent or Teaching Collections,
- Advise as to methods of conservation of objects,
- Approve long-term loans to and from the museum.

6. The North Carolina Maritime Museum shall adhere to the *Code of Ethics* of the American Association of Museums and the American Institute of the Conservation of Artistic and Historic Works. (See appendix A)

Wisconsin Maritime Museum Collection Policy and Procedures Manual

Statement of Collection Responsibility

A. Board of Trustees and Maritime Staff

The final responsibility [for] the collection lies within the auspices of the Board of Trustees of the Wisconsin Maritime Museum. From within the structure of the Board a special committee is designated as the Collections Committee. The Collections Committee is a standing committee of the Board of Trustees, established by and accountable to the Board. The Collections Committee consists of at least one Trustee who acts as chair, and four committee members selected from the maritime community/industry (i.e., diving, recreational boating). The members of the Collections Committee are appointed to a one year term (August to August). Appointments are renewable if agreed to by both parties (Museum Board and committee members) at the end of each term. Meetings are held 6 times per year; August, October, December, February, April, and June. Members will work with the curatorial staff to actively solicit artifacts, documents, photographs, archival material which support the work of the mission of the museum, as well as assist with procurement of storage locations, supplies and equipment. Collection Committee members will also work to recommend polices governing the care and use of the collection.

The Board of Trustees delegates authority to the museum staff members to administer the daily needs of the Collection. Staff members directly responsible for the care and use of the collection are: the Assistant Director/Curator and Registrar, who interact with the Collections Committee, and report directly to the Director; Volunteer Assistants, who work with and are under the direct supervision of the Registrar, Curator or Assistant Registrar. (See Collection Access Policy.)

William Hammond Mathers Museum Collections Management Policies & Procedures, 2003

Statement of Authority

The William Hammond Mathers Museum is organized as a unit within the Office of the Vice President for Research. The Director of the Museum reports directly to the Vice President for Research, and through the Vice President to the Chancellor of the Bloomington Campus, the University President, and the Board of Trustees (in that order). In turn, the Board of Trustees has delegated authority for the day to day operations of the Museum through the University President, the Chancellor of the Bloomington Campus, the Vice President for Research and the Director of the Museum. This delegation of authority follows the organizational structure described in the *Academic Handbook* of Indiana University.

The Director is the chief operating officer of the Museum, and is responsible for the operation of the Museum's programs, the development and maintenance of the Museum's collections, the needs of the building, and the security of the Museum. In matters of policy making the Director shares responsibility with the Policy Committee of the Museum, but bears the ultimate authority and responsibility for the implementation of the Museum's policies. The Director serves as an *ex officio* member on all subcommittees of the Policy Committee.

The Policy Committee is a consulting group established to assist the Director in formulating policies for the Museum. The Policy Committee and its Chairperson are appointed annually by the Vice President for Research.

The Policy Committee consists of voting and *ex officio* members. It shall have no fewer than six (6) voting members, appointed from the general community

and departments, programs, and other units of Indiana University whose work is related to that of the Museum. The voting members of the policy Committee do not represent specific constituencies. Instead, they should address themselves individually, to the best of their judgments and abilities, to the larger needs and goals of the Museum.

The number of *ex officio* members should not exceed the number of voting members. The *ex officio* members should include the Director and Assistant Director of the Museum and a representative of the Office of the Vice President for Research and Dean of the University Graduate School. *Ex officio* members do not vote except under the circumstances described below.

The Chairperson of the Policy Committee is appointed from the voting members. The Chairperson presides at the Committee's meetings.

The total membership of the Policy Committee is involved in all discussions, but it is the charge of the voting members to vote upon recommendations concerning the policies of the Museum. Policy drafts are prepared by the Director and the Assistant Director of the Museum, with input by the Museum staff, and submitted to the Policy Committee for discussion and voting. All policies or subsequent amendments must be approved by the Policy Committee according to the voting procedure described below.

The presence of two-thirds (2/3) of the voting members of the Policy Committee shall constitute a quorum on all matters. Proxy votes are not permitted. If a quorum exists, a simple majority of voting members shall effect a decisive vote. In the case of a tie vote, the Director of the Museum shall cast the deciding vote. The Director of the Museum shall also have the power to veto any decision made by the voting members. The Director's veto can be overruled by a vote of four-fifths (4/5) to the combined voting and *ex officio* membership (excluding the Director in this case). Records of all votes and decisions of the Policy Committee shall be maintained by the Museum. A copy of the approved policy or amendment shall be sent to the Office of the Vice President for Research, to which the Museum reports.

5

SCOPE OF COLLECTIONS

It is good to collect things,
but it is better to go on walks.
—Anatole France

The scope of collections policy is an important tool for managing the collections, now and in the future. It describes the collections and provides guidelines for future acquisitions. Many museums create separate, more detailed collections plans that supersede much of what was traditionally included in a scope of collections policy. In such cases, the scope often includes only broad, policy-driven directives on collecting.

The scope of collections policy can be a simple list of the types of elements in the collection and an explanation of how they are divided among collecting departments. However, the policy will be much more useful to the museum if it includes:

- a brief history of the collections, including past collecting practices and a description of the growth of those collections
- a review of collection strengths and weaknesses

⦿ **WHEN POLICY MEETS REALITY**

A good scope of collections policy serves to guide a museum staff on what to accept and not accept in the collections, and also provides a gentle way to turn down sincere but inappropriate offers. For example:

- A museum in Texas once was offered a pecan that grew on the tree in the yard of the house that Stephen F. Austin built, along with an elm tree root in the shape of a snake.

- The Butler-McCook Homestead in Hartford, Conn., was offered the vaccination scabs from the McCook children.

- A regional National Park Service branch museum was offered a model of the Statue of Liberty made of salmon skins.

- the current uses of the collections and how the collections help the museum fulfill its mission
- the role of the governing authority in regard to the collections
- a succinct statement that articulates the museum's philosophy of collecting and provides direction for the collection's development and growth
- a statement explaining what the museum does not collect

The scope of collections policy sets limits on what is added to the collections; these limits are based on the collections plan criteria discussed in chapter 1. The scope also guides the development of the collections in a manner consistent with the museum's mission and gives the staff intellectual control over the collections' growth and stewardship. The parameters that determine what can be added to a museum's collections often are based on a combination of several factors (see table 5.1), including:

- the geographic areas of interest to the museum
- the subject areas of interest to the museum
- the chronological frame relevant to the museum
- the intended use of the collections

The scope of collections policy reflects the curatorial and physical resources of the institution (Nicks, 1999). It addresses all the collections categories in the museum (see chapter 6, "Categories of Collections"), and includes a summary of the reasons why the museum collects what it does, ranking the justifications as primary and secondary, if appropriate.

References

Gardner, J.B. and E. Merritt. 2004. *Collections Planning*. American Association of Museums, Washington, D.C., viii + 93 pp.

Nicks, J. 1999. Collections management. In Lord, G.D. and B. Lord (editors). *The Manual of Museum Planning,* pp. 109-123. Second edition. AltaMira Press, Walnut Creek, CA., xvii + 462 pp.

TABLE 5.1. **Scope of collections criteria**

CRITERIA	EXPLANATION
Geographic	Regional area of interest to the museum.
Subject	Subject area of interest to the museum.
Time	Chronological period of interest to the museum.
Theme	Subject-related themes—e.g., slavery, voting rights, biological diversity—that may cut across collections areas and geographic and time-bounded categories.
Use	Intended uses for the collections; it generally is accepted that museums will not acquire objects they cannot put to appropriate use.

SAMPLE POLICIES

Collections Policy of the North Carolina Maritime Museum, 2001

Scope and Uses of Collection

1. The Collection consists of historical and biological objects, specimens, and artifacts relating and/or pertaining to North Carolina maritime material culture or coastal natural history.

2. The interpretive scope of the Museum includes all North Carolina maritime history and coastal natural history objects, artifacts, and biological specimens that meet the criteria set forth in the Statement of Purpose. Objects not meeting the criteria will not be accepted as a donation to the Collection.

3. The various sub-collections shall be used for scholarly research; teaching or interpretation purposes in conjunction with lectures, field trips, and visiting groups; outgoing loans to appropriate non-profit, educational institutions; or, exhibition or display within the Museum.

4. The Collection is divided into the following sub-collections:

 a. Permanent Collection: non-replaceable and/or priceless, or historically valued objects subject to special handling, storage, paperwork, and exhibition.

 b. Teaching Collection: replaceable and non-historically valued objects *not* subject to special handling, storage, paperwork, or exhibition.

San Diego Natural History Museum Collections Policy, 1997

The San Diego Natural History Museum is limited by its mission and purpose to housing collections of biological or geological specimens with their associated data and documentation, as well as library and archival materials. The San Diego Natural History Museum does not normally accept human remains into its permanent collections, with the exception of limited Recent human skeletal specimens accessioned as part of the mammal range for comparative purposes. Human remains and cultural materials are referred to other more appropriate institutions for their legal treatment and disposition.

CHAPTER 6

CATEGORIES OF COLLECTIONS

Museums usually have more than one category of collection. Categories of collections are defined in the collections management policy and describe how collection elements are acquired, cared for, made accessible, and used (e.g., permanent collection, teaching collection, or reference collection). There are no standard definitions for categories of collections, so each institution must write its own.

The policy addresses the specific standards of care, management, and documentation for each category of collections. The most common categories of collections are listed in table 6.1, but the exact definition of any category will vary from one museum to another. For this reason, the collections management policy defines each category of collections the museum has and describes how the collections in that category are acquired and used. The way a category of collections is defined affects other policy considerations, such as the amount of documentation required for collections acquisition or how the museum deaccessions and disposes of elements in that category. For example:

- *Permanent collections* are the museum's primary collections, maintained at the highest standards and requiring the most complete documentation. Accessions to the permanent collection are intended to be in the museum's care, held in public trust, for the foreseeable future. This does not necessarily mean that other collections are considered impermanent or disposable.

- *Education collections* are objects intended to be used in hands-on activities and demonstrations, so they usually are held to a lower level of care. Because they will suffer from wear and tear during educational programming, objects for these collections often are easy to deaccession and dispose of and are selected for their safety and durability. Some museums consider educational collections to be non-accessioned collections and thus not held in the public trust.

- *Exhibition collections* are objects or specimens that are usually of fine quality or rarity, intended for use in display and for loan to other institutions. These collections require a high standard of care, but the collections management policy must account for the particular needs of exhibition and loans.

- *Teaching or study collections* contain elements that are of good quality but have only minimal documentation. Study collections are suitable and appropriate for use by non-professionals such as students and visitors, and the collections management policy accommodates this use.

- *Collections on repository agreement* are managed by the museum but are not owned by the museum. Collections on repository (or managerial) agreement may be owned by the federal government or a foreign government. Some collections management policies allow the collections to be studied on site but not loaned to another institution, or require the museum to return them to the owner in the future. (For more information on repository agreements, see chapter 16, "Additional Stewardship Issues.")

References

Washburn, W. E. 1984. Collecting information, not objects. *Museum News* 62 (3):5-15.

TABLE 6.1. **Some categories of museum collections.**

CATEGORY	NOTES ON CONTENT AND CARE OF COLLECTION
Archives	Documentation of the museum and its collections, supplemental information for other collections, research, and scholarly activity.
Collections held under a repository or management agreement	The museum does not own these collections but it might be charged with cataloging and managing them. Can include specimens of federally protected species, forensic vouchers, controlled substances, or collections owned by a foreign government.
Education collection	Objects that are expendable, intended to be used for public programs, demonstration, experimentation, and exhibition. Can include a loan collection for off-site use.
Exhibition or display collection	Aesthetic, educational in nature. Can include collections in visible storage. Usually objects of fine quality, intended to be used for exhibitions and loans.
Library	Library, supplemental information for other collections, research, and scholarly activity.
Permanent collection	The main collection of the museum, considered the core collection to fulfill the museum's mandate. Can include one or more of the other collection types.
Research collection	Well-documented collections reserved for comparison, research, or scholarly study.
Reserve collection	Back-up collection for study, exhibition, or public programming; objects under consideration for accessioning or deaccessioning; objects to be transferred or exchanged.
Teaching or study collection	Good quality objects, often with minimal documentation, intended to be used by advanced students.
Type collection	In natural history museums, specimens that are holotypes, paratypes, or figured specimens. Use of these collections is highly restricted.

SAMPLE POLICIES

Art Museum of Western Virginia Collections Management Policy, 1998

Study Collection

The objects in the study collection are primarily used as auxiliary, supporting material to the permanent collection. Such objects may be handled and may be exhibited and stored under less rigorous standards than those applied to the permanent collection. Objects may come into this collection as gifts (designated as study collection on their Deeds-of-Gift), purchases, or transfers of deaccessioned items from the permanent collection. These objects may be used for exhibit props, educational outreach programs, and supplementary research material. The study collection shall be housed in a secured storage area under the educational department's control, and the registrar shall maintain accession records. Objects may be removed from the study collection if they are damaged, lost, or are no longer relevant to the collection's purposes; in such cases the executive director and director of education shall make the decision and shall notify the registrar, who shall note the reason and date of removal in the object's file.

William Hammond Mathers Museum Collections Management Policies & Procedures, 2003

Definition of Collections

The William Hammond Mathers Museum holds five collections within the institution. These are the Permanent Collection, the School Loan Collection, the Conservation Collection, the Library Collection, and the Exhibit Prop Collection.

The Permanent Collection consists of objects that have been acquired by the Museum for preservation, study, exhibition, and programming purposes in fulfillment of the Museum's Statement of Purpose. The highest degree of care and documentation is given to the objects and the highest degree of accountability is attached to this collection. Only those objects deemed suitable for acquisition

into the Museum's permanent collection are accessioned and curated.

The School Loan Collection consists of materials that have been acquired for use in the Museum's hands-on educational programming. These materials are non-accessioned and non-curated, but records are kept of acquisition and use of School Loan objects. Items designated as School Loan Collection materials are not subject to the collections management policies set forth in this document.

The Conservation Collection consists of materials that have been acquired for use in the Museum's Conservation Laboratory for research and experimentation into conservation methods and techniques. These materials are non-accessioned and non-curated, but records are kept of acquisition and use of Conservation Collection materials. Items designated as Conservation Collection materials are not subject to the collections management policies set forth in this document.

The Library Collection consists of materials that have been acquired for use in the Museum's Library for research and study by Museum staff, students and visitors. These materials are non-accessioned and non-curated, but records are kept of acquisition and use of Library materials. Items designated as Library Collection material are not subject to the collections management policies set forth in this document.

The Exhibit Prop Collection consists of materials that have been acquired for use in the Museum's Exhibition Program. These materials are non-accessioned and non-curated, but records are kept of acquisition and use of Exhibit Props. Items designated as Exhibit Props are not subject to the collections management policies set forth in this document.

Old Cowtown Museum Collection Management Policy, 2000

Collections Categories

Materials acquired by the Museum will be considered by the Collections Manager for inclusion in holdings of dif-

fering scopes and purposes. The Museum will manage each of these holdings according to professional museum standards to effectively serve the Museum's exhibit, collection, educational, and interpretive needs. Old Cowtown Museum's holdings will be classified under three primary divisions:

A. Permanent Collection

The Permanent Collection will contain accessioned items that have been considered under the criteria established in the Scope of Collections. Following is a summary of those guidelines:

- Objects dated or with known provenance from before 1880

- Objects not dated or of uncertain provenance but, in the Collections Manager's judgment, meet other Scope of Collections guidelines for collections objects

- Transitional objects that, although dated slightly after 1880, are fundamentally unchanged from like objects of the period (e.g., a kerosene lamp patented in 1875, 1878, and 1882).

- Archival documents, photographic materials, and ephemera predating 1880, including unpublished, original first-person accounts of personal experiences in the region before 1880.

The Collections Manager will determine the disposition and use of objects in the Permanent Collection. These objects are intended for exhibition, research, and preservation purposes. Proposals for other use of objects in the Permanent Collections will be considered in light of such factors as the object's condition, its rarity or duplication within the collections, the level of training received by the staff who will be interacting with the object, and the ability of the staff to provide adequate levels of security for the object.

B. Study Collection

The Study Collection will include objects that apply to the region and time period, but are not accessioned into the Permanent Collection due to fragmentation, duplication in the collections, or other reasons. Such items can include wallpaper samples, fabric and upholstery samples, paint color and finish samples, architectural elements from lost historic structures, and other like materials and objects.

Objects selected for inclusion in the Study Collection will be registered and marked as "SC" by the collections staff. These objects will be placed with the Permanent Collections in secure reserve collections areas.

Objects in the Study Collections are not intended for use in exhibits or for demonstration purposes.

C. Educational Resource Collection

The Educational Resource Collection or "Hands-on" Collection will contain objects that have been considered under the following guidelines:

- Objects of known or unknown provenance which duplicate the Permanent Collections holdings

- Transitional, dated, post-1880 unchanged objects which are already represented in the Permanent Collections

- Reproductions of period objects.

Objects assigned to the Educational Resource Collection will be registered and marked "HO" or "PROP" by the collections staff. The objects will then be turned over to the Museum's Interpretation Department to be managed, maintained, and stored at the discretion of the Director of Interpretation.

See also "Collections Policy of the North Carolina Maritime Museum, 2001: B. Scope and Uses of Collection," chapter 5, page 31.

CHAPTER 7

ACQUISITIONS AND ACCESSIONS

Accession Terminology

The process of adding stuff to the collection is similar in all museums. First, the museum acquires objects or specimens (e.g., by donation, gift, purchase, or field work). The museum staff then evaluates the acquisition—considering its suitability for the collection, quality of documentation, and so forth—and decides whether to accept it. Elements destined for the permanent collection are accessioned (the process by which the museum takes ownership of the elements). All museums use similar processes to add objects or specimens to their collections, but the terminology used to describe those processes has not always been used consistently.

- An *acquisition* refers to something obtained by a museum. Acquisition does not mean that a transfer of ownership has taken place.

- An *accession* is an acquisition that a museum formally adds to its collections, to be held in the public trust and administered according to the collections management policy.

- *Accessioning* is the process of transferring ownership of an acquisition to the museum, including the process of recording the acquisition as part

◉ WHEN POLICY MEETS REALITY

The National Museum of the American Indian now has its very own gold record. Felipe Rose, who is Lakota Sioux, was a member of the popular 1970s group The Village People. Rose donated a framed, gold 45-rpm single of the disco hit, "Y.M.C.A." to the museum.

◉ WHEN POLICY MEETS REALITY

There are at least 20 accepted variant spellings for Peter Ilyich Tchaikowsky—but to a computer, those would be 20 unique names.

THINGS GREAT AND SMALL: COLLECTIONS MANAGEMENT POLICIES

of the collection. Acquisitions cannot be added to the collection, registered, or cataloged until they have been accessioned.

- The *accession number* is a unique number assigned to a collection element or group of elements that comprise the accession. In some museums (particularly art museums) the accession number is the only number assigned to a collection object. In other museums, the catalog number is more commonly used to track individual collection elements. The accession number is sometimes called the registration number.

- The *accession record* contains the information documenting where the accessioned material came from, a brief description of the material, and how the museum took ownership of it. Historically, the accession record was a hand-written entry in a bound ledger book or card file called an accession register. Many museums now keep their accession records in an electronic format in addition to or instead of hand-written records.

- *Registration* is the process of recording the accession records in serial order. The accession records are recorded in an accession register.

- *Registration number.* Depending on the museum, the registration number might be a synonym for accession number or catalog number.

- *Cataloging* is the process of organizing the information about the accessions by creating a record of specific information about the object or specimen (to catalog means to place in categories). The catalog is a separate document from the accession register. Historically, museums maintained the catalog in the form of hand-written entries in a bound ledger book or on file cards. Many museums now maintain the catalog in an electronic format in addition to or instead of a hand-written version.

- *Catalog record.* The catalog record is created during the cataloging process. The catalog record usually contains more information about the collection elements than the accession record. In some museums each individual component of the accession is assigned a unique catalog number, an object number, or a registration number that is used to identify individual collection elements. In other museums, the accession number is used to identify individual collection elements.

◉ WHEN POLICY MEETS REALITY

Just because a classification system allows you to assign a category to everything does not mean that it is a useful system. In "The Analytical Language of John Wilkins" essayist Jorge Luis Borges describes a Chinese encyclopedia called *The Celestial Emporium of Benevolent Knowledge* that divided animals into 14 groups:

1. Those that belong to the Emperor
2. Embalmed ones
3. Those that are trained
4. Suckling pigs
5. Mermaids
6. Fabulous animals
7. Stray dogs
8. Those included in the present classification
9. Those that tremble as if they were mad
10. Innumerable ones
11. Those drawn with a very fine camelhair brush
12. Others
13. Those that have just broken a flower vase
14. Those that from a long way off look like flies

Using this system, it is possible to fit any animal into a category, but retrieving the information would not be easy.

- *Catalog number.* A number assigned to a particular object or specimen to provide a unique identification of the object or specimen. Synonyms for catalog number include object number and registration number.

Accession Policy

Generally, museums only accession elements that they intend to keep for the foreseeable future. A museum can acquire something that it intends to sell, but if so, should probably not accession it. Indiscriminate accessioning followed by deaccessioning creates a very poor image for the museum.

The museum has legal and ethical obligations concerning its accessions. For example, it must provide proper

● WHEN POLICY MEETS REALITY

A Question of Taxonomy

In a query to the *Museum-L* listserv a registrar asked for input on how to catalog some "hairy bunnies" that had awaited processing for way too long. (The mechanical Easter bunnies had been used as display props for a local department store in the 1950s.) Using the Chenhall system of nomenclature, the registrar asked if the bunnies should be classified under *Recreational Artifact,* or *Public Entertainment Device?* Recommendations included *Automata* and *Advertising Medium, Novelty.* Finally, a student wrote, "What's wrong with 'mechanical Easter bunnies c.1950?' Why is it we need to give this super specific name that no one would understand but the one who named it?"

Object title is one thing, but a classification or categorization of an object is another thing entirely. The purpose of using a standardized name is to reduce confusion (e.g., is it a couch, a chesterfield, a sofa, or a davenport?). The important thing to remember is that standardization is what makes a database useful.

what is accessioned that is sufficient to identify the component or components until they are marked with an accession number or a catalog number. The accession record also includes any documentation pertaining to the object's legal status, such as a deed of gift, bill of sale, collecting permit, or export and import permits.

It is recommended that the accession policy state who is responsible for accessioning and cataloging the collection elements and maintaining the associated records. Ideally, each museum will establish a standard nomenclature (or taxonomy) for categorizing its collections, and identify the standard in the accession policy document. For example, many museums use the Chenhall taxonomic system, which provides names for human-made objects in a hierarchical structure (Blackaby and Greeno, 1988).

Most accession policies state that accessions will conform to the museum's mission, enhance and strengthen the existing collections, come to the museum with free and clear title (i.e., unencumbered and free of liens), and be designated for the collection. Accessions are accompanied by evidence that documents the chain of ownership, transfer of copyright (if applicable), and legal exportation, importation, and acquisition by the museum. The accession policy describes acceptable methods of acquisition and refers to any other policies that govern acquisition methods (see table 7.1). For example, the scope of collections policy and collections plan help museum staff evaluate each potential accession and set limits on what can be added to the collection (see table 7.2).

storage, management, and documentation for everything in its collections and maintain those collections for the benefit of the public. The museum must accomplish this without compromising its ability to properly store and care for the objects already in its possession.

An accession can have a single component (i.e., consist of just one object), as is often the case in art museums, or it can comprise multiple components, as is common in anthropology and natural history museums. An accession is composed of everything acquired at the same time, from the same source, as a single transaction between the museum and that source (Burcaw, 1997).

Because the accession record is so important, the accession policy usually specifies what information is to be recorded concerning the transaction (e.g., the date of receipt in the museum, method of acquisition, name and address of donor or vendor, date of accession). The accession documentation can include a description of

It is a good idea for the policy to state that accessions must be acquired in an ethical manner. In so doing, the policy might refer to the museum's institutional code of ethics (see chapter 17). Each museum must contend with its own particular set of ethical issues. For example, a natural history museum might decline

> **"** In the past, it was the clergy who used to remind people they were mortal. Now it is the museum people. Very tactfully they let you know that you will not go on forever and they say—also tactfully—'You can't take it with you.' **"**
> —de Menil (1987)

specimens that were collected in a manner that caused environmental damage; an anthropology museum might decline objects that are regulated by the Native American Graves Protection and Repatriation Act (NAGPRA); an art museum might decline a work of questionable authorship. To avoid the possibility of both ethical and legal problems, some museums do not accession unprovenanced objects.

Numerous local, state, national, and international laws and regulations govern the acquisition, ownership, use, and transport of museum collections (see appendix C, "Laws and Legislation"). The accession policy identifies who is responsible for ensuring that the museum complies with applicable laws and ethical practices. In the past, lack of oversight has created problems for museums. For example, many art institutions have had to clarify the provenance of objects in their collections that might have been illegally appropriated by the Nazis between 1933 and 1945.

Unaccessioned Acquisitions

Some museums acquire collections that they do not choose to accession; for example, a teaching collection of objects intended to be handled regularly by children and other visitors. Because the museum does not intend to

⦿ WHEN POLICY MEETS REALITY

In her book, *Museum Law: A Guide for Officers, Directors, and Counsel,* Marilyn Phelan recounts the case of a 6,070-pound meteorite that was found on federal land in the Old Woman Mountain Range in southern California. State officials removed the meteorite, placed it on exhibit at the Los Angeles County Museum of Natural History, and then applied for a federal permit for it under the Antiquities Act. After consulting with the Smithsonian Institution, the Department of Interior and the Bureau of Land Management determined that the meteorite belonged to the Smithsonian. The State of California filed a lawsuit to prevent the Smithsonian from getting the meteorite, but in the end, it was deemed a federal resource, and awarded to the Smithsonian.

keep these objects in perpetuity as part of the collections held in public trust, the objects are not accessioned.

Gifts

Most museum accessions come in the form of gifts. A gift is a voluntary transfer of property from one person or organization to another without financial consideration or other compensation. The accession policy requires sufficient documentation to prove that each gift the museum receives is valid. A valid gift means that:

- The owner intended to make a gift of a property.
- There was a complete and unconditional delivery of the property.
- The recipient accepted the property as a gift.

The standard document required for this purpose is a deed of gift form. This form states that the person who owns the donation gives it to the museum without restrictions. Examples of *deed of gift* forms and the required legal language can be found in Malaro (1998).

Most accession policies prohibit or severely restrict partial and fractional gifts, deferred and promised donations, and restricted gifts. A *partial gift* or *fractional gift* means that the donor retains partial ownership of the donation. Partial or fractional gifts should be accepted only if a written contract or statement of intent requires the donor to transfer the remaining interest to the museum within a specified period of time. A *promised gift* or a *deferred donation* means that the donor wishes to retain ownership for the present, but wants assurance that the object will be accepted by the museum at some point in the future. A promised or deferred gift should be allowed only under terms of a written contract. Museums are advised to avoid *restricted gifts,* which oblige the institution to comply with certain requirements that govern the gift's use, attribution, display, or future disposition. For example, a donor might require an object to go on permanent exhibition or be returned to the donor's heirs if it is ever deaccessioned. If a donor wishes to impose restrictions on a gift, the museum staff can try to address the donor's concerns in some other way. The benefits of accepting a restricted gift must be weighed against the long-term impact the restrictions will have on the museum's operations.

issues as:

- who gives approval for the purchase (the level of approval required sometimes depends on the amount of the purchase);

- who are acceptable vendors (e.g., to avoid conflict of interest, most museums will not purchase material from staff or board members; some museums will not make purchases from private individuals);

- restrictions on what objects the museum will purchase (e.g., some museums consider it unethical to purchase commercially salvaged maritime artifacts, even if the artifacts are sold legally);

- safeguards to ensure that the purchase price is fair and reasonable (e.g., the policy requires the staff to determine whether a comparable object could be obtained through a donation instead of a purchase);

- the appropriate attribution of purchases bought with funds from particular sources (e.g., the policy requires exhibit labels to identify objects purchased with donor-restricted funds or with funds resulting from a deaccession).

Loans

Objects on loan cannot be accessioned because a loan does not involve the transfer of ownership (see chapter 9, "Loans").

Repository Agreements

Specimens or objects that are held under the terms of a repository agreement cannot be accessioned because a repository agreement does not involve transfer of ownership (see chapter 16, "Additional Collections Stewardship Issues"). Some museums establish a recordkeeping system that parallels the accessioning system to track collections on repository agreements in the institution's care.

Other Accession Policy Considerations

Depending on the museum and its collections plan, the accession policy will address bequests, exchanges, field collecting, or other means of acquiring collections.

- *Bequests:* Museums are under no obligation to accession gifts that are bequeathed to them. As Joseph Conrad once wrote, "It was imperative sometimes

WHEN POLICY MEETS REALITY

Howdy Doody finally had his day in court to resolve the issue of who is allowed to pull his strings. The Associated Press reported that custody of an original Howdy Doody marionette was awarded to the Detroit Institute of Arts, where he joined Punch and Judy and Kermit the Frog in retirement. The museum claimed that Howdy Doody's puppeteer, Rufus Rose, made a verbal promise of the marionette to the museum many years ago when the popular television show went off the air. Rose had loaned the puppet to the show's host, Buffalo Bob Smith, for a tour of college campuses in the 1970s. Later, Smith and Rose's son decided to sell the puppet and split the profits. Other members of Rose's family disputed not only the museum's claim to the puppet but that particular Howdy's authenticity as well. As it happens, there was more than one Howdy Doody puppet, including one without strings (made for taking publicity photographs) and the official stunt double that is now in the Smithsonian Institution, "Double Doody."

Appraisals and Donor Tax Deductions

An *appraisal* is a judgment by someone of what something is worth. Appraisals often are necessary to establish value for insurance, sale, or purchase; determine loss; or to allow a donor to take a tax deduction for a donated object. Most museum codes of ethics, as well as the Tax Reform Act of 1984 (see appendix C, "Laws and Legislation"), prohibit museums from providing appraisals of tax-deductible donations. It is recommended that the accession policy state that the museum will not make, arrange, or pay for appraisals of donations and that any internal appraisals will not be shared with donors. At some museums, staff can recommend outside appraisers to the donor. To avoid any appearance of a conflict of interest, in these institutions the accession policy stipulates that the museum will provide the names of two or more appraisers without preference.

Purchases

Typically the accession policy addresses the purchase of objects for the museum collection, considering such

to know how to disobey the solemn wishes of the dead." Many accession policies state that the museum will accept only bequests that fit the institution's collections plan.

- *Exchanges:* Some accession policies specify or restrict exchanges to other nonprofit museums or educational organizations, and bar exchanges with individuals or private dealers. (Museums customarily make exchanges only with other nonprofits to ensure that the objects remain accessible to the public.) It is recommended that the accession policy require that there is a written agreement between the museum and the other organization before a transfer of collections takes place. Exchange agreements specify what will be transferred, who will pay for packing and shipping, and have a specific beginning and ending date for the exchange activity.

- *Field collecting:* The accession policy might specify the level of authorization needed before staff undertake field collecting, or the level of review required to approve field collections for accessioning.

See table 7.1 for other means of obtaining accessions.

Who Makes Accession Decisions?

The accessions policy specifies who has the authority to make decisions about accessions. This might be the director, curator, registrar, collections manager, or an accession committee. Some museums require all accessions to be approved by their governing authority; others are required to report accessions to their governing authority. Determining who has the authority to approve an accession can depend on the nature of the accession or its estimated value (e.g., the policy might require accessions valued at more than $500 or $1,000 to be approved by an accessions committee or the director). The advantage to having an accessions committee is that by incorporating the viewpoints of a variety of stakeholders in the decision-making process, the museum reduces the chances that an accession decision will be short-sighted or one-sided.

References

Blackaby, J.R. and P. Greeno. 1988. *The Revised Nomenclature for Museum Cataloging: A Revised and Expanded Version of Robert G. Chenhall's System for Classifying Manmade Objects.* AltaMira Press/American Association for State and Local History, Nashville, 520 pp.

Burcaw, G.E. 1997. *Introduction to Museum Work.* AltaMira Press/American Association for State and Local History, Nashville, 240 pp.

de Angelis, I.P., and L. Hersh. 2001. Object of appraisal: legal & ethical issues. *Museum News* 80(5):46-57

Carnell, C. and R. Buck. 1998. Acquisitions and accessioning. In Buck, R.A. & J.A. Gilmore (editors). 1998. *The New Museum Registration Methods,* pp. 157-165. American Association of Museums, Washington, D.C., xvii + 427 pp.

Gardner, J.B. and E. Merritt. 2002. Collections planning. Pinning down a strategy. *Museum News* 81(4):30-33; 60-61.

Malaro, M.C. 1994. *Museum Governance: Mission, Ethics, Policy.* Smithsonian Institution Press, Washington, D.C., viii +183 pp.

Malaro, M.C. 1998. *A Legal Primer on Managing Museum Collections.* Second edition. Smithsonian Institution Press, Washington, D.C., xx + 507 pp.

Reibel, D.B. 1997. *Registration Methods for the Small Museum.* Third edition. AltaMira Press/American Association for State and Local History, 192 pp.

Segal, T. 1998. Marking. In Buck, R.A. & J.A. Gilmore (editors). 1998. *The New Museum Registration Methods,* pp. 65-93. American Association of Museums, Washington, D.C., xvii + 427 pp.

TABLE 7.1. **Acceptable means of acquisition.**

MEANS	COMMENTS
Adoption of orphaned collection	The museum carefully evaluates the quality of orphaned collections and considers the impact on its resources if the collection is accessioned. (See chapter 16, "Additional Collections Stewardship Issues.")
Bequest	Bequests are treated similarly to other gifts and donations and are documented with a deed of gift, signed by the donor or donor's agent.
Conversion of unclaimed or old loan	See chapter 10, "Objects in Custody."
Exchange	Exchanges are governed by the terms of a time-limited written agreement.
Field collection	The accession file includes copies of all collecting permits, import/export permits, declaration forms, etc.
Gift or donation	A voluntary transfer of property by one party to another without compensation. A deed of gift form is completed as part of the accession documentation.
Government deposit	These might be federally protected collections or confiscated collections. The closest thing to a "permanent loan" is a long-term government deposit (e.g., of a specimen of a federally protected species or artifacts from federal lands). In some cases, the government retains ownership but requests that the collection be cataloged and managed by the museum.
Purchase	Museum objects are classified as personal property, therefore sales and purchases in most states are governed by the *Uniform Commercial Code*. In some states, there are special regulations for works of art or museum objects.
Salvage	Salvage activities require permits from the appropriate local, state, or federal authorities; copies of the permits should be part of the accession record. (Salvage refers to the acquisition of dead animals or plants that were not intentionally collected as museum specimens.)

TABLE 7.2. **Considerations for accessioning decisions
(after Burcaw, 1997; Gardner and Merritt, 2002; Malaro, 1998).**

CRITERIA	COMMENTS
Care	Are there resources (space, staff, and facilities) for providing proper storage, management, and care of the acquisition without compromising the rest of the collection?
Condition	Is the acquisition in reasonably good condition? Will it take a large amount of resources to stabilize or restore it? Is it so badly damaged that it will soon be worthless?
Cost of upkeep	Is the cost of keeping the acquisition equal to the benefits of having it in the collection?
Duplication	Does the acquisition duplicate something that is already in the collection?
Documentation	Is the documentation adequate to establish the significance of the acquisition to the museum?
Legal title	Will the museum be able to secure clear and legal title to the acquisition?
Legality of accession	The museum is responsible for making sure that everything it accessions was legally obtained, exported, and imported. (Otherwise the museum probably will not be able to claim ownership of the acquisition.)
Potential use	Is the acquisition likely be used for research, reference, loan, exhibition, education, or exchange? Is it an object, artifact, or specimen that is a voucher (an example or proof) for research or other scholarship activity?
Provenance	Is the provenance of the acquisition established and adequately documented?
Public relations	How will the addition of this acquisition affect the museum's image? Will it attract visitors or damage public support?
Purchase price	Is the purchase price in line with current market values?
Relevance	Is the acquisition relevant to the mission of the museum and the scope of collections?
Restrictions	Is the acquisition free from restrictions on ownership, intellectual property rights, copyright, and trademark?
Safety and security	Will the acquisition compromise the safety or security of the staff or visitors? Will the acquisition require expensive safety measures to protect?
Scope	Does the acquisition fit the scope of the collection (geographic, subject, temporal, and use)?
Special considerations	Are there extenuating circumstances or conditions that affect the decision to acquire or not acquire the acquisition for the collections?

SAMPLE POLICIES

James A. Michener Art Museum
Collections Management Policy, 2001

Acquisition

Collection building activity is fundamental to JAMAM's long-term success. Objects are considered for acquisition on the basis of various factors that include: quality; rarity; artistic merit and aesthetics, intellectual value, attribution and provenance; size, volume, or quantity of the objects; price; cost of conservation, storage, and maintenance; restrictions of use; and potential for use in exhibition and research.

Objects may be added to the collection by means of gift, bequest, purchase, exchange or any other transaction by which title to an object passes to the museum. All objects accepted into the collection become JAMAM's exclusive property and, if unrestricted, may be displayed, loaned, retained or disposed of in the best interests of the museum and the public it serves.

During the acquisition process, JAMAM strictly adheres to professional ethics and the law. JAMAM's procedures assure prompt recording and full accounting of all accessioned objects.

Adequate resources to store and care for objects are at a premium in most museums, as is true at JAMAM. If resources for collections care are inadequate, a decision to curtail or suspend acquisitions is a responsible option. When an important object cannot be accommodated, JAMAM's staff may inform potential donors of international, regional, or local repositories that can effectively use the object for educational or not-for-profit purposes.

JAMAM does not acquire culturally sensitive Native American objects. Culturally sensitive material includes objects whose treatment, custodianship, or use is a matter of concern to contemporary cultural groups. These groups, or individual members of these groups are defined by their ability to demonstrate cultural affiliation and or/legal cultural standing.

The Collections Committee, by approval of the Board of Trustees, has the authority and responsibility to assess potential acquisitions and approve purchases or gifts. The Committee is made up solely of board members, with the Director, Registrar, and appropriate curators attending the meetings. The staff provides research and recommendations about objects proposed for acquisition, subject to approval by a majority vote of the Committee.

The Committee considers objects for acquisition based on the following guidelines:

1) The object is useful to the purpose and collecting goals of the Michener Art Museum.

2) The object has aesthetic merit, possesses potential for research and scholarship, or has historical/cultural significance.

3) The object is useful for exhibition purposes.

4) The object, after careful examination, can be conserved within the resources of the museum or is being received with a monetary donation specifically for its conservation. No object shall be acquired for the collection if the museum cannot give it proper storage, protection and preservation.

5) Unless there is a compelling reason to do otherwise, the Collections Committee will only accept acquisition of unrestricted gifts wherein free and clear title shall be obtained without restriction as to use or future disposition. If objects are acquired with limitations, the conditions will be stated clearly in an instrument of conveyance that will become part of the accession records of the object.

6) The authenticity and provenance of an object must be satisfactory to the Director and the appropriate curator. Full documentation attesting to the provenance of an object should be received with the object and shall be maintained by the Registrar as well as disclosed by the museum.

7) The museum seeks to secure exclusive or non-exclusive copyright license on all acquisitions. Identifying copyright ownership often requires extensive research that JAMAM undertakes as an activity of the acquisition process. In general, the fair use

doctrine of the 1976 Federal Copyright Act permits the museum to carry out its exhibition programs, even when the museum does not hold copyright or a non-exclusive license. Unless the museum can document that it owns copyright, the museum cannot grant rights to reproduce objects in the collection for any other purpose. The acquisition of copyright is handled by the Registrar's Office when transfer documents are signed for new acquisitions.

8) The Director shall ensure that a valid deed of gift is created to document transfer of ownership for objects donated and that a valid bill of sale is secured for objects purchased. These documents shall fully describe the objects to which they pertain, record the precise conditions of transfer, convey title of ownership (including intellectual property rights when possible) to the museum and be signed by the donor/vendor and an authorized representative of the museum.

9) All documentation related to objects shall be kept as part of the permanent accession files by the Registrar.

A decision by the Collections Committee shall be made at a meeting attended by at least a majority of the members. An object considered for acquisition must be presented with appropriate documentation to the committee that shall determine whether it meets the criteria set forth herein and whether the gift or purchase is otherwise suitable. After approval by the committee, the Registrar shall be responsible for ensuring that all necessary documentation is obtained and kept in archivally safe storage in a system where information is easily retrievable.

Objects promised to the Museum as future gifts or bequests will not be presented to the Collections Committee for accessioning unless the intent of the donor is expressed in a written instrument that is irrevocable and binding.

de Saisset Museum, Santa Clara University Collections Management Policy, 2002

Acquisitions

Criteria

1. Criteria and considerations relevant to all acquisitions include but are not limited to the:
 - object's relevance to collecting goals;
 - object's quality;
 - historical significance of the object, in terms of the artist's career, a historical movement, relationship to Santa Clara Mission or College or Santa Clara Valley's indigenous people;
 - potential of the work for exhibition or study purposes;
 - nature and physical condition of the object to the extent that the same may be relevant to the resources required for the object's storage, restoration, or conservation (whether immediate or long term) or its installation requirements;
 - degree, if any, to which accessioning the object might appear to give rise to commercial exploitation or bring discredit upon the Museum;
 - degree, if any, to which the retention by the vendor, donor, transferor or any other party of copyright or any similar intellectual property rights would impair the Museum's use of the object;
 - satisfactory provenance; and
 - restrictions or conditions attached to the acquisition. The Museum shall not acquire works with restrictions as to perpetual exhibition or retention. Any conditions or restrictions attached to works of art or artifacts must be approved by the Director and the Vice Provost for Academic Affairs or his/her designee. If acceptance of a restricted gift is approved, the Director shall countersign the Deed of Gift expressly stating the restrictions.

2. Criteria and considerations that pertain specifically to purchases include but are not limited to the:
 - fairness of the purchase price;
 - possibility that a comparable object might be obtained by gift or bequest;

- terms of any restrictions that might apply to the purchase funds intended to be used;

- availability of funds to cover the cost of purchase, transportation, documentation, conservation, and storage of the object; and

- purchase price relative to the importance of the object to the collection.

3. Criteria and considerations that pertain specifically to gifts include but are not limited to the aims and intentions of the donor;

4. Criteria and considerations that pertain specifically to exchanges include but are not limited to the relative:

- importance of the object to be released from the collection and the object to be acquired; and

- fair market values of the objects to be exchanged as ascertained, in appropriate instances, from outside sources.

5. Criteria and considerations that pertain specifically to offers of whole collections include, but are not limited to the following. The Museum's ability to:

- fulfill the responsibilities associated with the care, preservation, and utilization of the number of objects in the collection proposed for acquisition; and

- retain the right under the terms of purchase, gift, bequest, or exchange to accession the collection either in whole or in part.

Process

Permanent collection objects may be acquired by gift, bequest, purchase, or exchange. The Curator will compile a biography of the artist, a photograph of the object or the object itself, and a written statement of the object's attribution, provenance, condition, price or value, and appropriateness to the collection. The Curator will then make a recommendation to the Director who will specifically approve each accession. A Deed of Gift document will be drafted by the Collections Manager and signed by the donor and the Director.

Purchase Funds

Funds allocated by or donated to the Museum for the purchase of objects shall be maintained separately.

San Diego Natural History Museum Collections Policy, 1997

Illicit Trade and Illegal Importation

Section 30: The San Diego Natural History Museum will not enter into the illicit trade in collections specimens or knowingly acquire specimens collected or imported illegally, unless such material is legally reposited with the Museum by an oversight or enforcement agency.

30.1 The San Diego Natural History Museum will not suppress information received on illegal collecting activities at any time. Such information will be referred by the Board Research and Collections Committee to the appropriate agencies for investigation, if that information is verifiable and substantiated.

Foreign Collections

Section 31: The San Diego Museum of Natural History does maintain collections of biological and geological specimens from many areas outside the United States, most significantly from Mexico, and some related historical material donated by museum researchers.

31.1 It is the responsibility of the San Diego Natural History Museum and its research staff to ensure that all United States and foreign collecting permits are obtained and updated, and that collecting outside the provisions of these permits does not occur.

31.2 In the event that a foreign government requests a review of the San Diego Natural History Museum specimens which were collected in or originate from its country, the San Diego Natural History Museum will comply through the exchange of information (copies of permits, collections records and field notes, photographs, etc.). Direct examination of specimens will only be permitted on-site. Specimens in question will be barred from loan or research use until their ownership is determined, including loan to the authorities originating the review.

31.3 The San Diego Natural History Museum does not and will not knowingly acquire or maintain collections made against the laws of the United States or any country of origin at the time of their collection.

31.4 The San Diego Natural History Museum will cooperate fully with the investigation of any questions of provenance or legal ownership of its specimens.

31.5 In the event that repatriation is mandated, the San Diego Natural History Museum will provide copies of pertinent documents. Original documents will remain with the San Diego Natural History Museum.

California Science Center Collections Management Policy, 1998

Acquisition of Collection Objects

Objects for CSC's collections may be acquired by donation, bequest, exchange, purchase, or by any legal means whereby title and the object are conveyed to the California Science Center.

All objects acquired for the collections shall be registered, and information about the objects and their source of acquisition shall be organized into a permanent record.

The staff of the California Science Center shall not appraise donations for the benefits of the donor. Appraisals for the purpose of establishing tax deductible value shall be the responsibility of the donor.

All donations shall be considered outright and unconditional gifts to be used or not used at the discretion of the California Science Center. The California Science Center shall not guarantee that objects will be exhibited, retained in the collection, or preserved in their current state.

A. Criteria for Acquisition

1. The Acquisition of the object or collection of objects furthers the purpose and activities of the California Science Center as stated in the Mission Statement, and would strengthen the collections and/or the exhibits of the Center.

2. The California Science Center can provide adequate storage, care, and security as well as the maintenance and conservation for the object or collection of objects.

3. The object or collection can not be encumbered by restrictions either expressed or implied, thereby permitting the California Science Center to have full and complete ownership and freedom of use as permitted by the extent of the law.

4. The conveyor of the object or collection is the legal owner or authorized agent for the legal owner

B. Restrictions on Acquisition

1. No object or materials shall be knowingly or willfully accepted or acquired which are known to have been illegally imported into, or illegally collected in the United States contrary to state law, federal law, regulation, treaty and convention.

2. The California Science Center subscribes to the provisions of the ICOM Convention of 1973. CSC shall refuse to accept materials and objects where there is cause to believe that the circumstances of their collection involved the destruction of historic sites, buildings, structures, habitats, districts, and objects.

3. No object or collection will be accepted unless accompanied by all rights, copyrights, title, and other interests.

C. Acceptance of Objects

The curator of the collection for which the acquisition is intended, along with the advice and consent of the Deputy Director of Exhibits and Education and the Executive Director, will accept or refuse the object or collection which is considered for addition to the expendable collection. When an object or collection is considered for addition to the permanent collection, the Collections Committee of the California Science Center Board of Directors shall be consulted.

Henry Art Gallery, University of Washington Collections Management Policy

Acquisitions

Collections Committee

The Collections Committee is a standing committee of the Board of Trustees of the Henry Gallery Association consisting of the Museum Director, the museum's curators, and appointed members from the Henry Gallery Association Board and selected members from the community at large. The Committee Chair is appointed by

the President of the Henry Gallery Association upon the recommendation of the Museum Director. It is the function of the Committee to act as an advisory body to the University of Washington by encouraging and pursuing gifts and purchases related to the collecting goals of the museum, judging acquisition possibilities with values of $10,000.00 or higher and overseeing deaccessioning procedures. The Committee reports to the full board of the Henry Gallery Association at the discretion of the Committee Chair and Chief Curator. In exceptional cases the Museum Director, in conference with the curatorial staff, may override the decision of the Committee.

Criteria for Accessioning

The Henry Art Gallery collections grow as the result of gift, bequest, purchase and exchange. The Gallery has a continuing program of donor cultivation that seeks the acquisition of exceptional works through gifts and planned giving, from the community at large. Through allocation of funds and development efforts, the Henry Gallery Association purchases objects on behalf of the University of Washington. All works submitted as potential gifts or purchases are processed through The Office of Curator of Collections. The Curator of Collections presents the object for review to the director and curatorial staff according to the following guidelines:

- Each work will be scrutinized in terms of authenticity, aesthetic merit, historical or cultural significance and appropriateness to the collection. Care will be taken to avoid duplication of artworks already in the collections.

- Each work should be of exceptional quality and in good condition. Consideration will be given to works in need of some conservation if their artistic significance is determined to warrant their preservation by the museum's curators.

- When considering a work for accession, the Gallery will assess its ability to provide proper storage and care for the object. Works that cannot be cared for properly will not be taken into the collection.

- Works will be in a condition to exhibit, they will be available for study and there will be evidence that, within the context of existing collections, they will be studied and/or exhibited.

- The Henry Art Gallery will not knowingly acquire objects that are unethically collected or removed from their society of origin as described by UNESCO's *Convention on the Means of Prohibiting and Preventing the Illicit Import, Export and Transfer of Ownership of Cultural Property* (1970).

- The donor or seller must certify true, rightful and legal ownership of works being conveyed to the Henry Art Gallery collections.

- The Henry Art Gallery will not accept gifts that are unreasonably encumbered with conditions set by the donor regarding ownership, use, display, labeling or future disposition. Title and all rights to acquisitions should be granted free and clear, with the exception of partial and/or promised gifts, or in certain cases involving new media.

- The Henry Art Gallery will not accession a work with the express purpose of subsequent sale to increase or upgrade collections.

CHAPTER 8

DEACCESSIONS AND DISPOSAL

> *Deaccessioning . . . can be compared to a bowl of marshmallows. It looks benign until you dig in, then it can become messy.*
> —Malaro (1988)]

> *A museum, no more than an individual, cannot constantly ingest without occasionally excreting.*
> —Thomas Messer, former director of the Guggenheim Museum

> *From a preservation perspective, sale on the open market can put objects in danger of physical and intellectual depredation. Items are separated from their histories, altered, and sometimes lost forever. This is hardly how museums are supposed to care for their collections. The public, and the press in particular, sees commercial sale as an abrogation of an almost sacred duty.*
> —Miller (1996)

eaccessioning is the opposite of accessioning; it is the permanent removal of an object from the collection. Disposal is the process of getting rid of the object that has been deaccessioned. Deaccessioning is one of the most controversial practices in museums, but it is also an important tool for exerting control over collections. Attitudes towards deaccessioning have changed greatly with the professionalization of museum staff. For example, in 1927 AAM Secretary Laurence Vail Coleman wrote, "On occasion, worthless material may be accepted and later thrown away rather than give offense by refusing it." Today, it is widely recognized that the best control a museum has over deaccessioning is a good accessions policy.

The Context for Deaccessioning

AAM's *Code of Ethics for Museums* (appendix B) states that the museum staff is accountable for the acquisition, conservation, management, and deaccession of collections; thus deaccessioning must be considered in the context of the museum's public trust responsibilities. *Code of Ethics for Museums* specifically states that a museum must ensure that:

- the collections in its custody support its mission and public-trust responsibilities;

● WHEN POLICY MEETS REALITY

The Dulwich Picture Gallery in England owned a number of paintings that were favorite targets of art thieves—eight paintings by Rubens and Rembrandt were stolen between 1966 and 1971. The thefts included a Rembrandt painting that was stolen, recovered, and then stolen again, three times. The museum finally deaccessioned one painting (Domenchino's *Adoration of the Shepherds*) to the National Gallery of Scotland for £100,000 and used the money to buy a burglar-alarm system.

- acquisition, deaccession, and loan activities are conducted in a manner that respects the protection and preservation of natural and cultural resources and discourages illicit trade in such materials;
- acquisition, deaccession, and loan activities conform to its mission and public trust responsibilities.

Although some people believe that deaccessioning is a violation of the public trust (because the museum yields control of the objects in its care), deaccessioning is part of the proper exercise of collections stewardship (Smith, 1992).

Using museum resources to maintain inappropriate collections can be an abrogation of the public trust. Collections are dynamic, not static. They grow and change over time and sometimes deaccessioning becomes necessary; examples include a change in the museum's mission or focus, a reduction in the museum's resources (affecting its ability to care for everything in the collection), or new information regarding an object's provenance or title. Maintaining elements that do not belong in the museum diverts resources from the care of collections that are central to the institution's mission and activities.

Weil (1987) made three important points about deaccessioning:

1. The retention of each and every object in a collection involves an ongoing expense for the museum (care and management costs).

2. Deaccessioning may generate funds that can be used to acquire other objects or specimens more critical to the collecting plan.

3. Deaccessioning a collection element to another museum (particularly to a peer institution) may better serve the museum community, the discipline, and the collection element itself.

Deaccessioning is a way to improve the collections by refining, upgrading, or focusing them. This might occur if the deaccessioned objects are more appropriate for another collection—particularly if the museum exchanges them for objects more suited to its own—or if a transfer would better serve the academic discipline (e.g., by distributing duplicate specimens among natural

⊚ **WHEN POLICY MEETS REALITY**

What do you do with a deaccessioned forgery? This question was posed by an art museum curator who was confident that a painting in the collection was a forgery. The curator wanted to deaccession the painting for sale at auction, but did not want her museum's name associated with it. Some colleagues suggested that the painting be indelibly marked to indicate it is a reproduction because if the forged signature were removed, it could easily be replaced. Others suggested that the museum keep the painting because of its value as an example of a forgery, or put the painting in the teaching collection.

history museums). There may be monetary reasons for deaccessioning, for example, if the cost to care for the object is more than the museum can afford. An object may be deaccessioned to return it to its rightful owner, as in the case of Nazi-looted objects, NAGPRA material, or other types of cultural property; or if it is discovered to be a fake or forgery or is at the center of a title dispute.

Most European museums follow the International Council on Museums (ICOM) *Code of Ethics* (see appendix D), which states that "... there must always be a strong presumption against the disposal of objects or specimens to which a museum has assumed formal title." AAM's *Code of Ethics for Museums* states that the "... stewardship of collections entails the highest public trust and carries with it the presumption of rightful ownership, permanence, care, documentation, accessibility, and responsible disposal" and that "... disposal of collections through sale, trade, or research activities is solely for the advancement of the museum's mission."

Most people intuitively understand that museums take care of collections on their behalf (as a public trust). For this reason, deaccessioning often receives intense public scrutiny. Deaccessioning decisions that are judicious, well-informed, well-intentioned, and grounded in an understanding of the legal and ethical issues meet the standards of collections stewardship. Documenting each step of the process helps ensure that deaccessioning is carried out in a proper and consistent manner.

Public Accountability

When contemplating a deaccession, bear in mind that the museum must maintain the public's confidence. One way to do this is to prepare a communications plan that places the deaccessioning decision in the context of the museum's mission, vision, strategic plan, collections plan, code of ethics, and other policy and planning documents. Some museums want to conduct deaccessioning and disposal discreetly, as a way of avoiding negative publicity. In these situations, it is a good idea if the institution is prepared to explain the decision publicly if called upon to do so. The public is better served when the museum operations are transparent and open to scrutiny.

● WHEN POLICY MEETS REALITY

Deaccessioning is rarely reversible. In 1958, the Lady Lever Gallery in Merseyside, England, sold a Fantin-Latour painting for £9,045. The deaccessioning of this artwork caused an uproar among the museum's patrons, so the decision was made to buy it back when it appeared on the market again. Unfortunately, the next time the work was offered for sale, the price had jumped to £950,000, and the museum could not afford to make the purchase. Furthermore, the increase in price led many people to question the circumstances of the original sale.

The Deaccession Policy

Typically the policy specifies the level of authorization needed to approve a deaccession. This level of authorization should be equal to or higher than that needed to accession such an object (see chapter 7, "Accessioning"). By directing the museum to incorporate the viewpoints of a variety of stakeholders in the decision-making process, the policy reduces the chances that a deaccessioning decision will be short-sighted or one-sided. To inform the process, some policies also direct the staff to obtain an outside appraisal or solicit opinions from qualified professional colleagues or consultants with appropriate expertise.

It is a good idea for the deaccessioning policy to mandate a minimum length of time that an element must be in the collection before it can be deaccessioned. The purpose of this restriction is to guard against the impression that the museum is trafficking in deaccessions and keep donors from running into problems with the Tax Reform Act of 1984 (see appendix C, "Laws and Legislation"). The standard minimum time period between accessioning and deaccessioning is two years.

It is recommended that the policy state that a deaccessioned object or specimen's accession, registration, and catalog numbers cannot be re-used; these numbers are part of the collection's permanent record. The museum retains all documentation for deaccessioned collections as part of its permanent archives.

Deaccessioning decisions are guided by consideration of the benefit to the museum and the collection element, in keeping with the institution's public-trust responsibilities. The deaccession should comply with ethical standards and all pertinent laws and regulations. The policy usually states whether an attempt should be made to notify the original donor of the deaccession decision.

Further guidelines for deaccessioning decisions are provided in tables 8.1 and 8.2.

Title

It is important to establish the institution's clear and unrestricted title to an object, because it is difficult for a museum to deaccession something that it does not own. In instances where title is not clear or is incomplete, the museum can execute a quit-claim deed (i.e., transfer whatever title it does own to a second party, who bears the burden of resolving any other title claims that exist). Many deaccession policies state whether or not the museum will take such an action.

Objects Found in Collections

It is not uncommon for museums to have objects in the collections that do not have sufficient documentation to substantiate ownership. Objects found in the collections might include things left for authentication but never retrieved, unclaimed objects on loan from another institution (see chapter 10, "Objects in Custody"), or objects that were never properly accessioned or lacked

sufficient documentation for accession. Such objects cannot be disposed of easily. Some museums permit the deaccessioning and disposal of such material after a good-faith effort to locate the associated documentation or if evidence proves the material was a loan that should not have been accessioned in the first place. Some deaccession policies state that the museum presumes ownership if no such evidence is found. In all cases, carefully consider the proposed means of disposal of such objects following their deaccession. There are no quick and easy answers when dealing with objects found in collections.

Missing or Stolen Objects

It is unwise for the policy to permit the deaccession of missing collection objects. If something cannot be located, it cannot be disposed of and the deaccession cannot be completed. In addition, there is always the chance that the missing object may show up. A more prudent practice is to require the documentation records to be annotated to indicate that the object cannot be located.

Deaccession of Objects with Restrictions

Occasionally, a museum has valid reasons to deaccession an object even if there is a legal restriction against removing it from the collection. The most common type is of restriction is called a *precatory restriction*, in which a donor stipulates that the donation cannot be deaccessioned or can only be deaccessioned in a certain way (e.g., by returning it to the donor's heirs). Precatory restrictions sometimes can be overturned via *cy pres* proceedings. *Cy pres* is "the doctrine in the law of charities whereby when it becomes impossible, impracticable, or illegal to carry out the particular purpose of the donor, a scheme will be framed by a court to carry out the general intention of applying the gift to charitable purposes that are closely related or similar to the original purposes" (Weil, 1990). The policy might require the museum to consult with its legal counsel before proceeding with the deaccession of a restricted gift.

Notification Regarding Deaccessioning

If an accession came to the museum as an unrestricted gift, the donor no longer has any legal interest in it. Nevertheless, some museums choose to notify donors

of deaccession actions. Many museums weigh each case on its own merit. Sometimes notification is done as a courtesy, but there is a practical aspect as well. If the donor or the donor's heirs are notified of a pending public sale, they will have an opportunity to acquire the object. Some museums also inform the donor or heirs that objects purchased with the resulting funds will bear a credit line in their name. Museums sometimes notify living artists when their works are deaccessioned and will consider returning or selling the work to the artist or exchanging it for another work. The policy states whether the museum will notify a donor or the donor's heirs about deaccessions or consider returning, exchanging, or selling a deaccessioned work to a living artist.

Disposal

Disposal refers to what happens to an object or specimen after it is deaccessioned. In most instances, the deaccession policy includes a list of acceptable means of disposal, and guidelines to the circumstances that favor one method over another.

Disposal can be a sticky legal and ethical issue if not approached carefully. There is no uniformly correct method for disposal of deaccessioned objects; each situation must be considered individually. For example, some

● WHEN POLICY MEETS REALITY

An October 1995 article in *Time* described the Denver Art Museum as "suffocating from generosity. Benefactors had given so many objects to the Denver Art Museum over the decades that it had to close off an entire floor of its seven-story building just to store the relics." The museum director "came to a decision not just to cut the fat but to sell it," rationalizing that "if we display one or two Chippendale chairs, why do we need to keep all six?" An auction of 1,500 objects (described as "white elephants") earned the museum $866,793 and freed up 20 percent of its storage space. The Denver museum sent letters to every original donor it could locate, advising them or their heirs of the sale, but staff reported that "a handful were furious at the low prices attached to family heirlooms."

deaccession policies state that the most important factor is to maximize the monetary return to the museum, thereby increasing its ability to purchase new collections. Others choose methods of disposition that bring in less money but enable the material to go to another museum and thus remain in the public domain.

Professionally acceptable methods of disposal of deaccessioned objects include sale, transfer of ownership, and destruction (see table 8.3). To avoid the appearance of conflict of interest and to fulfill public trust responsibilities, it generally is recommended that the sale of deaccessioned objects be handled by a disinterested third party at a public sale or public auction. Another approach is to transfer deaccessioned collection elements to another museum or nonprofit institution, a legitimate owner, or a donor or seller. Objects or specimens that are severely deteriorated, fakes or forgeries, or composed of hazardous materials can be destroyed by a safe and appropriate method, with the destruction witnessed by an impartial observer.

Methods of disposal generally regarded as inappropriate include sale in the museum shop or sale or transfer to museum staff or board members (see table 8.4). It is considered a best practice for the policy to prohibit the sale or transfer of deaccessioned objects to a museum employee, officer, board member, or their representatives or immediate family members. A few museums make exceptions to this rule for objects disposed of via a public offering or auction, as long as board members or staff have no special knowledge or advantage concerning the sale. Other museum policies distinguish between staff who had direct input into the deaccessioning decision and those who did not.

A deaccession policy usually specifies that the museum will inform prospective recipients of all known hazards associated with the deaccessioned material. These hazards can be inherent (e.g., toxicity, radioactivity, physical hazards) or due to care of the object (e.g., treatment with toxic substances for pest control).

The policy can state whether or not accession numbers, registration numbers, and/or catalog numbers can be removed from deaccessioned collection elements. In general, numbers are removed from deaccessioned

objects unless they are being transferred to another museum. This is because museum numbers on deaccessioned objects that are sold can affect their market value and may cause confusion concerning ownership in the future. The policy also might state that deaccessioned fakes, forgeries, and replicas are permanently marked as such to prevent future misrepresentation.

Many policies require deaccession and disposal to be documented carefully. Museums often develop a form that includes the reason for the deaccession, along with the signatures of those making the decision and the date of the decision. This documentation becomes part of the permanent record of the museum's collections.

Use of Proceeds Resulting from Deaccessioning

This is a very contentious issue, about which there is limited consensus. AAM's *Code of Ethics for Museums* states that "Proceeds from the sale of nonliving collections are to be used consistent with the established standards of the museum's discipline, but in no event shall they be used for anything other than acquisition or direct care of collections." An examination of some museums' practices reveals that the definition of "direct care" varies widely in the field and includes:

- conservation treatment
- conservation and preservation supplies (e.g., acid-free housing materials, storage furniture)
- technology for monitoring and regulating climatic conditions in storage and on exhibit
- computer hardware and software for collections documentation and management
- reference materials relating to the care and documentation of collections
- consultants
- salaries of collections staff
- staff training and development

Some museums take a conservative approach to deaccession proceeds, establishing policies that maintain the value of the original gift—usually by acquiring new collections, though some include conservation treatment in this category. Other museums draw the line between

operating and non-operating funds. They do not use deaccession proceeds for operating expenses (such as staff salaries, supplies, etc.), but will fund capital expenditures that help preserve the collections (e.g., storage and HVAC equipment).

Note that AAM's *Code of Ethics for Museums* specifies that "proceeds . . . are to be used consistent with the established standards of the museum's discipline." Two discipline-specific codes of ethics also have addressed this issue.

The American Association of State and Local History's (AASLH) *Statement of Professional Ethics* (2002) specifies that "Collections shall not be deaccessioned or disposed of in order to provide financial support for institutional operations, facilities maintenance, or any reason other than the preservation or acquisitions of collections." This language is more precise than the statement in AAM's *Code of Ethics*, but it still leaves the definition of "preservation" open to interpretation.

The Association of Art Museum Directors' (AAMD) *Notes on Art Museums' Use of Proceeds from the Sale of Works of Art from the Collection* (1993) states that the AAMD "is strongly committed to the principle that the proceeds from the sale of accessioned works of art by an art museum be used only to replenish the collection through the acquisition of other works of art; the proceeds must not be applied to operating expenses."

The museum's use of funds gained from deaccessioning will determine whether it must capitalize its collections (i.e., assign a monetary value to all the collections and report that value as capital assets on the institution's financial documents). Statement 116 of the Financial Accounting Standards Board (FASB) specifies that if deaccession proceeds are used for anything except the acquisition of new collections, the museum is required to capitalize its collections or risk a qualified audit. Both AAMD's *Professional Practices in Art Museums* (2001) and AASLH's *Statement of Professional Ethics* state that collections should not be capitalized; AASLH also says they should not be treated as financial assets. AAM's code states that collections should be unencumbered (which precludes, for example, their use as collateral for financial loans) but does not prohibit capitalization per se.

> ## ◉ WHEN POLICY MEETS REALITY
>
> Kimmelman (1984) wrote about a controversial decision by the Frank Lloyd Wright Foundation to sell some of the original architectural drawings in its collection to raise funds "to maintain the archives and refurbish" the facilities. The sale was a success, raising more than $2 million, but was criticized by other professionals as an outrageous breaking up of the archives. Furthermore, because the sale was handled by a commercial gallery, the foundation was criticized for "dispersal of the collection into private hands."

These are all issues to consider when establishing a policy regarding deaccession funds that conforms to the museum's values.

Deaccession Procedures

Because deaccessioning is such a serious and potentially controversial step, this is one area where collections management policies sometimes mandate procedures. For example, the policy might require staff to:

1. Review the museum's deaccession criteria.

2. Ascertain that the museum has the authority to dispose of the object by reviewing the documentation, conferring with legal staff, and confirming the museum's ownership.

3. Organize facts and figures, both pro and con, concerning the deaccession, and consider the mission of the museum and its public trust responsibility.

4. Obtain a written appraisal by one or more qualified and disinterested third parties for objects with estimated values over a set limit.

5. Obtain authorization for the deaccession decision from the appropriate authority.

6. Document the deaccession process.

7. Create a written statement for the permanent record explaining the reason for the deaccessioning decision and how it supports the museum's collections goals.

8. Remove any accession numbers or other marks that identify the object as museum property, as appropriate.

9. Notify the donor, if appropriate.

10. After the deaccession decision-making process has been completed, determine the appropriate method for disposal of the object (see tables 8.3 and 8.4).

11. Create a permanent record of the disposal.

References

American Association for State and Local History. 2002. Statement of Professional Ethics. www.aaslh.org/ethics.htm.

Association of Art Museum Directors. 1993. *Notes on Art Museums' Use of Proceeds from the Sale of Works of Art from the Collection.* www.aamd.org/documents/deaccess.html.

Coleman, L. 1927. *Manual for Small Museums.* G.P. Putnam's Sons, New York.

Hennum, P. 1992. Get rid of it! Perspectives on the disposal of deaccessioned items. *Registrar's Quarterly,* winter, pp 3-4, 14.

Kimmelman, M. 1984. The Frank Lloyd Wright estate controversy. *ARTnews* 84(4):1-2-105.

Lewis, G. 1995. Attitudes to disposal from museum collections. In Fahy, A. (editor). *Collections Management,* pp. 172-181. Routledge, London and New York, xii + 304.

Malaro, M.C. 1988. Deaccessioning: The importance of procedure. *Museum News 66(4):74-75.*

Miller, S.H. 1996. "Guilt-free" deaccessioning. *Museum News* 75(5):32; 60-61.

Smith, L.F. 1992. Deaccessioning. *Registrar's Quarterly,* winter, pp. 1-2.

Weil, S.E. 1987. Deaccession practices in American museums. *Museum News* 65(3):44-50.

Weil, S.E. 1990. *Rethinking the Museum and Other Meditations.* Smithsonian Institution Press, Washington, D.C., xviii + 173 pp.

TABLE 8.1. **Considerations for deaccessioning.**

CONSIDERATION	COMMENTS
Donor notification	If applicable and desirable, has the museum made a reasonable effort to notify donors or their survivors of the deaccessioning decision?
Ethics	What ethical considerations are associated with the deaccession?
Legal aspects	Does the deaccession and disposal process comply with all pertinent laws and regulations?
Public trust	Will deaccessioning benefit the collection by helping the museum fulfill its public trust responsibilities? Will the deaccession ensure that former collection objects are kept in the public domain (if appropriate)?
Regional	Will deaccessioned material remain in the geographic region?
Title	Does the object have a contested title? Do the accession records indicate that the museum has clear and unrestricted title to the object?
Value	Is the decision to deaccession based on considerations other than the object's market value?
Vouchers	Is the collection element a voucher (an object or specimen that was used for research, cited or figured in a publication, or otherwise documented)? If so, it should be deaccessioned only to another museum.

TABLE 8.2. **Criteria for deaccessioning collection elements.**

CRITERIA	COMMENT
Authenticity	An object that has been discovered to be a fake or forgery.
Condition	An object or specimen that has deteriorated so much that its value has been lost, it is no longer suitable for exhibit, or it has deteriorated beyond the possibility of repair or restoration.
Cost of care	Components of the collection that the museum can no longer store, protect, or preserve.
Documentation	An object whose documentation has been determined to be inaccurate or fraudulent; a corrected attribution could render an object inappropriate for the collection.
Mission	An object that is not appropriate to the museum's mission, or is no longer relevant for museum purposes due to loss of documentation that affects authenticity, provenance, or association.
Program strength	A deaccession that will enable the institution to strengthen its other collections or programs (e.g., an object of insufficient quality or one that the museum can replace with a superior example using funds earned from the deaccession).
Requests for return of objects	Requests for return can pose many legal, ethical, and practical problems. The museum must ascertain whether the object was a valid gift or purchase, balance the request against its public trust responsibilities, and be prepared to defend its actions as "prudent and in good faith" (Malaro, 1998).
Restitution and repatriation	An object of personal or cultural property or other material that must be returned to the original owner, the owner's descendants, or other claimants (e.g., material returned to a tribe under NAGPRA).
Scope	Objects that were accepted as part of an accession but are not within the scope of the collection.
Use	Collection elements that the museum will never use, including duplicates, copies, fakes, second-rate objects, and other unneeded or substandard material.

TABLE 8.3. **Methods of disposal of deaccessioned collection objects generally considered to be appropriate.**

METHOD	COMMENT AND POTENTIAL CONCERNS
Destruction	Sometimes appropriate for severely deteriorated objects or specimens, fakes, forgeries, or hazardous material. Destruction should be documented and witnessed by an impartial observer.
Exchange	Objects or specimens might be exchanged with a dealer or a nonprofit institution.
Repatriation	Objects or specimens might be deaccessioned for return to the appropriate national government, tribal entity, or cultural group.
Return to donor	Some museums prefer to return certain deaccessioned objects to the donor or the donor's heirs.
Return to living artist	Some museums choose to donate, sell, or exchange deaccessioned works of art to the artist.
Sale at public auction	Sale must be handled by a disinterested third party to avoid conflict-of-interest or the appearance of conflict-of-interest.
Sale through a reputable dealer	Less desirable than sale at a public auction; avoids conflict-of-interest and the appearance of conflict-of-interest.
Transfer	Objects can be transferred to another department within the museum or donated to another nonprofit institution.

TABLE 8.4. **Methods of disposal of deaccessioned collection objects considered to be inappropriate.**

METHOD	COMMENTS
Sale in the museum shop	This is contrary to professional standards and could be viewed negatively by the press and the public.
Sale to a staff member or a member of the governing authority	This generally is considered to be a bad idea and could be viewed negatively by the press and the public. Some museums allow staff or board members to purchase material at public auction, as long as they have no special knowledge or advantage of the sale.
Transfer to a staff member or a member of the governing authority	This can raise issues of actual or perceived conflict of interest.

SAMPLE POLICIES

James A. Michener Art Museum Collections Management Policy, 2001

Funds resulting from the deaccessioning of any work of art (both principal and interest) will be restricted to acquiring other works of art for JAMAM's permanent collection. Any acquisitions from this fund will be limited to objects of similar genres. For example, funds from sales of contemporary Bucks County art will be used to purchase contemporary Bucks County art. Proceeds from all deaccessions shall be deposited into a restricted fund and shall be separately attributed to the original donor as an individual component of the fund, proportional to the amount from each donor in the fund.

Science Museum of Minnesota Policy Statement on Collections Management, 2004

Deaccessioning

Legal and Ethical Constraints

All of the provisions for deaccession shall be consistent with legal and ethical constraints presented in the section on Accessions. The Museum will comply with all applicable laws and statutes including but not limited to the Minnesota Property Act.

The Museum acts as steward of materials for the broader benefits of society. This, at times, requires permanent removal of artifacts and specimens from the Museum. Removals may include artifact and specimen transfers, physical discard, or destruction of artifacts and specimens. Permanent removal of accessioned artifacts or specimens (deaccessioning) will require the implementation of appropriate deaccessioning procedures.

Determination of Values

Estimates of the scientific, exhibition, and fair market values of an artifact or specimen shall be the responsibility of the Accessions Committee. Estimates will rely on staff knowledge, market comparables, and possible referrals to external expertise. Estimates, including a written justification of the findings, shall be filed with the Registrar. When the value is estimated to be over $1,000 for an individual artifact or specimen, or when the aggregate value of a collection is estimated to be more than $5,000, an independent professional appraisal will be required by the President of the Museum before approving the transfer.

Artifact and Specimen Transfer

Transfers of artifacts and specimens with an aggregate fair market value of less than $1,000 shall be recommended by the Accessions Committee. If the total fair market value of a transaction is greater than $1,000 but less than $50,000, then the written approval of the President shall be required. Transfers involving total fair market value of more than $50,000 shall require the written approval by the Board of Trustees.

Gifts and exchanges

It is customary for certain scientific disciplines to retain appropriate duplicate examples for the collections of their institution. Gifts or exchanges of artifacts and specimens to an appropriate scientific, educational, or cultural institution may be deemed to be in the best interests of the Museum and society.

All gifts or transfers must follow the provisions of approval presented in the section on Artifact and Specimen Transfer and Deaccessioning (above). All gifts and transfers of artifacts or specimens require the written approval of the Division Head. All gifts and transfers of artifacts or specimens with an estimated value of more than $5,000 will require the written approval of the President.

Sales

In cases where gifts or exchanges cannot apply, and if the appropriate curatorial and collections staff concur that certain specimens or collections no longer have value for the future research or exhibition program of the Museum, then they may recommend that these specimens may be sold, subject to the following guidelines:

All sales will require the written approval of the Division Head. Written approval of the President will be required if the sale of artifacts, specimens, or items exceeds $5,000, individually or combined. All attempts will be made to secure a fair and reasonable price for the object, specimen, or item being sold.

There shall be no private sales of Museum material to staff members, the Board of Trustees, or their representatives. In the event of public sale, such individuals shall be eligible, as any other private individuals, to bid on offered items.

Negotiated private sales, public auction, sealed bidding, or open bidding over a period of time are acceptable options, provided that the availability of such material for sales has been given publicity aimed at the appropriate audience of potential purchasers. In all cases of items offered for sale, a reserve price may be established in advance, or all offers rejected, if an appropriate staff member of the Museum determines that such action is advisable. The purchase price of each item or collection shall be available upon request, together with a summary of other bids or offers received. If substantially equivalent offers are received for a specimen or a collection, then the President, as advised by the appropriate content expert, is authorized to complete the sale to the bidder who appears most likely to provide the highest and most stable degree of care for and make the most appropriate research, educational, or exhibition use of the artifacts, specimens, or items being sold. In most cases, priority is given first to other museums or institutions that hold scientific collections in the public trust. Second priority is given to all other non-profit educational institutions. Third priority is given to members of the general public.

All funds received from the sale of artifacts or specimens, net of selling costs, shall be placed in an account reserved for obtaining other artifacts or specimens by collecting or purchase, or placed in an appropriate endowment in support of collections conservation, curation, and management activities.

Artifact and Specimen Disposal

Removal or culling of undocumented material from the permanent collection is a continual and routine process. Often culled material is used in the Museum's education program.

If such artifacts or specimens are not needed to support the educational mission of the museum, then they may be given to appropriate educational institutions for use in teaching activities, or even, if no alternative exists, be discarded completely or destroyed. Such materials for disposal shall be so acknowledged in the permanent collection catalogs by the responsible Collections Management staff member.

Deaccessioning of more valuable culled materials shall follow the approved guidelines outlined for transfer of specimens.

Reporting Annual Deacquisitions and Deaccessions

Annual deacquisitions and deaccessions will be reported to the Board of Trustees Collections Committee as part of the annual collections audit.

University of Oregon Museum of Art Collections Management Policy

Manner of Disposition

A. Permanent removal and disposition of deaccessioned objects from the collections shall be done in an ethical and legal manner.

B. The manner of disposition chosen shall represent the best interests of the Museum, the University, the public they serve, the public trust they represent in maintaining and preserving the collections, and the scholarly and cultural communities they represent.

C. Primary consideration will be given to placing removed objects, through gift, exchange, or sale in another tax-exempt public or private institution with collections' policies comparable to those of the Museum, wherein they may serve a valid purpose in research, education, exhibition or public services.

D. If sale or exchange with a comparable museum is not desirable or feasible the item may be sent to public auction with a suitable reserve on it where full disclosure of the object's history and provenance would be made. All auctions shall be public and as well publicized as possible.

E. If sale is deemed the most appropriate method of disposing of a deaccessioned object, but an auction is not practical, consideration will be given to selling the object in the public market in a manner that will best protect the interest, objectives and legal status of the Museum.

F. If an object has been broken, or has deteriorated beyond use for the Museum's exhibit, study, teaching, or research programs or is of negligible value, it will be deaccessioned and destroyed. Only if an object is going to be destroyed can it be given back to the donor at his/her express wish.

Ethical Considerations of Deaccessioning

A. The Museum Director and Advisory Committee must realize that they have a public accountability for their decision to deaccession and the method by which they choose to dispose of an object. There should be no expectation of concealing the transaction.

B. Objects of value will not be given or sold directly or indirectly to University employees or their representatives. In the event of public sale, such individuals shall be eligible, as any other private individual, to bid on offered items.

C. If practical and reasonable to do so, considering the value of the object(s) under question, the Museum shall notify the donor if they intend to dispose of such objects within ten years of receiving the gift. This action is a courtesy and shall be construed as a desire for approval, but not permission, to withdraw the object from the collection.

D. At all times the original donor's wishes will be considered, and where appropriate, new acquisitions obtained through the sale or trade of the original donated item, will bear the legend "Gift of … By Exchange."

Laumeier Sculpture Park Collections Management Guidelines

Deaccessions

Deaccession is the formal change in recorded status of the object. Disposal is the resulting action taken after a deaccession decision.

The decision to deaccession an object in the permanent collection of Laumeier Sculpture Park shall be made with great care, taking into consideration the interests of the beneficiaries, the interests of the general public, and any unusual restrictions or considerations which may influence the disposal method. Laumeier's collection includes site-specific works that may employ fragile, ephemeral materials or rapidly obsolescent components.

When an object is made of materials that require all or part of a piece to be remade each time it is displayed, or materials which the artist acknowledges will change radically in appearance over time [if] allowed to take their course, the artist will be involved, when possible, in deciding whether to intervene in the aging process and under what circumstances to consider reasonable re-fabrication, replacement, or deaccessioning.

The process requires complete and candid discussion and disclosure of the intent, method, reason and outcome.

The Cooperative Governance Agreement between Saint Louis County Parks and Laumeier Sculpture Park 501(c)3 signed on July 31, 2001, further clarifies the conditions for Disposition of the Permanent Collection with regard to works of art owned by Saint Louis County Parks. Article 13, section (b) *Disposition of Artwork* states:

"If this contract is terminated by the County for convenience or by County default or non-appropriation, County agrees to remove, crate, and transport, at County expense, all Artwork owed by the Corporation, with the exception of Art Fixtures (means Artwork owned either by the Corporation or the County that is either incorporated into the grounds at Laumeier or is attached to the Buildings such that its removal would require the use of tools or equipment) to an alternate site in the St. Louis Metropolitan Area designated by the Corporation. Further, the Corporation may remove, crate, and transport, at its expense, any Art Fixtures it owns, provided that notice of its intent to relocate the Art Fixture(s) is provided [to] the County within thirty days of the termination of the Contract and the Art Fixture(s) are removed, promptly thereafter.

If the contract is terminated by the Corporation for convenience or by the Corporation's default or insolvency, all Art Fixtures shall become the property of the County and the Artwork owned by the Corporation must be promptly removed, crated, and transported by the Corporation and at its expense to another site.

The County agrees not to dispose of any Art Fixtures it obtains at the time of contact termination without offering the same to Corporation (Laumeier Sculpture Park) upon terms to be negotiated by the parties. Corporation

may accept such offer not later than thirty (30) days after receipt thereof. If Corporation does not accept such offer, County may then, at its option, dispose of the Art Fixtures in accordance with its Purchasing Code and any applicable policy of Deaccessions then in effect."

The decision to deaccession shall be approved by the Collections Committee and with the Board of Trustees' unanimous approval. The museum must have clear and valid title to the object under consideration. Deaccessioning shall be proposed when the object is:

- No longer relevant or useful to the purpose of the museum or the object collected is clearly outside the scope of the museum's mission.

- Beyond the capacity of the museum to maintain. The object can no longer be preserved or has deteriorated beyond a useful life.

- Duplicated in other collections.

- Better used by other educational institutions.

- Not useful for research, exhibition, or educational programs in the foreseeable future.

- Poor, less important, incomplete, or an unauthentic example.

- Subject to a legislative mandate, e.g., repatriation.

- Subject to contractual donor restrictions the museum is no longer able to meet.

Methods of disposal are by sale, exchange, donation, or in some extreme cases, by destruction.

- Private sales to employees and trustees are not permitted.

- Monies obtained through the sale of an object shall be used for the sole benefit of the collection through establishing a special purchase fund or endowment fund for collections and shall not be used for operational or other expenses.

- If disposed of [through] exchange, the objects or objects acquired and accepted for the collection shall be of comparable or greater overall value than the object(s) deaccessioned.

- Objects obtained for the collection as a result of a sale or exchange of deaccessioned donated objects shall be noted as objects acquired through the original donor's generosity.

Whatcom Museum of History and Art Collections Management Policy, 2002

Deaccessions and Changes in Status

Deaccessioning is an uncommon practice for the Museum. Decisions to deaccession are made following extensive deliberation and input from the staff, the Collections Committee and the Board of Directors. Funds generated by the sale of such property will be placed in a separate, restricted account designated solely for the purchase of additional collection material.

Deaccessioning and the process [of] deaccessioning are designed to keep the Museum's identity clear and focused. When properly used, deaccessioning can assist the Museum in defining its mission, planning for its future, and improving its collections.

Conscious of its responsibilities to donors and ever mindful of its obligations to the public, the Museum will follow rigorous procedures in selecting objects for disposal, sale, or trade. From curatorial recommendation to final Board approval, each work is to be carefully scrutinized and its relevance to the Museum's present and future properly weighed. Disposal through sale shall follow the exact guidelines of city and state regulations to ensure that they are to be offered to the largest possible audience. Board members, the staff of the Museum, and members of their immediate families are restricted from bidding during such sales.

Occasionally works may be given to the Museum with the express purpose that they are to be sold. In such cases, the Museum shall channel these items through the Whatcom Museum Society, with the proviso that the Museum clearly articulate this distinction to the donor, and that funds provided through any sale or items come to the Whatcom Museum Society.

7-A. Reasons for Deaccessioning Objects from the Collections

Accessioned objects may be deaccessioned from the Museum's holdings when one or more of the following conditions exists. An object may be deaccessioned because it:

1. Does not support the Museum's mission statement.

2. Does not support the collecting policy of the Whatcom Museum.

3. Contradicts current policies on culturally sensitive materials.

4. Does not have clear, legal title.

5. Does not provide clearly defined copyright.

6. Does not comply with laws and treaties governing cultural properties.

7. Does not support the research, education, or exhibition uses of the Museum.

8. Unnecessarily duplicates other objects in Museum collections.

9. Requires storage or conservation resources that cannot be provided by the Museum.

10. Has been requested by a Native American tribe that human remains, funerary objects, or sacred objects of known lineal descent associated with that tribe be repatriated.

11. Is damaged beyond repair or conservation.

7-B. Disposition of Deaccessioned Objects

Under no circumstances may a deaccessioned item be returned to the previous owner or any private individuals from the Whatcom Museum of History and Art or other City Departments. A deaccessioned item can only be:

1. Transferred without compensation or exchanged for other objects with a state, municipal, or a public educational institution, whose mission is relevant to the deaccessioned item, that will adequately care for the object, and that can assure public access.

2. Sold at public auction.

3. Repatriated in accordance with NAGPRA policies, UNESCO treaties, and current Museum Sensitive Materials Policy.

4. Destroyed, if the object cannot be repaired or conserved, or if it presents a physical danger to life or property.

7-C. Change from Collection to Non-Collection Status

Objects may be transferred from the collections of the Museum to be used for education or as an exhibition prop. To accomplish such a change in status, the object must first be deaccessioned and then administratively transferred to the appropriate department within the museum.

The status of an object may be changed only because the object:

1. No longer supports research uses.

2. May duplicate other objects in Museum collections.

3. Is damaged beyond use.

7-D. Exchange of Deaccessioned Objects with Outside Institutions

A deaccessioned object may be exchanged with an outside institution when independent appraisers determine that the fair market values (or research values for archaeological materials) of the items to be exchanged are approximately equal. Recommendations for exchange shall be evaluated according to the following criteria:

The reasons for deaccession fall within the Museum's accepted deaccession policy.

1. The condition of the objects warrants exchange.

2. Conservation reports detail needs and repair costs.

3. Another institution can better preserve or exhibit the items.

4. Repatriation request is in accordance with the NAGPRA and the Whatcom Museum's Culturally Sensitive Materials Policy.

The costs of appraisals to determine fair market values shall be divided equally by the two institutions. The materials coming to the Museum should be evaluated according to the criteria elaborated in the policy for Acquisitions.

The Plains Art Museum
Collections Management Policy, 2003

Deaccessions

3.1 Introduction

It is the policy of the Plains Art Museum to select objects for the collections with care so that deaccessioning of objects seldom will be necessary. However, the museum recognizes the importance of periodic evaluation of the collections and that judicious use of deaccessioning may strengthen the quality of the museum's collections over time. The museum holds collections in the public trust which obligates acting in accordance with the highest ethical standards as defined by the American Association of Museums.

3.2. Reasons for Deaccession

.1 Quality

 .a Artistic or Technical Quality

 An object is determined to have insufficient quality of design and/or workmanship.

 .b Historical or Artistic Significance

 An object is determined to have insufficient historical and/or artistic significance.

 .c Better Example

 A better example has been acquired.

.2 Authenticity

 An object is determined not to be authentic.

.3 Condition

 .a Maintenance

 The museum cannot provide for the maintenance or treatment of an object at professionally accepted standards.

 .b Threat to Collections

 An object poses a threat to other objects in the collection.

 .c Threat to Persons

 An object poses a threat to the health or safety of the museum staff or visitors.

 .d The object is beyond the repair by a professionally trained conservator.

.4 Redundancy

 A type or category of object is determined to be over-represented in the collection. Factors 3.2.1-3 will be considered in selecting redundant objects for deaccession.

.5 Relevancy

 An object does not lie within the scope of the collections as stated in the Acquisitions Policy.

.6 Title

 It is determined that the museum's possession of an object is not legitimate.

.7 Unintentional Destruction

 In the case of unintentional destruction, which results in a de facto deaccession status for the object, the standard procedures do not apply. It will be sufficient for the registrar to inform the Vice President of Collections and Public Programs, Collections and Acquisitions Advisory Group (CAAG) and the Program Committee of the Board of Trustees of all particulars concerning the loss.

3.3 Means of Deaccession

Objects in the collection may be deaccessioned only upon the formal written recommendation of the Vice President of Collections and Public Programs and the majority of the Collections and Acquisitions Advisory Group (CAAG), and the written approval of the museum's President/CEO and the Program Committee of the Board of Trustees. Such approvals shall be confirmed by the whole Board at a regularly scheduled meeting.

.1 Signature Requirements

 A minimum of four signatures of the Collections and Acquisitions Advisory Group (CAAG) and signatures from the majority of the Program Committee of the Board of Trustees is required to approve a proposed deaccession.

.2 Outside Experts

 If deemed necessary, outside experts will be consulted before a decision to deaccession is presented either to the Collections and Acquisitions Advisory Group (CAAG) or the Program Committee of the Board of Trustees.

3.4 Disposal of Deaccessioned Objects

.1 Title and Restrictions

.a Title

The museum's clear and unrestricted title to the object shall be verified by the Vice President of Collections and Public Programs and/or registrar.

.b Restrictions

(1) Mandatory restrictions will be strictly observed unless deviation from their terms is authorized by the donor, his/her official and legal designate, or a court of competent jurisdiction.

(2) Reasonable efforts will be made to comply with any precatory (non-binding) restrictions.

.2 Notification of Donor

.a Precatory Restrictions

If precatory statements apply to an object the Museum wishes to deaccession, the Collections and Acquisitions Advisory Group (CAAG) shall determine whether consultation with the donor or donor's heirs is advisable.

.b Tax Code Requirements

The museum will comply with requirements for notification of the donor and the Internal Revenue Service.

.3 Manner of Disposition

In considering alternatives for the disposition of deaccessioned objects, the museum will consider the best interests of the museum, the public, scholarly and cultural communities it serves, and the public trust it represents. The museum will also consider the reasons for which deaccession was recommended.

.a Approved Methods of Disposition (in preferred order)

(1) Gift, exchange, or sale to an appropriate tax exempt institution will be given first consideration.

(2) If objects are offered for sale to the public, preference will be given to an advertised public auction, or other public market place, that will best protect the interests, objectives, and legal status of the museum. Members of the museum's staff and Board as well as their immediate families are restricted from purchasing objects the museum offers for sale or at auction.

(3) Destruction of objects may be necessary because of biohazard, deterioration beyond retrieval, or having been deemed a fake. The method of destruction must comply with local, state, and federal codes; must be witnessed by a museum staff member, and attested to in writing that is deposited in the object's permanent file.

(4) If possession of an object by the museum is found not to be legitimate, the object will be given to the legitimate owner as determined by the appropriate authority.

.b Restrictions on Disposition

(1) Objects may not be given or sold to employees, officers, trustees of the museum, members of auxiliary museum groups (i.e. museum foundation), or to the family or representatives thereof.

(2) In general, no agent acting on behalf of the museum in the sale of deaccessioned objects shall use the name of the museum to imply in any way that the value of such objects is supported or attested to by the museum.

(3) The museum may provide information about an object based on current Collections and Public Programs opinion, but in no such case shall it represent the value of an object.

(4) The name of the museum may not be used in any promotional material regarding the sale of deaccessioned objects without the approval of the President/CEO as to form and content.

3.5 Proceeds from Deaccessioning

All proceeds from the sale of deaccessioned objects will be deposited in a restricted account designated as the "Acquisitions Fund." Such funds will be used exclusively for the purchase of objects for the collections as is prescribed by AAM's code of ethics.

3.6 Documentation of Deaccessioning

All aspects of the conditions and circumstances of deaccession and disposition of objects are the [responsibility of the] registrar and will be recorded and retained in the museum's collection records.

CHAPTER 9

LOANS

Borrowing and lending parts of their collections are one way that museums meet their responsibility to disseminate knowledge and share information.

What Is a Loan?

A loan refers to what happens when one party allows a collection element it owns to be temporarily transferred to the custody of a second party for some length of time, without a transfer of ownership taking place. In legal terms a loan is a *bailment*, the borrower is a *bailee*, and the lender is a *bailor*. In museum terms, when a museum makes a loan to another institution, it is referred to as an *outgoing loan*; when a museum borrows something, it is called an *incoming loan*.

A loan can be made:

1. for the primary benefit of the borrower;

2. for the primary benefit of the lender; or

3. for the mutual benefit of both borrower and lender.

◉ WHEN POLICY MEETS REALITY

In 2004, the Museum of Fine Arts, Boston found itself the subject of a critical article in the *New York Times* after it loaned 21 Impressionist paintings to a store in a Las Vegas casino. It was no ordinary loan. The museum expected to earn at least $1 million by charging for the loan, and the store expected to make at least $2.5 million by charging an admission fee to see the paintings. The article reported that the arrangement violated the ethical standards of the Association of Art Museum Directors.

Legally, there are different responsibilities and standards of care for loaned objects, depending on who benefits from the loan. The liability for the loan rests on the primary benefactor of the transaction, usually the borrower but sometimes the lender. If the loan is for the borrower's primary benefit, then the borrower is bound to exercise great care or extraordinary diligence over the objects. If the loan is for the lender's primary benefit, the borrower is held to a lesser standard of care and is liable only for gross negligence. If the loan is for the mutual benefit of both lender and borrower, both parties may be equally responsible. However, if the loaned object is lost or damaged by a third party, the borrower is not excused unless it is clear that the act could not have been foreseen or prevented and that no fault or neglect of the borrower contributed to the damage or loss.

Legally, the loan agreement is known as a *bailment contract*. As with any contract, the rights and responsibilities of each party must be stated clearly. This generally is done in museums by printing the loan conditions on the loan documents; the loan documentation then serves as a written contract. Historically, in some disciplines (particularly natural history), unwritten contract terms were recognized by both parties (e.g., that specimens could not be dissected or that restoration work could not be done on an object without prior permission), but such unwritten terms have little legal standing. It is preferable to state loan conditions in writing on the loan documentation (Merritt, 1992).

The Loan Policy

The loan policy states to whom the museum will make loans and for what purposes. For example, most museums make loans to peer institutions for purposes of exhibition, scholarly use, or educational use. A peer institution generally is a museum with a similar purpose or mission that is capable of caring for collection elements or specimens while they are on loan. Some museums ask borrowers to demonstrate the scholarly significance of the supported activity (e.g., by affirming that a proposed exhibit will include a published catalog, or that results of proposed research will be submitted for publication). Approval of a loan for a traveling exhibit may be contingent on the number of venues in the tour.

Typically, museums will not loan their objects for purely decorative purposes (e.g., for display in a private office) because loans, like all museum activities, are meant to serve the public good.

Sometimes museums are required to make loans that serve the needs of their parent organizations. For example, a university museum might be asked to loan paintings for the offices of university officials. In these instances, museum staff are encouraged to help the members of their governing authority undertake a thoughtful review of the situation to determine whether such a loan serves the organization's mission and purposes and the public good. Where the governing authority has determined that such loans are appropriate, the loan policy will require the museum to exercise appropriate oversight and care of the loaned objects. Some museums accommodate the desire of the parent organization for such loans by maintaining separate loan

● WHEN POLICY MEETS REALITY

Having just hosted the annual Museum Studies Alumni Party and Survivors Reunion at your place of employment, you realize that things are slowly getting back to normal. The sprinkler heads have all been reset, the camel has been returned to the zoo, and the wine stains in the carpet will hardly show once you rearrange the exhibit cases. One morning, just as you are sitting down to write a check to the AAAAM (an organization for people whose museum jobs have driven them to drink), the director appears at your door, with the demand that a newly acquired painting be loaned to the chairman of the board of trustees. The chairman wants to hang the painting in a private home for a reception for rich potential donors and was the person who purchased the painting for the museum in the first place. He is also your spouse's employer (which is how you could afford to write those large checks to the AAAAM). You report directly to the director. To complicate matters, as everyone on staff knows, the director and the chairman are having a torrid affair. What do you do?

collections of lesser importance than the permanent collections, or by offering photographs or reproductions of original art in the collection.

The loan policy requires requests for loans to be made in writing and the borrower to demonstrate appropriate institutional approval for receiving the loan. Institutional approval is of particular concern when dealing with research loans from natural history or anthropology collections; in those cases the policy must make clear that the loan is the responsibility of the borrowing institution and not the individual conducting the research. Most loan policies state that the museum will make loans only to other nonprofit institutions or institutions with similar missions and activities, not to individuals affiliated with those institutions.

Because collections are managed for the public good and their use should benefit public, not private, interests, most loan policies do not allow loans to be made to private individuals or for-profit galleries or institutions. These loans might be seen as serving private ends or cause a conflict-of-interest for the lender. However, some museum policies occasionally permit such loans (e.g., to recognized dealers or artists) if it will benefit the institution. Loans to private individuals or for-profit institutions require a higher level of approval than do routine loan requests.

The policy addresses the borrowing institution's ability to provide proper care and security for the loan. It often requires the borrowing museum to be recognized as a peer institution, be accredited by the AAM or another professional museum association, or provide a current *Standard Facility Report* (AAM Registrars Committee, 1998) before the loan request is approved. It allows the museum to refuse loans to borrowers that have mistreated loaned material in the past or failed to return objects in a timely manner.

The loan policy often states who is responsible for approving outgoing loans. Some museums require all outgoing loans to be approved by the governing authority; other museums may delegate approval responsibility to the director or to curators, particularly if the requested collection elements do not have a high monetary value.

● WHEN POLICY MEETS REALITY

The failure to thoroughly research the history and provenance of objects or specimens, whether they are accessions or loans, can cause public relations nightmares. In 1998, a newspaper reported that a Monet painting on display in a museum "was almost certainly plundered in 1941 by Hitler's art looters" from a French collector. The account stated that the museum "had not disclosed on its exhibition label that the [painting] was one of 1,955 artworks now in French custody that were in German hands during the war; most of those were believed to have been confiscated or sold under duress." Instead, the museum had referred to the painting only as "recovered after World War II."

Approval of the loan may involve multiple parties in the museum or the decision of a loan committee.

The time interval between the approval of an outgoing loan and the shipment of the objects to the borrower is another issue addressed by the loan policy. The ideal schedule will give the museum staff enough time to consider all risks and contractual obligations involved with the transaction. Loan policies often allow exceptionally long deadlines for extraordinary circumstances, such as the processing of a complex loan request, or the handling of objects that are exceptionally difficult to pack and ship properly.

Typically the loan policy identifies which party has the responsibility to insure collection elements while they are on loan, and who determines the amount of insurance that will be required. Typically, providing insurance is the responsibility of the borrowing institution (because the borrower benefits most from the loan), although the lending institution's policy may set insurance standards. A typical insurance standard is a requirement for "wall-to-wall" coverage, which is insurance that covers a loaned object from the time it is removed from storage or exhibit until it is returned.

The loan policy can delimit what the museum will and will not loan from its collections. For example, the policy

might list categories of objects (such as pastels or panel paintings) or specific collection objects that will not be loaned. Sometimes this list is maintained as a separate document—distinct from but referred to in the loan policy itself. The policy also might state that certain collection elements are not available for loan because:

- there is ongoing research involving the object;
- the object cannot withstand the rigors of packing and transport;
- there are cultural considerations that prevent loaning the object;
- the object has great monetary value;
- the object is too important to the museum; or
- the absence of the object would have a negative impact on the visiting public.

Criteria that can help determine if a particular collection element is suitable for loan are provided in table 9.1.

The loan policy can establish restrictions on the use of the loaned material by the borrower. For example, the policy might:

- limit photography of the object by the borrower;
- restrict photography of the object by the public or press;
- state that the lending museum retains ownership of the copyright and use of any images of the object on loan;
- put restraints on casting or other reproductions of the object;
- limit preparation of the object (e.g., removing the matrix from fossil material);
- prohibit alterations to the object (e.g., not allow the changing of hanging hardware on paintings).

It is recommended that restrictions on the use of the loaned material by the borrower be printed on the loan form.

The policy usually stipulates that the collection elements in a loan must be packed in accordance with professional standards. It states that loans being returned are to be repacked as they were received unless a change in packing is approved by the lender.

Some policies include guidelines for determining if a courier is required for transport of loaned objects, how this decision is made, how the courier is selected, what qualifications the courier should have, and the particular courier procedures. Most museums only choose couriers that follow the *Code of Practice for Couriering Museum Objects* (1998). More information on the use of couriers for loans can be found in Rose (1998).

The loan policy also can specify the length of time that the objects can be borrowed. Loan periods vary depending on the type of museum and the purpose of the loan. The standard loan period can be as short as six months or as long as several years. The policy states whether loans are subject to renewal and how many times a loan can be renewed. It requires long-term loans to be reviewed annually by both the lending and borrowing institutions.

The policy usually states whether the museum has to prepare a condition report before the object is loaned to another institution. In most museums, it is standard practice for the lending institution to prepare a condition report before the loan is sent out and another one as soon as the loan is returned. The condition report becomes part of the collection's permanent documentation.

The lending museum's loan policy can require the borrowing institution to use a particular credit line when

exhibiting the borrowed material. Such credit line requirements may include the name of the lender, the accession number, and/or the name of the donor.

Many museums require the borrower to cover the costs associated with the loan. Loan costs either are calculated from a schedule of fees set by the lending institution or are the actual itemized costs associated with research, handling, photography, condition reporting, conservation, packing, shipping, and insurance. A fee sometimes is charged per loan or per object in addition to the fees for the cost of loan preparation.

AAM's Registrars Committee (1991) provides a useful list of questions to be considered for approval of an outgoing loan request, including:

- What is the purpose of the loan?
- To whom will the museum lend?
- Who has the authority to approve the loan?
- What restrictions will be placed on the loaned object?
- Is the object suitable for loan?
- Can the object withstand the rigors of packing and shipping?
- Are there specific provisions regarding transport, such as use of a courier?
- Can the borrower provide adequate security for the loan?
- Can the borrower provide an adequate storage or exhibit environment for the loan?
- What is the loan period?
- What documentation is required for the loan?
- What insurance is required for the loan?
- What credit line will be used in the exhibits?
- Will loan fees be charged?
- Under what conditions will the loan be recalled?

Other criteria for granting an outgoing loan request are reviewed in table 9.2.

Permanent Loans

Although some museums use the term "permanent loan" to refer to loans of indefinite duration, a permanent loan does not meet the field's expectations regarding best practices. By definition, a loan is a temporary arrangement of finite duration, subject to renewal. If ownership is not transferred, then a loan remains a loan. A museum can lend an object for a very long time but a loan cannot be permanent. The nearest thing to a permanent loan is the status of specimens placed "on deposit" in museums by the federal government, such as bald eagles, manatees, or certain other protected species. In these instances, although the federal government retains ownership of the specimens, it encourages the museum to accession and catalog the specimens in the collection (see also chapter 6, "Categories of Collections"). When ownership is not transferred but accessioning and cataloging of the collection is required, a repository agreement is a better solution than a "permanent loan" (see chapter 16, "Additional Stewardship Issues").

Recall of Loans

Many loan policies stipulate that the museum has the right to recall a loan if the contract terms are violated or if the borrower provides inadequate security or inadequate care for the loan.

A review of the terms and conditions for recalling a loan is provided in table 9.3.

Incoming Loans (Borrowed Objects)

The loan policy often ensures that there is a clear connection between the use of a borrowed object (e.g., for exhibition, education, or scholarship) and the museum's mission, and that the lending museum maintains intellectual integrity and institutional control over the use of borrowed objects. This is generally not an issue when both the lender and borrower are museums or nonprofit institutions. But it can be a sensitive issue when the lender is a private collector or a for-profit entity, particularly if the lender also is sponsoring the exhibit that will display the loaned object. Some policies require the borrowing museum to examine its relationship with the lender before the loan transaction takes place and determine whether there are any conflicts of interest. It is a good idea for the policy to prohibit the museum from accepting a commission or fee from the sale of objects borrowed for exhibition or from exhibiting a work solely to enhance its value (except in the case of objects bor-

rowed to be organized explicitly for sale). These issues are addressed further in AAM's *Guidelines on Exhibiting Borrowed Objects*.

The policy also can ensure that before a loan is requested from another institution, the borrowing institution consider the following questions:

- How will the borrowed object be used?
- From whom will the museum borrow the object?
- Does the lender have clear title to the object?
- Is the object to be borrowed culturally sensitive?
- What restrictions will be placed on the use of the object while it is on loan?
- Can the museum provide adequate security for the loan?
- Can the museum provide an adequate storage environment or exhibit environment for the loan?
- What is the length of the loan period?
- What documentation is required for the loan?
- Can the museum afford the insurance, repacking, and shipment costs incurred with the loan?
- Who is responsible for monitoring the collection elements while they are on loan?
- Who is responsible for unpacking and repacking the loan?
- Who will provide insurance for the loan?

Policies usually require the museum to apply the same legal and ethical standards to incoming loans that it applies to the acquisition of collections. For example, the lender must have clear title to the loaned material. If the lender does not have clear title, while the object is in the borrower's possession a legal claim could be filed by a third party claiming ownership, resulting in both legal and public relations problems.

Other considerations regarding the receipt of incoming loans addressed in the policy include:

- that the loan is to be returned to the lender at the address provided on the loan documentation, unless the lender provides signed authorization for alternate arrangements;

- that it is the lender's responsibility to inform the museum if any changes of ownership of the objects take place during the tenure of the loan;
- the authorization for any necessary conservation, cleaning, pest treatment, or removal from housing supports (e.g., mats or frames) while the objects are on loan.

Many museums refuse to store borrowed objects if they are no longer needed for the purpose of the loan. This is to prevent the museum from becoming a *de facto* storage repository for lenders, and to prevent the museum from having to provide space and care for loans that are no longer to its benefit.

The loan policy can state whether the museum routinely provides insurance for incoming loans or negotiates insurance coverage on a case-by-case basis. In any case, it is a good idea for the policy to identify who is responsible for determining the insured value of the loan. Although insurance is normally the responsibility of the borrower, sometimes lenders prefer to maintain insurance or give permission for insurance to be waived. Loan policies often state that the borrowing institution will insure only those objects that have monetary value (e.g., most scientific specimens are not insured while on loan).

Old Loans

The term "old loan" refers to an expired or unclaimed loan whose lender cannot be easily found. The lending institution might no longer exist or perhaps the lender has died or moved. In such cases, the museum must break its legal bailment relationship to resolve the loan (de Angelis, 1998).

Many states have enacted old loan statutes to help museums legally resolve these problems or there may be a statute of limitation on the loan. If no specific state laws apply, the principles of common law can be used to resolve an old loan. Common law generally holds that the institution must make a *good-faith* effort to find the lender before the loan is converted. *Conversion* is a legal term referring to the unauthorized assumption of ownership of property belonging to someone else (de Angelis, 1998). Reasonable good-faith efforts by

the museum include sending a letter to the lender's last known address and publishing a legal notice with a due date for the resolution of the loan. The loan policy can require the museum to apply the appropriate legislation or common-law principles to resolve an old loan, and keep meticulous records of any good-faith efforts made to resolve the problem.

If applicable, it is recommended that the loan policy affirm that the museum follows the state's old loan legislation and include a reference to that legislation.

References

AAM Registrars Committee. 1991. Statement of practice for borrowing and lending. *Registrar* 8(2):3-10.

AAM Registrars Committee. 1998. *Standard Facility Report.* Second edition, revised. American Association of Museums, Washington, D.C., 32 pp.

American Association of Museums. 2000. Guidelines on Exhibiting Borrowed Objects. *Museum News* 79(6):54-55. See also www.aam-us.org.

Code of Practice for Couriering Museum Objects. 1998. In Buck, R.A. & J.A. Gilmore (editors). 1998. *The New Museum Registration Methods,* pp. 355-358. American Association of Museums, Washington, D.C., xvii + 427 pp.

Demeroukas, M. 1998. Condition reporting. In Buck, R.A. & J.A. Gilmore (editors). 1998. *The New Museum Registration Methods,* pp. 53-62. American Association of Museums, Washington, D.C., xvii + 427 pp.

de Angelis, I.P. 1998. Old loans. In Buck, R.A and J.A. Gilmore (editors). *The New Museum Registration Methods,* pp. 281-287. American Association of Museums, Washington, D.C., xvii + 427 pp.

Merritt, E. 1992. Conditions on outgoing research loans. *Collection Forum* 8(2):78-82.

Rose, C. 1998. Couriering. In Buck, R.A. & J.A. Gilmore (editors). 1998. *The New Museum Registration Methods,* pp. 151-55. American Association of Museums, Washington, D.C., xvii + 427 pp.

TABLE 9.1. **Recommended criteria for determining if a collection element is suitable for lending to another institution.**

CRITERIA	COMMENTS
Validation	Does the collection element have proper documentation?
	Does the collection element have clear and adequately researched provenance?
	Does the museum have clear title to the collection element?
Care	Will the collection element withstand the rigors of packing and shipment?
	Will the collection element receive adequate care from the borrower?
	Can the collection element withstand the intended use while on loan?
Use	Is the collection element needed for a scheduled educational program?
	Is the collection element an important part of a permanent exhibit installation?
	If the collection element is requested for research use, is it suitable for the intended purpose?

TABLE 9.2. **Considerations for making decisions concerning requests to borrow collection elements.**

CRITERIA	CONSIDERATIONS
Purpose	What is the intended use of the collection element to be borrowed?
	Is the intended use of the collection element compatible with the museum's mission?
	Will the intended use of the collection element compromise its care?
Duration	How long is the loan period?
	Will the museum permit the loan period to be extended?
Borrowers and lenders	Is the proposed borrower or lender a nonprofit institution?
	What is the loan history of the borrower or lender?
	Are the borrower and lender capable of packing, shipping, and caring for the collection element in ways that meet professional standards?
	Is a *Standard Facility Report* required before the loan is approved?
Care of the objects	Has the borrower demonstrated intent and ability to provide adequate care and security for the loan?
Legal issues	Does the lending institution have free and clear title to the collection element?
	Are there any questions about the provenance of the collection element?
	Are there competing claims to ownership of the collection element?
Ethics	Does the loan conform to ethical standards (e.g., the standards of AAM and the Registrars Committee)?
Restrictions and exemptions	Do special considerations need to be made for a fragile, delicate, or sensitive collection element?
	Do special considerations need to be made for a rare collection element?
	Do special considerations need to be made for a culturally sensitive collection element?
	Who is empowered to authorize exceptions to the rules for granting loan requests?
Authorization	Has authorization been obtained from the lender to loan the collection element, and the borrower to receive it on loan?

TABLE 9.3. **Terms and conditions that may be specified in the loan policy (based on the AAM Registrars Committee 1991 *Statement of Practice for Borrowing and Lending*).**

CATEGORY	CRITERIA
Approval and notification	Loan requests are received in writing.
	The borrower is notified of approval or denial of the loan request in a timely manner.
	There are approved methods for notifying the borrower that the loan has been shipped (e.g., mail, telephone, e-mail).
	The lender is notified when the borrower receives the loan.
Identification	Collection elements are accessioned by the lender and marked or otherwise identified before they are loaned out.
Packing and shipping	Collection elements are packed in accordance with professional standards, and repacked as received unless the change in packing is approved by the lender.
	Shipping is by a safe and direct method, approved by lender in advance.
	Courier terms are specified in advance.
	The loan contract specifies who pays packing costs.
	The loan contract specifies who pays shipping costs.
	The lender notifies the borrower in writing of any changes in return address or shipping procedure that occur during the loan period.
	The loan contract specifies who pays loan processing costs (which may include research, appraisal, conservation, condition reporting, packing, shipping, courier services, or administrative costs).
Care of material on loan	Standards of care for borrowed and loaned material are stated in the loan contract.
	Lenders send copies of condition reports with the loan. The condition report is verified when the loan is unpacked by the borrower, who immediately notifies the lender about any damage.
	The borrower closely monitors the condition of the collection elements on loan. Environmental monitoring and maintenance records are kept and returned with the loan.
	Written permission is obtained from the lender before any repairs or conservation treatments are undertaken, except in emergency situations. Written reports of repairs or conservation treatments are sent to the lender.

Use of material on loan	The length of the loan period is stated in the loan contract.
	Acceptable use (e.g., exhibition photography, use of images) is delimited in the loan contract.
	The lender is credited on all exhibit labels and all approved use of images.
	The lender provides installation guidelines for objects that are to be exhibited.
	Photography is permitted for the purpose of compiling a record of the loan (including exhibition, education, or research, use) unless restricted by the lender.
	Technical examination is permitted only with the permission of the lender.
Legal requirements	All permits required for the loan are arranged in advance (e.g., CITES, UNESCO Convention).
	All required declarations are filed with the proper authorities, with copies to borrowing and loaning institutions (e.g., U.S. Fish and Wildlife 3-177 declaration).
	Immunity from seizure protection is considered if appropriate.
	Material on loan remains with the borrower until it is returned to the lender; no sub-loans or transfers may be done without the lender's written approval.
	Rights to reproductions or images of the collection elements remain with the copyright holder unless otherwise specified in the loan contract.
	The lender is responsible for notifying the borrower if ownership of the collection elements changes during the loan period.
Risk management	Signed invoices are returned promptly.
	Appropriate insurance coverage (usually wall-to-wall) is provided (usually by the borrower).
	Appropriate security measures are enforced during the loan period.
	The borrower's loan history is evaluated before the lender approves the loan request.
Special conditions	A *Standard Facility Report* is requested from the borrower.
	The loan contract specifies particular environmental requirements for collection elements on loan.
	The loan contract specifies particular handling and shipping requirements for the collection elements.
	The loan contract states that the lender reserves the right to call for early removal of the loan.
	Loan conditions are established by the lender and agreed to by the borrower. Any changes or amendments to the loan conditions or contract are made in writing.

SAMPLE POLICIES

de Saisset Museum, Santa Clara University Collections Management Policy, 2002

Outgoing Loans

The Museum lends works from the collection for educational and scholarly purposes, not decorative purposes, with the exception of on-campus loans to SCU's president, provost, vice provosts, associate vice provosts, and academic deans. In general the Museum lends works only to other similar nonprofit institutions. It does not lend works to commercial galleries or private individuals or organizations unless it is clearly and overwhelmingly in the Museum's best interests to do so, and to do so would not:

- jeopardize the physical integrity and safety of the work;
- give rise to commercial exploitation of the Museum; or
- bring discredit upon the Museum.

Prerequisites for the Consideration of Outgoing Loans

- Institutions wishing to borrow objects or works of art from the de Saisset Museum will send a written loan request outlining the:
 1. reasons for the loan request,
 2. details of the exhibition,
 3. dates of the proposed loan,
 4. proposed travel arrangements,
 5. names of other institutions at which the work will be exhibited on tour, and
 6. proposed insurance arrangements.
- When appropriate, a facilities report will be completed by the borrowing institution and all other institutions to which the object will travel.
- Museum staff will determine the current insurance value of the work requested; and
- Museum staff will:
 1. report on the physical condition of the object; and
 2. make a recommendation to loan or not to loan the object

3. receive in writing the specifics of the borrowing institution; and
4. receive in writing the willingness of the borrowing institution to agree to and apparent ability to fulfill appropriate terms regarding packing and travel arrangements and costs, insurance coverage, special conditions of display, and special handling requirements.

Process

The Director approves outgoing loans. The borrowing institution shall be charged an appropriate processing fee that may be waived at the discretion of the Director.

Prerequisites for the Release of Outgoing Loans

The following must be on file with the Museum:

- A signed, written agreement between the Museum and the borrowing institution detailing the terms of the loan;
- A receipt of certificate of insurance if appropriate, with borrowing institution naming Santa Clara University, its officers, officials, employees, volunteers, and agents as Additional Insured on their liability insurance policy(s) but only as respects liability arising out of the loan agreement.

Incoming Loans

Criteria

The Museum accepts loans of artwork, objects, and artifacts under prescribed circumstances for temporary and long-term exhibition. The object on loan may comprise part of a larger loan for an exhibition or it may be an individual object that adds needed content to an already existing display. In general, the Museum will return all objects removed from display to the lender in a timely manner and avoid retaining these objects in storage for extended periods alongside the Museum's permanent collection. Loans are accepted dependent on:

1. the ability of the object to enhance the Museum's offerings;
2. the ability of the object to be kept on display for a substantial portion of the loan period;
3. whether the Museum has appropriate exhibition and storage space for the loaned item;

4. whether the object to be loaned is in good condition and able to withstand the ordinary strains of packing and transportation;

5. whether the lender is willing to agree to appropriate terms, including a definite duration, in a loan agreement; or,

6. the possibility that the loan might aid in eventual acquisition of the work through gift or bequest.

Loans must be refused whenever there exists:

1. the possibility that the loan might appear to give rise to commercial exploitation or bring discredit upon the Museum;

2. unreasonable restrictions on the loan;

3. an unsatisfactory provenance; or

4. the possibility that the primarily reason for the loan is for safe or proper storage of the object.

Process

Incoming loans must be approved in advance by the Director. The Director may delegate this authority to the Curator or other staff.

Art Museum of Western Virginia Collections Management Policy, 1998

Loans

The Museum is encouraged to participate in a loan program to provide public access to objects that are not in the Museum's collections and to extend the availability of the Museum's collections to others. These loans shall be consistent with long-term conservation of the objects and the needs of the Museum's exhibition and educational programs.

A. General Criteria

Each loan shall be for a specified period of time and shall be documented and monitored according to established procedures of the Office of the Registrar. Each loan must be secured by a written loan agreement between the Museum and its borrowers and lenders prior to receipt or shipment of the object. The Registrar shall be notified by the Curator well in advance in order to effectively plan and expedite the loan.

A written condition report shall be made for each loan entering or leaving the Museum. The advice of a conservator shall be obtained if there is any question regarding the condition of the object or its ability to withstand the stress of transportation, handling or changed environmental conditions. All works on loan shall be insured. As a general practice, incoming loans shall be insured by the AMWV or the lender. Outgoing objects shall be insured by the Borrower or by the AMWV at the Borrower's expense. Any exceptions or waivers of this policy shall be approved by the Director and the Collections Committee. Insurance values shall be consistent with fair market value whenever possible. Insurance shall be arranged by the Office of the Registrar, in consultation with the Director and Curator.

Loans shall be monitored by the Office of the Registrar for compliance with terms of the loan. Renewal and return status shall be checked with the Curator at time of expiration. Long-term incoming loans shall be reviewed by the Curator every three years for return, extension, or conversion to accession. Outgoing loans shall be reviewed by the Curator and Director every three years for possible recall or deaccession. The Curator shall see that loans which are not covered by current loan agreements are updated according to a schedule established by the Registrar.

Outgoing loans shall be recommended by the Curator and require the Director's approval. The Collection Committee shall be notified of all outgoing loans. All loan agreements must receive the final review and signature of the Registrar. When no lender or owner can be established or where lenders of long-term loans have not been in contact with the AMWV for at least ten years and cannot be contacted by the Museum through diligent effort, objects are classified as "found in the collection" and shall be declared abandoned property. Legal counsel shall be sought, and public advertisements shall be published in an attempt to locate the legal owner. With the approval of the director and the Collections Committee, the object may be either removed from the Museum's possession or accessioned.

B. Incoming Loans

Incoming loans shall be accepted only for objects needed for exhibitions or research. The Museum shall not provide free storage, conservation treatment, and insurance to lenders beyond the agreed loan period. The Museum shall not exhibit work solely for the purpose of enhancing a work's value. Costs of storage, security, transportation, conservation and condition considerations, insurance, ability to withstand travel, a lender's restrictions, and problems of provenance or copyright shall all be considered before accepting any loan. All loans shall be evaluated by the Curator, approved by the Director, and shall not exceed a duration of three years. Loans may renewed at the end of the three-year period by resubmission by the Curator to the Collections Committee with strong justification for the request. No loan of indefinite duration may be made to the Museum. Non-renewed loans not removed by the lender as of 90 days following notification (or other time period as arranged with the Registrar) shall be assessed a $100.00 or higher annual storage fee per object. This fee is non-refundable and not subject to being prorated. If no arrangement can be made with the lender after a reasonable period of time the matter shall be referred to the Collections Committee for appropriate action.

No repairs, alterations (including unmatting or rematting of graphic works), or conservation treatment of loaned objects shall be undertaken without properly documented permission of the lender.

C. Outgoing Loans

Loans from the Museum's permanent collection shall be made for non-profit artistic, educational, and scholarly purposes. The Museum shall be properly acknowledged as the lender of the work on loan. Neither the loaned object nor the AMWV name shall be connected with any product endorsement without the approval of the AMWV Director and Board. Objects shall not be lent to individuals for personal use. Loans from the permanent collection shall be made for use in appropriately climate-controlled and secure environments. The Registrar shall obtain current facilities reports from proposed borrowers. The possession of a loaned object shall not be transferred to any individual or institution without prior written consent of the Director.

Objects must be clean, exhibitable, and in stable condition unless a provision of the loan is conservation by the borrower using methods approved by the Curator and Registrar. Objects must be able to withstand transit, climate changes, and handling. In addition, objects must be registered by accession or loan number and photographed prior to a loan. The Curator must review and the Director must approve all loans for any purpose. Property of others in the Museum's custody may not be lent without the owner's written permission.

Any and all objects may be withdrawn from loan if for any reason the borrower does not comply with all policies and procedures set forth by the AMWV regarding outgoing loans. A $100.00 processing fee shall be assessed to the borrower for the loan of each object. The fee may be adjusted or waived at the Director's discretion.

D. Custody Loans

If the Museum agrees to receive a loan for purposes chiefly benefiting the lender or a third party (i.e. for identification, consideration for purchase, temporary storage for another non-profit, or during matting or rehousing not connected with an AMWV exhibition) then the loan shall be deemed a custody loan. The Museum shall not cover the loan under its fine arts insurance, and shall only assume liability for gross negligence on the Museum's part. The maximum loan period shall be no more than four months.

The Museum shall facilitate annual custody loans of work by regional artists to regional legislators' General Assembly Building offices, during the period of the Assembly session.

Museum of the Rockies, Montana State University, Collections Policy Manual, 1998

Loans

Objects and specimens are borrowed and loaned by museums in order to make objects, otherwise unavailable, accessible for research, exhibition, replication, and educational programs. The Museum of the Rockies loan program, for both incoming and outgoing loans, is designed to achieve maximum accessibility to collections. The Museum's loan policies relate to care and conservation,

transportation and packing, insurance, returns, period of loan, costs and cancellations, and use of the objects.

When making decisions on loan requests from other institutions, the Curator and the authorized Museum official designated by the Museum Director must take into account the condition and conservation needs of the objects requested, as well as the short-term exhibit and research plans of the Museum. Issues to be considered when making or receiving loans are as follows:

- The condition of the object(s) and the ability to withstand the stress of transportation, handling, or changed environmental conditions.

- All incoming and outgoing loans will be for specified periods of time and will be documented and monitored according to established museum practice and procedures.

- All loans must be contracted through written loan agreements between the Museum and its borrowers or lenders prior to receipt or shipment.

- If appropriate, written condition reports will be made for all loans entering or leaving the Museum.

- The loan agreement between the Museum and the lender will stipulate whether or not an incoming loan is insured by the Museum. This may depend upon the loan policy of the lending institution. If a lender wishes to carry his/her own insurance, they must provide the Museum with a Certificate of Insurance prior to the date of the loan.

- If an outgoing loan is to be insured by the borrower, a Certificate of Insurance must be provided before the shipment or pick-up date.

- Borrowing institutions may be asked to provide the Museum with a standard facilities report if one is not already on file. Borrowing institutions must meet certain standards established by the Museum.

- Stated values, if called for in loan documents, must be in line with fair market value.

- Materials borrowed or loaned by the Museum of the Rockies cannot be transferred to a third party without written consent by the original lender.

- Additions or deletions to agreements by either lender or borrower must be written and agreed to by both parties.

Incoming Loans

The Museum of the Rockies may request the loan of a specific object(s) from an individual or from another institution for the purpose of exhibitions, replication, or for study and research. Such loans, either short or long term, must be for a predetermined length of time, whereupon, at the expiration of this time period, the object(s) will be returned to the owner. Prior to formal receipt of the object(s), the appropriate Loan Agreement from, specifying the use of the object(s) and the time period of the loan, will be signed by the owner, the appropriate Curator, and authorized Museum official (designated by the Museum Director). Unless provisions as to responsibility are mutually established in advance of the loan, the Museum of the Rockies assumes no responsibility for the loss or damage of object(s) loaned. Upon return of the object(s) to the owner, said owner must sign the Loan Agreement form (or equivalent release statement), acknowledging the return of the property and the termination of the loan.

It is the policy of the Museum of the Rockies not to accept unsolicited loans. Any objects(s) brought to the Museum and left by the owner for purposes of identification, study, or as a possible gift or loan should be recorded on a Receipt form, stating the owner's name, address, and his reason for leaving the object(s). Failure to remove the object(s) may eventually result in its (their) disposal or treatment as a gift (subject to accessioning into the collection).

Outgoing Loans

The following criteria apply to all loans made by the Museum of the Rockies to other institutions:

- The borrowers must be approved; loans are made only to qualified museums, educational, or research institutions whose missions are in the public interest and whose objectives are in concert with those of the Museum.

- All objects must remain in the condition in which they are received. They shall not be cleaned, repaired, retouched, treated, unfitted, remounted, reset, dissected, marked, copied (e.g., cast or replicated), or submitted to any examination or application which would tend to alter their condition except when spe-

cifically authorized by the Museum Curator handling the loan. Tags or other identification should not be removed without specific approval by the Curator handling the loan.

- When permission is given to copy (e.g., cast or replicate) museum specimens, the number of duplicates may be specified and the Museum may request the return of the original mold(s).

- Damages, whether in transit or on the borrower's premises and regardless of who may be responsible therefore, shall be reported to the Museum immediately. No action is to be undertaken to correct the damage without the Museum's approval.

- The borrower may photograph art object(s) for educational, catalog, record, or publicity purposes. Reproduction for sale is expressly forbidden except in the context of an exhibit catalog. The Museum must approve all matters relating to commercial reproduction. Paintings and drawings may not be removed from frames for photography. The Museum can furnish unframed photographs of these, provided advance notice is given.

- The borrower will undertake to provide protection from the hazards of fire, exposure to extreme or deteriorating light, extremes of temperature and relative humidity, insects, dirt, vandalism, theft, and mishandling or handling by unauthorized or inexperienced persons or by the public.

- The borrower (except when exempted in writing) will insure the object(s) at the value stated by the Museum, this insurance to be in force from the time the object(s) leaves the physical possession of the Museum until it is returned. This shall be an all-risk policy subject only to the standard exclusions. The borrower shall furnish a Certificate of Insurance no later than the scheduled delivery or pick-up time.

- The cost of insurance, special communications, security provisions, special packing, or any other incidental costs created in the loan will be paid by the borrower, unless waived by the appropriate program director.

- When returning borrowed materials, they shall be packed in exactly the same manner as received and, in the case of art objects, with the same cases, packages, pads, wrappings, and other furnishings. Any changes must be specifically authorized in advance. Borrowers will be billed for the cost of packing materials if objects are returned in other than the original container.

- Upon return, the objects are to be transported in the same manner as received and all costs for transportation connected with the loan will be paid by the borrower except in the case where other arrangements are made. Any change in mode of transportation must be cleared by the Museum before release to the carrier.

- All objects will be loaned for a specific time and, if requested, must be returned before that time limit expires. The borrower will receive a 30-day written notice and the Museum will try to provide assistance in securing a substitute object.

- When on display, all objects borrowed must be credited to the Museum including any special wording as directed. Reproductions for publicity must also be credited.

- All loans must be approved by the Curator and the borrowing institution.

- A signed copy of the Loan Agreement form must be in the possession of the Museum before any physical transfer of object(s) is complete.

- Objects or specimens are not to be used as "hands-on" teaching aids unless specifically approved on the loan form.

- Loans will be made for a specified time period as agreed upon and recorded on the loan document. To renew the loan, the borrower must request an extension in writing.

- Long-term loans shall be reviewed annually and, upon approval of the Curator and the authorized Museum official, may be renewed for periods of up to another 12 months.

OBJECTS IN CUSTODY

" . . . everybody's got a little place for their stuff. This is my stuff, that's your stuff, that'll be his stuff over there. That's all you need in life, a little place for your stuff. . . . "
—George Carlin

What Are Objects in Custody?

Objects in custody are elements for which the museum is responsible but that are not covered by the categories of acquisitions, accessions, or loans. These objects could have been left at a museum for one of several reasons, such as for identification, authentication, or examination for purchase. For example, someone might leave an object at the museum to be considered for donation but never return to retrieve it. Or a staff member working in the storage area might find an object that lacks the documentation to prove the museum owns it.

When an object is left at a museum at the owner's initiative, the institution's liability is reduced; nevertheless it does bear some responsibility for the object (Malaro, 1998). For this reason, and because the museum's resources are used to care for all objects in its custody, it is necessary to have a policy concerning objects in custody that are not acquisitions, accessions, or loans.

The Objects in Custody Policy

The policy identifies the kinds of objects the museum can receive, how the objects are documented, and how long the objects can remain in the museum's custody.

Some museums do not allow objects to be brought into the museum at all (unless the object is an acquisition, accession, or loan). Other museums permit objects to be inspected by the staff but do not allow them to be left in the institution's custody. Some museum policies state that the staff can provide only oral opinions concerning an object brought in for inspection; to avoid the perception that the museum has accepted responsibility for the object no written evaluations or reports are allowed. (See chapter 18 for a discussion of appraisals, authentication, and research services related to objects left in custody.) Some museums allow objects to be left in their custody but strictly limit the number of such objects that can be in the institution at any one time.

The policy typically identifies who at the museum has the authority to accept objects in temporary custody. It usually mandates any object left in the museum to be documented with a receipt that states that it was left at the owner's initiative and risk, and that the museum will provide reasonable care for but will not insure the object. The information recorded on the receipt for each object is reviewed in table 10.1.

Often the policy provides a time limit that identifies how long objects can be left in the museum's custody before action is taken. This helps avoid instances in which someone might take advantage of a museum by using it as a storage facility or a show room for prospective buyers. Most museums regularly inventory and monitor the physical condition of all objects in their custody, including those of unknown or unclear ownership. It is recommended that the objects in custody policy require that the documentation relating to such objects be retained permanently—even if they are returned to the owner—in case there are subsequent claims of ownership or damages. It is also a good idea for the policy to specify a periodic review of all objects left in custody to ensure that they are handled expeditiously.

Old Loans, Unclaimed Loans, and Objects Found in Collections

It is not uncommon for staff to find objects in the museum that it does not own or cannot prove that it owns. Examples include objects that were loaned to the museum in the distant past or donated objects that lack proper documentation. Because many states place a statute of limitation on bailment contracts, sometimes a museum can take ownership of undocumented or unclaimed objects even if this is done just to dispose of those objects. Several states have "old loan" statutes that make it easier for museums to establish ownership of such material (see chapter 9, "Loans").

If another institution or individual claims ownership of an object found in the museum, the burden of proof rests with the claimant (Malaro, 1998). Because of this, it is recommended that the objects in custody policy require a claimant to provide evidence to support the claim of ownership and submit a formal statement indicating

● WHEN POLICY MEETS REALITY

An art museum accepted a collection on indefinite, long-term loan from a well-to-do patron. The paintings were documented using the museum's standard, renewable loan form; in return, the museum was allowed to exhibit the works however and whenever the curators decided. There was an unwritten understanding that eventually the artworks would become a gift to the museum. As time went by, it became apparent that the museum was being used to store the paintings that previously had hung in one of the patron's homes while she was living in another. Eventually, the patron sent her art dealer to the museum to view the works, which made the registrar feel "like a salesgirl." In the end, after taking advantage of the museum's storage and security systems for a prolonged period of time, the patron sold the works to someone else.

that he or she is the sole party of interest or is authorized to represent all parties of interest. If the claimant produces the necessary documentation, the policy requires the museum to review its records with great care and determine whether there is evidence that:

- the museum periodically has displayed or publicized the object as its own;
- the claimant knew or should have known that the museum thought it owned the object;
- the claimant failed to exercise due diligence by taking too long to make the claim.

Disposal of Objects in Custody

Museums dispose of objects with unconfirmed ownership very carefully as that action poses several risks (Malaro, 1998). The objects in custody policy states that such objects cannot be sold because the museum could be liable if a claimant later comes forward. However, the museum probably can give the object away without liability. The policy also provides guidelines for making disposal decisions based on the fact that the more common the object is, the harder it is for a claimant to establish ownership. And the more distinct the object is, the easier it is for the claimant to demonstrate ownership.

Furthermore, if the museum consistently has claimed ownership of the object and has treated the object as its own in exhibition and other uses, it is more difficult for a claimant to make a case.

References

de Angelis, I.P. 1998. Old loans. In Buck, R.A and J.A. Gilmore (editors). *The New Museum Registration Methods*, pp. 281-287. American Association of Museums, Washington D.C., xvii + 427 pp.

Malaro, M.C. 1998. *A Legal Primer on Managing Museum Collections.* Second edition. Smithsonian Institution Press, Washington, D.C., xx + 507 pp.

TABLE 10.1. **Information included on the Temporary Receipt of Custody.**

CATEGORY	EXPLANATION
Date	Date the object is received in the museum.
Museum identification	Name, address, and telephone number of the museum and the contact information for the staff member receiving the property.
Identification of owner	Name, address, telephone number, and e-mail address of the person placing the object in the museum's custody.
Duration of custody	The date the owner must pick up the property.
Forfeiture	Statement that property not claimed by the specified date will be forfeited to the museum.
Responsibility	Statement that the property is left in the museum's custody at the owner's risk and that the museum is not responsible for it.
Description of the property	A description that is detailed enough to identify the object with certainty.
Actions	Documentation of any actions related to the object, including examinations, appraisals, reviews, provenance or title research, or return to owner.
Purpose	The reason the object was left at the museum.
Number	The temporary number used to identify all documentation related to the object in custody.
Receipt	A receipt for the object is signed by a museum staff member and the owner or the owner's agent and a copy is given to the object's owner or the owner's agent.

SAMPLE POLICIES

James A. Michener Art Museum
Collections Management Policy, 2001

Temporary Custody

JAMAM often receives objects or collections in temporary custody for purposes of attribution, examination, or identification, or for consideration as a purchase or gift. The work of attribution, examination, and identification will be expeditiously accomplished. Decisions to purchase or accept a gift are expected to occur in a timely and professional manner. Standard practice compels JAMAM to record every object received promptly and to care for it at generally accepted levels of care. An Incoming Object Receipt must be completed for every object taken in by the museum for temporary custody.

Currier Museum of Art
Collections Management Policy, 1997

**[name change effective 2005; formerly
Currier Gallery of Art]**

Unclaimed Loans/Abandoned Property

Generally, unclaimed loans are long-term loans left unclaimed by the owner over a long period of time. Abandoned property is any object for which a formal loan request does not exist. These are most likely objects which were unsolicited by the Gallery (objects left in custody) or simply loans for which no formal agreements were ever drawn up. The Gallery is guided in managing such objects by the Museum Property Act of 1990 (New Hampshire State Law, Chapter 201-E). The following procedures comply with those outlined in the Act.

Unclaimed Loans

Unclaimed loans are objects for which a loan agreement exists but contact with the lender has lapsed. In order for the Gallery to terminate the loan or assume title to the object, the Gallery must make a good faith effort to contact the lender to officially notify him of the termination of the loan (see below for notice requirements).

Such loans may not be considered for termination and their titles transferred to the Gallery unless the following requirements have been met:

- the object has been on indefinite loan and held by the Gallery for 5 years or more. If an object has been on "permanent" loan, that object shall be considered loaned for an indefinite term.

- the object has been on loan for a specified amount of time and no action has been made by the lender to claim the object once the loan period has expired and the gallery has given notice of the termination of the loan.

Abandoned Property

Abandoned property is any object held by the Gallery for a period of 5 years or more for which there is no formal loan agreement and for which the owners have made no effort to contact the Gallery. Such objects shall become the property of the Gallery if a good faith effort is made by the Gallery to notify the owners of its intent to claim ownership and no reply is received. (see below for notice requirements)

Notice Requirements

When the Gallery must give notice of the abandonment of property or the termination of a loan, the Gallery shall:

- send a notice by certified mail (return receipt requested) to the last known owner at the most recent address on record. If no address is on record, the museum shall publish notice in a newspaper (see requirements below).

If the Gallery receives no written proof of receipt of the notice within 30 days of the date mailed OR if no address is on record, the Gallery shall publish notice, at least once each week for two consecutive weeks, in a newspaper of general circulation in both the county in which the Gallery is located and the county of the last known address of the owner (if known). This notice shall contain:

- A description of the object.

- The name and last known address of the owner.

- A request that anyone knowing of the whereabouts of the owner provide written notice to the Gallery.

- A statement that if written assertion of title is not presented by the owner to the Gallery within 90 days from the publication date of the second notice, the object shall be considered abandoned or donated and shall become the property of the Gallery.

Responsibilities

The Gallery must, in accepting any property on loan for long-term or indefinite periods of time, inform the owner of the existence of New Hampshire Museum Property Act and its provisions. If an indefinite loan is accepted by the Gallery, the Registrar shall annually renew the loan in order to keep records of the lender current. The Gallery must also provide the same care and handling it gives its own collection, regardless of the status of an object. All such objects shall be documented, as completely as possible, by the Registrar who will maintain files on all unclaimed loans/abandoned property.

The Lender must promptly notify the Gallery, in writing, of any change of address or ownership of the object.

Museum of the Rockies, Montana State University, Collections Policy Manual, 1998

Receipt of Objects

The Museum's policy is to maintain a record of all objects entering the Museum. Objects submitted by individuals or organizations for identification, as potential gifts, for educational programming, or for other purposes are subject to the procedures outlined in this section.

The Museum's Receipt form is designed to provide accountability for objects until final disposition. If such object(s) becomes a part of the permanent collection, the receipt shall be kept as a part of the permanent record. Receipt forms are placed at all potential entry points for objects, e.g., reception desk, Museum administrative offices, curatorial offices, etc.

William Hammond Mathers Museum Collections Management Policies & Procedures, 2003

Temporary Custody Policy

The Mathers Museum accepts temporary custody of artifacts primarily for acquisition consideration, but also for other activities, including identification and conservation review. All activities regarding temporary custody of objects must be completed within two weeks of receipt of the object(s).

Legal Considerations

Bailment is established when the Museum accepts temporary custody of artifacts for acquisition consideration, and therefore, the same care given its own collections will be extended to artifacts that fall into this category.

Objects on premises for identification or other activities that do not evoke bailment will receive care, but will not be insured by the Museum.

CHAPTER 11

DOCUMENTATION

Documentation is the supporting evidence—recorded in a permanent manner and using a variety of media—that provides the identification, condition, history, use, and value of the collection. It includes digital images, audio recordings, notes, letters, receipts, photographs, books, and so forth. The word comes from the Latin *documentum*, meaning proof, pattern, or example. Documentation is the proof of what a collection object is, where it came from, what has happened to it, and who owns it. It is an integral aspect of the use, management, and preservation of collection elements, and the primary means by which a museum exerts intellectual and physical control over its collections.

The test of a documentation system is the ability to retrieve information from it (no matter what format the documentation is in). To meet the information retrieval test, the policy requires documentation to be clear, permanent, legible, and comprehensive.

Be clear: Write in simple, plain prose. Avoid excessive jargon and slang, but do use appropriately defined technical terms. If necessary, include a glossary of technical terms as part of the permanent documentation. Use drawings, photographs, and other permanent images when they add information to the object record.

Be permanent: Record documentation in an archival format, using stable, archival materials, such as non-acidic paper and light-fast, non-acidic ink. Back up electronic data adequately and transfer it periodically from one generation of electronic memory to another. Collections documentation is rarely static, but increases in content and complexity as objects are loaned out, used for research and exhibition, stored, treated, and photographed. A reliable back-up system must be able to accommodate regular updates of the stored information without losing data.

Be legible: Documentation must be legible to more than just the person who wrote it and accessible well into the future. Print rather than use cursive script for hand-written records. Do not use pencil, which both fades and smears. Avoid small or exotic type fonts on machine-written records. Use archival materials. Digital and electronic records pose particular problems because software, storage media, and equipment must be updated at regular intervals to keep the documentation legible and avoid information loss. Attempts are underway to develop permanent archiving of electronic data; bear in mind, however, that with computers everything is possible, but many things are neither probable nor practical.

Be comprehensive: Documentation must be as complete and comprehensive as possible as it is a record of all the activities that affect the collection. The U.K. Museums and Galleries Commission (1995) states that "… a museum should know at any time exactly for what items it is legally responsible (this includes loans and deposits as well as permanent collections), and where each item is located. It is recognized that the format for such records will differ between museums, but each museum should be able to demonstrate that these broad principles are reflected in its documentation procedures."

These principles apply whether the documentation is maintained via a manual or an electronic system.

The Documentation Policy

The policy usually ensures that the museum will manage properly all collections documentation, both written and electronic. It is recommended that the policy outline the types of records that will be kept, the kinds of information the records contain, and who is responsible for keeping the records. For example, some policies require the museum to maintain a complete and permanent record of acquisitions, accessions, deaccessions, incoming and outgoing loans, use of the collections, and the location of all objects in its custody. Categories of documentation addressed in the policy are presented in table 11.1.

The documentation policy often ensures that records are updated regularly and permanently maintained on archival media, and that duplicate records are kept in a secure (ideally, off-site) location. Regular back-up is required for all documentation, no matter what the medium.

Documentation has to be managed carefully. If the link between the object and the documentation is lost, both will lose their value.

References

Edge, M. 1992. The deterioration of polymers in audio-visual materials. In Boston, G. (editor). 1992. Archiving the Audio-Visual Heritage, pp. 29-39. Technical Coordinating Committee and UNESCO, Northants, U.K. 192 pp.

IMLS. 2001. A framework of guidance for building good digital collections. Institute of Museum and Library Services. http://www.imls.gov/scripts/text.cgi?/pubs/forumframework.htm

Kenney, A.R. 2000. Mainstreaming digitization into the mission of cultural repositories. In *Collections, Content, and the Web,* pp. 4-17. Council on Library and Information Resources, Washington, D.C. 73 pp.

Museums and Galleries Commission. 1995. *Spectrum: The UK Museum Documentation Standard.* Cambridge.

Reilly, B. 2000. Museum collections online. In *Collections, Content, and the Web,* pp. 40-47. Council on Library and Information Resources, Washington, D.C., 73 pp. www.clir.org/pubs/reports/pub88/coll-museum.html.

Tooby, P. 2001. Preserving electronic records for posterity. *Envision* 17(4):6-7.

TABLE 11.1. **Categories of documentation (adapted from the Museums and Galleries Commission, 1995).**

CATEGORY OF DOCUMENTATION	PURPOSE
Entry Records	Entry records are made as soon after receipt as possible. Include a tracking number for the object or specimen; the name of the depositor (as well as address, telephone number, and e-mail address); date of receipt; brief description; date that it is to be returned to the owner if not accessioned; signatures of depositor and a museum staff member; packing details (if appropriate); condition report; any other terms of the deposit.
	Provide a unique means to identify each object or specimen that comes into the museum, usually with a unique number and description.
	Explain where the object or specimen is located in the museum.
	Provide a receipt for the depositor of the object or specimen.
	Establish the extent of the museum's liability if the object or specimen is lost or damaged.
	Establish a finite end to the deposit interval, after which the object is returned to the owner, accessioned by the museum, or disposed of at the museum's discretion.
	Enable the object or specimen to be returned to the depositor as required.
	Help establish the museum's legal title to the object or specimen if it is acquired and accessioned.
	Capture key information about the object or specimen.
Accession Records	The accession records provide written evidence of the free and clear transfer of title to the museum.
	Produce a unique number that is assigned to and associated with the object or specimen in the accession.
	Provide a description of the acquisition listed in a permanent accession register and associated with a unique accession number.
Catalog Records	The catalog records provide object- or specimen-specific information and usually a unique identification number (catalog number, object number, or registration number, etc.) for each collection element.
Location Records	The location records explain where the collection element physically can be found in the museum, whether in storage or on exhibit.
	Provide a record of the temporary location of the collection element if it is not in its normal location in the museum.
	Record the movement of each collection element within the museum and if it leaves the museum on loan.

(continued on next page)

(continued from previous page)

Loan Records for a borrowed object or specimen	The loan contract specifies the conditions and limitations of each loan transaction and the beginning and ending dates of the loan period.
	Copies of all loan arrangements and contracts are archived permanently in the museum.
	Loan contracts include details of insurance coverage for the loan period.
Loan Records for objects or specimens that are loaned to another institution	The museum maintains the records of all loan transactions (including details about the borrower, venues, loan period and the purpose of the loan) as part of its permanent archives.
	Borrower confirms intent and ability to provide an acceptable level of care and safekeeping for the collection element and conform to the specified conditions of the loan.
Marking and Labeling	A unique number is assigned to and physically associated with the object or specimen, either by marking or attaching an archival label to the object or specimen.
	Marking and labeling is done according to standard acceptable methods.
	Labeling and marking methods are secure; reversible; safe for the object or specimen, discreet but visible; easily located; not on physically unstable surfaces or across a fracture; not on surfaces prone to abrasion or wear. All detachable parts of the object or specimen are marked or labeled with the number.
Validation Records	Letters, deeds of gift, other titles or deeds, field notes, maps, citation of the specific element in the literature, and other records.
Use Records	Condition reports; treatment reports; use of object for research, exhibition, or education; exhibit catalog.

SAMPLE POLICIES

Currier Museum of Art
Collection Management Policy

**[name change effective 2005; formerly
Currier Gallery of Art]**

Documentation

Upon final approval of the Board of Trustees, all existing information relating to the object, including a copy of the Board meeting minutes at which the object was approved, the Curator's (or Director's) report, appraised value (if known), bill of sale, correspondence with donor, etc. is given to the Registrar, who shall create records to formally document the object's acceptance into the Gallery's collection.

The Registrar shall assign a permanent accession number when the object is accepted. In the case of gifts, the Registrar shall promptly send the donor a Deed of Gift form to be signed by the Donor then countersigned by the Director and Registrar. The Director shall promptly send all Donors, regardless of the gift's value, a letter of appreciation, a copy of which shall be kept with the object's file as additional proof of ownership.

The following records shall be completed by the Registrar for all acquisitions:

- Deed of Gift form (when appropriate)
- accession sheet
- main file card
- main file folder

James A. Michener Art Museum
Collections Management Policy, 2001

Documentation

JAMAM's collection, like all museum collections, includes both the physical collection and its related documentation, sometimes called the intellectual collection. Accurate, complete, and timely documentation increases research opportunities and improves access and collection care. Collection records must, therefore, be of the highest order of accuracy and completeness. JAMAM's collections information consists of the historic and aesthetic data that are a principal research capital, and operational data generated by collections management activities. These data are required to maintain JAMAM's programs successfully.

Legally binding contracts are developed by the Registrar, reviewed by JAMAM's legal counsel and, where appropriate, with JAMAM's risk management and insurance specialists. These contracts include: loan agreements, deeds of gift, temporary custody receipts, insurance contracts, and exhibition agreements.

COLLECTIONS CARE

Collection care is costly, time-consuming, and relatively 'invisible' to those who are not intimately acquainted with museum work. As a result, when budgets are being discussed or donors are being approached, collection care is usually the dowdy stepsister who is expected to defer to her more appealing siblings: public programming, new construction, and marketing.

—Malaro (1998)

Proper collections care has been a problem for museums for as long as museums have existed. In the early 1700s the composer George Frederic Handel visited the manuscript collection of Sir Hans Sloane, whose collection eventually became part of the British Museum. While examining a particularly rare manuscript, Handel carelessly set a buttered muffin on top of it.

Museums have both a legal and an ethical obligation to provide proper care for their collections. Through the collections care policy the museum demonstrates its commitment to providing its collections with an optimal storage environment, continuous environmental monitoring, and protection from the agents of deterioration (table 12.1) by means of a preventive conservation program.

● WHEN POLICY MEETS REALITY

Even a collection housed in the desert isn't safe from water damage. The Arizona Republic reported that a sudden storm flooded the basement of the Mesa Historical Museum, where 80 percent of the collections were stored. According to the newspaper reports, the basement had been flooded before so "staff members had placed most of the artifacts on cinder blocks, but some were still on the carpet." The bad news was not just the damage from the flood waters, but the risk of mold and mildew in the six rooms that were soaked. The good news was that the flood spurred the museum and its supporters to initiate a capital campaign to renovate the museum's 1937 building. The museum's director, Lisa Anderson, told the *Arizona Republic* that "we hold the history of Mesa, and it is important to everyone. To top it off, if we get a disaster, we're really in trouble."

Ideally, every element in the museum's collections will receive the same level of care. In practice, however, this is usually not possible, due to budget and staff time constraints. For this reason, the policy establishes a framework for prioritizing collections care, recognizing that some elements in collections are more valuable than others and that some need more care than others. One method of ensuring the proper allocation of the museum's limited resources is called collections *grading*. This is a system of ranking the collections according to specific criteria. Different grades of collection elements receive different levels of collections care. The grading schemes that have been proposed for history collections (table 12.2) and natural history collections (table 12.3) can be adapted for other types of collections and incorporated into a museum's collections care policy.

The Collections Care Policy

Though collections care policies vary greatly in the level of detail they provide, most include general statements concerning:

- staff responsibilities
- preventive conservation
- handling of objects in the collections
- conservation treatments
- packing and shipping
- special care of sacred or culturally sensitive objects
- storage environment
- pest control
- off-site storage
- collection inventories.

Staff Responsibilities

It is a good idea for the policy to state clearly who is responsible for which aspects of collections care. Collections care requires a long-term commitment to the continuous provision of an optimal storage environment and protection from the agents of deterioration.

Preventive Conservation

Preventive conservation refers to actions taken to ensure that the agents of deterioration that affect the collections are detected, avoided, blocked, or mitigated. Because 90 percent of preventive conservation is accomplished by controlling the storage environment, the collections care policy often provides for a comprehensive preventive conservation program as part of the museum's long-range conservation plan. An outline for a long-range conservation plan is provided in table 12.4.

The collections care policy also can direct the museum to protect the collection from deterioration. A good basis for this policy is the five control measures presented in table 12.5. The first four control measures are considered preventive conservation; the fifth is remedial conservation. Because each control step is accompanied by an increase in cost and because the need for remedial conservation likely will lead to irreversible changes, many policies emphasize that institutional resources are better spent on the first four measures than on the last one.

Handling of Objects in the Collections

Typically collections care policies specify which staff members (e.g., curators, registrars, collections managers) and trained volunteers are allowed to handle objects, and what level of training is required for handling objects. Some policies also mandate that the museum provide staff, volunteers, and visiting researchers a set of printed guidelines for handling collections.

Conservation Treatments

By mandating the application of preventive conservation, the collections care policy greatly reduces the need for individual objects to receive conservation treatment. Because such treatments are expensive and can be controversial, the policy usually specifies which staff members have the responsibility for authorizing treatments and requires conservation treatments to be done only by a recognized, professional conservator. (For guidance on conservation decisions, refer to the American Institute of Conservation *Position Paper on Conservation and Preservation in Collecting Institutions.*)

Packing and Shipping of Collections

Many collections care policies require packing and shipping of the museum's collections to conform to standard professional practices (see chapter 9, "Loans") that provide maximum protection for the objects.

Special Care of Sacred or Culturally Sensitive Objects

Sacred objects and certain culturally sensitive objects in museum collections can require special care and attention; some of these objects may have to be repatriated (see the section on NAGPRA in chapter 13). In some cases, the care these objects require contradicts the principles of preventive conservation. For example, some Native American sacred objects require cleansing with burning sage, or ritual feeding with corn pollen. A damaged Talmud scroll probably should not undergo conservation treatment (Greene, 1992). Maori houseboards must be stored upright, not flat, and some sacred objects cannot be frozen for pest-control purposes (Simpson, 2001). Special handling for sacred or culturally sensitive objects usually is addressed in the collections care policy and its accompanying procedures. Some museums require staff to work with the appropriate tribal or cultural representatives to establish a policy and procedures that address such objects.

Storage Environment

To meet the institutional obligation to provide a good storage environment for the collections, the policy often provides guidelines for the storage environment and requires environmental monitoring of storage conditions. It establishes the length of time that monitoring records are archived as part of the collection's documentation. Because the storage environment records describe the conditions the collection elements have been exposed to, they can help diagnose conservation problems and establish preservation strategies. The policy can state that all collections, including objects borrowed from other institutions, are maintained at the appropriate environmental standards. Each museum will need to assess which environmental standards are appropriate, depending on the mission, collections, resources, geographic location, and so forth. Examples of general recommendations for the collections storage environment are provided in table 12.6.

Pest Control

It is recommended that the collections care policy mandate the implementation of a program of integrated pest management to reduce the regular use of prophylactic chemical treatments. Integrated pest management requires the museum to commit staff time and resources to prevent pests from reaching the collection, monitor the collection for the presence of pests, and use non-toxic means to control pests when possible.

Off-Site Storage

The policy establishes the museum's minimal standards for off-site collections storage. Among the considerations are the storage environment, security, and the increased wear-and-tear as collection elements are moved between the off-site facility and the museum. It is recommended that the policy also require decisions to move collections to off-site storage to take into consideration the increased risk of loss or damage to objects, possible increased costs for handling off-site collections, and staffing costs for the off-site facility.

Collection Inventories

Because museums are accountable for knowing what they have and where it is, it is recommended that they inventory and document their collections on a regular basis. The collections care policy can establish a regular collection inventory and specify who is responsible for verifying the location of every element in the collections. Inventory intervals vary greatly from one institution to another. Some policies require an annual collections inventory, others that it be conducted once every 10 years; still others establish a requirement for partial inventories (intended to be statistically representative of the whole collection). Although a partial inventory is not ideal, it is sometimes the only compromise given the available time and resources. Some collections care policies specify different inventory intervals for different parts of the collection. More frequent inventories might be required for objects of high value or objects at a greater risk of theft. For example, the policy could require an annual inventory of the fine arts collection, but allow a 10-year inventory interval for the archaeological collection.

Collections Care and Handling

Policy considerations regarding the museum's public trust responsibility to provide proper collections care are summarized in table 12.7. Policy guidelines for handling collection elements are summarized in table 12.8.

References

Ainslie, P. 2001. A collection for the millennium: grading the collections at Glenbow. *Museum Management and Curatorship* 19(1):93-104.

American Institute of Conservation. *AIC Position Paper on Conservation and Preservation for Collecting Institutions.* http://aic.stanford.edu/about/coredocs/positionpaper.html.

Applebaum, B. 1991. *Guide to Environmental Protection of Collections.* Sound View Press, Madison, 270 pp.

Bachmann, K. (editor). 1992. *Conservation Concerns. A Guide for Collectors and Curators.* Smithsonian Institution Press, Washington, D.C., ix + 149 pp.

Greene, V. 1992. "Accessories of Holiness": defining Jewish sacred objects. *Journal of the American Institute for Conservation* 31(1):31-39.

Ladden, P. 1988. Choosing off-site collection storage: problems encountered and solutions to consider. *Registrar* 5(2).

Malaro, M.C. 1998. *A Legal Primer on Managing Museum Collections.* Second edition. Smithsonian Institution Press, Washington, D.C., xx + 507 pp.

Michalski, S. 1994a. A systematic approach to preservation: description and integration with other museum activities. In Roy, A., and P. Smith (editors). *Preprints of the Ottawa Congress, Sept. 12-16, 1994: Preventive Conservation, Theory and Research,* pp. 8-11. International Institute for Conservation of Historic and Artistic Works, London, 244 pp.

Michalski, S. 1994b. Leakage prediction for buildings, cases, bags and bottles. *Studies in Conservation.* 39:169-186.

Moore, B.P. and S.L. Williams. 1995. Storage equipment. In Rose, C.L., C.A. Hawks, and H.H. Genoways (editors). *Storage of Natural History Collections: A Preventive Conservation Approach,* pp. 255-267. Society for the Preservation of Natural History Collections, x + 448 pp.

Price, J.R. and G.R. Fitzgerald. 1996. Categories of specimens: a collection management tool. *Collection Forum* 12(1):8-13.

Rose, C.L. and C.A. Hawks. 1995. A preventive conservation approach to the storage of collections. In Rose, C.L., C.A. Hawks, and H.H. Genoways, (editors). *Storage of Natural History Collections: A Preventive Conservation Approach,* pp. 1-20. Society for the Preservation of Natural History Collections, x + 448 pp.

Simmons, J.E. and Y. Muñoz-Saba. 2003. The theoretical bases of collections management. *Collection Forum* 18(1-2):1-37.

Simpson, M.G. 2001. *Making Representations. Museums in the Post-Colonial Era.* Revised edition. Routledge, London, xi + 336 pp.

Waller, R.R. 1995. Risk management applied to preventive conservation. In Rose, C.L., C.A. Hawks, and H.H. Genoways (editors). *Storage of Natural History Collections: A Preventive Conservation Approach,* pp. 21-27. Society for the Preservation of Natural History Collections, x + 448 pp.

Waller, R.R. 2003. *Cultural Property Risk Analysis Model. Development and Application to Preventive Conservation at the Canadian Museum of Nature.* Göteborg Studies in Conservation, no. 13, xvi + 107 pp.

TABLE 12.1. **Agents of deterioration in collections**
(after Michalski, 1994a; Rose and Hawks, 1995; and Waller, 1995 and 2003).

AGENT OF DETERIORATION	NATURE OF AGENT	CONTROL MEASURES
Direct physical forces	Cumulative or catastrophic forces, including sudden and gradual physical forces (e.g., gravity, dropping, inadequate support, abrasion) and deterioration caused by the intrinsic nature of the material (inherent vice).	Staff training, proper object supports, stable collection storage environment.
Thieves, vandals, displacers, and curatorial neglect	Human activities, physical neglect and intentional damage, including poor curation and security issues.	Staff training, good security.
Fire	Damage from fire, smoke, heat, and water and fire suppression as well as the clean-up processes.	Building integrity, adherence to safety standards; control of fuel and ignition sources.
Water	Flooding; leaking pipes, windows and ceilings.	Building integrity, regular inspections.
Pests	Any organism that damages collections or serves as a food source for other pests.	Program of integrated pest management.
Pollutants and contaminants	Organic and inorganic gases, particulate pollutants (acidic and/or abrasive).	Staff training, building integrity, control of chemicals used in building, application of microenvironments.
Light and radiation	Ultraviolet, visible, and infrared radiation.	Use of barriers and filters.
Incorrect temperature	Temperature that is too high, too low, or has extreme fluctuations	Building integrity, HVAC control, staff training, application of microenvironments.
Incorrect relative humidity	Humidity that is too high, too low, or has extreme fluctuations.	Building integrity, HVAC control staff training, application of envelope concept, application of microenvironments.

TABLE 12.2. **Grading strategy for history collections (after Ainslie, 2001).**

GRADE	COLLECTION	CONTENT
1	Core collection	Objects of great historical or aesthetic importance.
2	Community collection	Stable objects that are available for use in non-museum environments.
3	Interpretive collections	Objects used for hands-on programs.
4	Collection to be deaccessioned	Objects of poor quality, or objects not relevant to the museum's mission.

TABLE 12.3. **Grading strategy for natural history collections (after Price and Fitzgerald, 1996).**

GRADE	COLLECTION	CONTENT
1	Category 1	Primary types and specimens of extinct Recent species.
2	Category 2	Secondary types, historic specimens, rare or endangered species, recent species.
3	Category 3	Vouchers for research, geographic distribution, etc.
4	Category 4	Specimens that are identified to species and are used for reference.
5	Category 5	Specimens for active research use.

TABLE 12.4. **Outline for developing a long-range conservation plan.**

GOAL	HOW GOAL IS ACHIEVED
Risk assessment (see also chapter 14, "Risk Management")	Determine the risks to the collections and take steps to avoid or ameliorate each risk.
	Survey the condition of the collections to identify elements at risk.
	Prepare an environmental survey of the collections and evaluate risks to the collections.
	Survey and evaluate the existing protective systems and practices.
Needs assessment	Survey the building needs; plan a phased program to respond to the needs.
	Survey the collections needs; plan a phased program to respond to the needs.
	Survey the policy needs; develop policies that respond to the needs.
Evaluation	Evaluate the effectiveness of existing protective systems and practices.
	Periodically reassess the risks and modify plans as needed.
	Periodically resurvey the condition of the collections and modify plans as needed.
	Continuously monitor the storage environment and modify plans as needed.
Valuation	Assess the value of the collections.
Resource assessment	Determine what resources are available to reduce risks, achieve long-term preservation goals, and provide for long-range conservation of the collections.
Conservation planning	Prepare a comprehensive, prioritized list of preservation and conservation goals, how these goals can be achieved, and the resources needed to achieve them.
Remedial preservation and conservation	Where necessary, plan for remedial preservation and conservation actions.

TABLE 12.5. **Means of controlling the agents of deterioration in collections (after Waller, 1995).**

CONTROL MEASURE	NATURE OF CONTROL	RELATIVE COST
1. Avoid the source	Preventive conservation	Low
2. Block the agent	Preventive conservation	Low to moderate
3. Detect the agent (monitor)	Preventive conservation	Low to moderate
4. Mitigate the effects of the agent	Preventive conservation	Moderate to high
5. Recover from the effects of the agent (treatment)	Remedial conservation	Very high

TABLE 12.6. **Examples of general collections storage environment recommendations and set points (based on Applebaum, 1991, and Bachmann, 1992).**

MATERIAL	TEMPERATURE	RELATIVE HUMIDITY
General museum collections	65-70°F 18-21°C	47%-55%
Furniture	ca. 65°F ca. 18°C	47%-55%
Magnetic media	49-59°F 9-15°C	25%-45%
Natural history collections	65-70°F 18-21°C	47%-55%
Painted metal objects	65°F 18°C	35%
Paintings	65-75°F 18-24°C	40%-55%
Photographic film	<68°F <21°C	20%-50%
Photographs, negatives, and glass plates	59-77°F 15-25°C	20%-50%
Textiles	55-68°F 12.7-20°C	40%-50%
Wooden objects other than furniture	65°F 18°C	50%-55%
Works on paper	60-65°F 15-18°C	45%-55%

TABLE 12.7. **Considerations for meeting the museum's collections care responsibilities.**

COLLECTIONS CARE ACTION	HOW COLLECTIONS CARE ACTION IS CARRIED OUT
Maintenance	Regular schedule of inspections and repairs of physical plant by trained staff and contractors.
Education	Staff training in preventive conservation and collections care.
	Train users in safe techniques for handling collections.
Preventive conservation	Provide a stable storage environment that meets appropriate environmental standards.
	Use only archival support materials.
	Use only archival documentation materials.
	Use only storage furniture that is modular, made of inert materials, and appropriate for the collections (Moore and Williams, 1995).
	Maintain an active environmental monitoring program.
	Maintain an active integrated pest management program.
	Maintain an active risk assessment and risk management program.
	Maintain an active fire detection, prevention, and protection program.
	Maintain an active flood detection, prevention, and protection program.
	Establish collections handling procedures and guidelines for all collections care workers and collections users.
Conservation treatments	Use professionally trained conservators as appropriate.
Security	Maintain a comprehensive collections security plan.
Inventory	Perform periodic, regular collections inventories.
Condition reports	Prepare condition reports before and after an object is loaned, before and after an object is treated, whenever change in an object is noted.
Consultation with experts	Consult with experts as necessary and appropriate.

TABLE 12.8. **Guidelines for handling objects in collections.**

TOPIC	GUIDELINE
Fundamental principles	Use common sense. Think before you act.
	Handle objects as little as possible.
	Handle each object as if it were irreplaceable and very fragile.
	Handle only one object at a time.
	Move slowly, never hurry.
	Do not overload containers or carts.
	Never walk backwards when handling an object.
Before object is handled	Know the condition of the object before you pick it up. Do a visual inspection, even if it is an object with which you are very familiar. A change that you are not aware of might have occurred.
	Before you pick something up, decide where you are going to set it down and clear that area.
Object protection	Wear cotton gloves, neoprene gloves, etc., as appropriate. The wrong gloves could be worse than no gloves at all.
	Use two hands, or two people, if necessary.
	Lift the object. Do not slide or drag the object.
	Handle the object by its most stable surface.
	Support the object's weight carefully.

SAMPLE POLICIES

San Diego Natural History Museum Collections Policy, 1997

Obligation to Collections

Section 27: The museum's obligation to its collections is paramount. Each object is an integral part of a scientific composite and that context also includes a body of information about the object which establishes its proper place and importance and without which the value of the object is diminished. The maintenance of this information in orderly and retrievable form is critical to the collections and is a primary obligation of those charged with collection management.

27.1 All persons affiliated with the San Diego Natural History Museum, as staff, volunteers, or Trustees, are considered to have an ethical obligation to support the acquisition of important specimens, the improvement of the content, storage, documentation and accessibility of the San Diego Natural History Museum collections.

27.2 An ethical duty of museums is to collect the material record of the natural world and to preserve it, when possible, in enhanced form.

27.3 Museum staff will be in control of their collections and know the location and the condition of the objects that they hold.

27.4 Procedures will be maintained for the periodic evaluation of the condition of the collections and for their general and special maintenance.

27.5 The physical care of the collections and their accessibility shall be in keeping with professionally accepted standards.

27.6 Collections care and conservation shall be of a uniformly high standard. Unacceptable collections care will be upgraded or referred to the Research and Collections Committee of the Board for resolution.

27.7 The Board is ethically obligated to provide professional collections care or to dispose of the collections to another comparable institution willing to provide professional care and management.

27.8 While the governing entity bears final responsibility for the collection, including both the acquisition and disposal process, the Curatorial and administrative staff, together with their professional associates, are best qualified to assess the pertinence of an object to the collection or the Museum's programs. Only for clear and compelling reasons should an object be disposed of against the advice of the Museum's professional staff.

27.9 In the acquisition and disposal of Museum objects, the Board and staff will weigh carefully the interests of the public for which it holds the collections in trust, the donor's intent in the broadest sense, the interests of the scholarly and the cultural community and the institution's own financial well being.

27.10 Staff will follow the policies and procedures of the Museum's Collections Policy in the acquisition and disposal of objects.

27.10 The Board and staff will continue to develop policies that allow them to conduct their collections activities in line with the complexities of existing legislation and with the reasonable certainty that their approach is consistent with the spirit and intent of such legislation.

27.11 When carrying out their job responsibilities, it is incumbent upon staff to review and understand the Museum's Collections Policy and procedures as adopted by the Board.

William Hammond Mathers Museum Collections Management Policies & Procedures, 2003

Conservation Policy

The Mathers Museum houses an original collection of largely irreplaceable artifacts. Conservation seeks to preserve the physical and chemical substrate in its original form, or at its present level of stability. The objective of such effort is to foster intellectual research into the actual object, and to preserve the collection for posterity.

The Mathers Museum adheres to and functions within the framework of the Code of Ethics and Standards of

Practice of the American Institute for the Conservation of Historic and Artistic Works. The Museum specifically affirms those concepts itemized in part I section II, including: respect for the integrity of the object, adoption of a single standard, establishing the suitability of treatment, and maintaining the principle of reversibility.

The Mathers Museum preserves artifacts as physical evidence of cultural history. Conservation is consequently oriented towards the meaning of the artifact as a whole; its original cultural context, artistic intent, evidence of use and change, and physical condition.

The Mathers Museum keeps abreast of current research in conservation, maintains an active dialogue with conservation professionals, and works to keep its standards of practice current.

Conservation proceeds via preventive care, remedial treatments, and public education.

Preventive Care

The Museum seeks first and foremost to do no harm to the collection, and to provide a safe haven. To this end the provision of a stable environment should take precedence. However, the fulfillment of our commitment to the collection requires equal effort in all of the following areas.

a. The Museum provides a stable environment for the collection at all times and in all situations.

b. The Museum handles the collection safely and responsibly.

c. The Museum provides safe and secure storage for the collection in all situations, temporary and permanent.

d. The Museum ensures that new acquisitions do not threaten the existing collection.

e. The Museum seeks to ensure that safe and stable conditions will be provided for outgoing loans.

f. The Museum ensures that Museum activities do not jeopardize the collection.

Remedial Treatments

In addition to preventing deterioration, the Museum acts to intervene with the artifacts in the collection to stabilize an existing condition, repair damage, or restore an artifact to a previous condition, within cultural guidelines. Treatment decisions are guided by the following considerations:

a. The actual condition of the artifact in need

b. The priority of the artifact in need, with regard to curatorial and educational objective of the Museum

c. Current understanding in the field of conservation of the meaning and value of restorative treatments of ethnographic artifacts

d. The capacity of treatment to stabilize the problem and preserve the artifact

e. The resources to provide treatment, and maintain consequential needs that may result from treatment

Public Education

In addition to work on its own collection, the Mathers Museum also seeks to represent, foster, and promote preservation in the community at large. It is the role of the Mathers Museum to communicate the need for preservation in the community, and demonstrate methods. Maintaining the collection according to conservation standards at all times has the automatic consequence of raising public awareness of preservation issues. The Museum may offer preservation workshops, sell archival supplies in the Museum Store, and offer its facilities for use in the preservation of external collections. However, the Museum acknowledges that these activities must be carefully and cautiously approached. The Mathers Museum does not endorse specific uses of archival materials sold in the Museum Store, or specific applications or training received on its premises. . . .

Inventory Policy

A periodic inventory of the permanent collections is of primary importance in maintaining accountability for the Museum's Permanent Collection. The inventory enables Museum staff to reconcile records and documentation with the artifacts, in order to update and upgrade

the written record. The inventory also provides the opportunity for review of the physical integrity of the Museum's collection.

Historical Society of Frederick County Collections Management Policy, 2003

Care of Collections

Care of the collection is a continuing responsibility accepted by the Society on behalf of the general public.

The Society shall carry out the legal, ethical, and professional responsibilities required to provide necessary care for all collections acquired, borrowed or placed in the museum.

The Society shall provide information and training opportunities to all staff on the proper care of collections.

A. Use and Activities

Awareness [of] care of the collections shall be incorporated in all museum activities.

No use or activity shall take priority over the care and safety of the objects or records.

The intended use or purpose (i.e., category of collection) of an object shall be determined and noted at the time of acquisition and the Curator shall justify any proposed changes to the use or purpose of the item.

B. Environmental Controls

The environmental conditions appropriate to the preservation of the artifacts and documentation records shall be monitored and maintained at all times within the limits of available facilities and/or monetary funds.

Preventive and protective measures shall be taken and proper materials shall be used to minimize the damaging effects of the environment.

The use of living and dried plants shall be restricted to the staff kitchen or outside of the building. If plants are brought into the kitchen, they must be sprayed with an appropriate insecticide.

Smoking shall not be permitted in the building.

Live animals shall not be permitted in the building other than living-assistance animals.

Food shall not be permitted in the building except in staff offices and the staff kitchen. Food may be permitted in the Special Exhibit Room for events pre-approved by the Executive Director. All food related trash must be deposited in the kitchen waste baskets, and removed from the building after special events.

Beverages are prohibited in the building except non-alcoholic beverages in staff offices and in the staff kitchen. In accordance with the Building Rental Policy, alcohol and non-alcoholic beverages may be permitted in the Special Exhibit Room for events pre-approved by the Executive Director.

C. Handling

Professional standards and supplies will be utilized, under the Curator's supervision, when handling or moving artifacts within the building or when packing and shipping.

Only trained staff and volunteers shall handle objects or collections records, under the supervision of the Curator or the Executive Director.

Museum staff, volunteers or contractors responsible for cleaning exhibit or storage areas shall adhere to object handling procedures and standards.

D. Conservation

Although preventive conservation care is the preferred method of care for the collection, there are times when conservation treatment is necessary. Any repair or conservation treatment of objects within the Accessioned Collection shall be performed by skilled museum professionals/conservators approved by the Executive Director after proposals/bids have been submitted. The Curator shall obtain bids from professionals who adhere to professional museum standards. Artifacts shall be treated only by those with appropriate levels of skills and supervision, and who are authorized to carry out the specific treatment.

Priority shall be given to actively deteriorating artifacts of significant historical importance.

Objects needing professional conservation treatment shall be placed on a "Conservation Treatment Priority Plan."

Priorities for conservation treatment shall be established and revised based upon established guidelines, periodic reviews of collections, and conservation object surveys. Artifacts are placed on the "Conservation Treatment Priority Plan" based on the following considerations:

a) historical significance;

b) condition;

c) recommendation of conservator;

d) technical feasibility;

e) request for exhibit;

f) financial resources.

Proper documentation must be recorded for justification and treatment of artifacts.

ACCESS AND USE

Museums have long placed controls on access to and use of their collections. For example, in 1792, the Holfburg Museum in Vienna was open only "On Mondays, Wednesdays and Fridays, to anyone with clean shoes," and in 1820 the Prado in Madrid was accessible only "On Wednesdays and Saturdays, except on rainy days" (Singleton, 1987).

Access and use are still sensitive issues in museums, particularly with today's emphasis on the museum's public trust responsibilities. Museums are expected to preserve their collections for future generations, but they also are under increasing pressure make the collections available to the widest possible range of users. Access and use policies help museums balance these competing priorities. Some general considerations for granting access to collections and collections information are presented in table 13.1.

Access and Use Policy

To meet its basic public trust responsibilities, a museum must give the public reasonable access to the collections and their associated records. The access and use policy balances the museum's legal responsibility to provide access to the objects with its obligation to protect the collections for future generations. One of the characteristics of an accreditable museum is that "Guided by its mission, the museum provides public access to its collections while ensuring their preservation" (American Association of Museums, 2005). Access and use policies generally establish who can have access, to which collections, in what manner (e.g., physical access, electronic access, access only to records), for what purposes, and with what safeguards. In addition, the policy identifies categories of objects or documentation that have restricted access.

Access can be accomplished in a variety of ways; each museum must evaluate its physical facilities, staff, resources, and collections to arrive at the

best solution. Some access and use policies designate a collections access manager to be responsible for scheduling access to the collections. Some museums also provide alternatives to viewing the collection in person, such as access to catalogs, photographs, exhibits, and websites. Allowing access to the collections doesn't necessarily require a lot of staff time; table 13.2 presents some non-traditional means of access that museums with few resources can incorporate into their policies. The access and use policy also can specify different levels of access for different collection users (see table 13.3).

Because increased physical access puts the collections at higher risk, many access and use policies establish safeguards to mitigate the risk. For example, increased access causes disruptions to the storage environment and orderly arrangement of the collections, and makes it more likely that objects will be damaged. Increased access also provides greater opportunities for theft.

Traditional access to collections is expensive, both in terms of staff time and the wear and tear on objects, containers, and supports. Museums can operate within the constraints of their public trust mandate and charge visitors reasonable access fees. Table 13.4 compares the relative resource cost for access by audience type; table 13.5 presents requirements that the policy might mandate for different types of access. Other factors to consider when evaluating collections access and use are presented in table 13.6.

◉ WHEN POLICY MEETS REALITY

The Henry Luce III Center for the Study of American Culture at the New-York Historic Society has 10,000 objects on view in a visible storage system. An Associated Press story about the center quoted Stewart Desmond, then director of public affairs, as saying, "You may have to get on your knees to see a painting or make an appointment to see a cloak worn to George Washington's inauguration, but you can see just about everything in our collection. Traditionally, they say only about 2 percent of a museum's collection is on view at any one time. The center turns that concept on its head."

◉ WHEN POLICY MEETS REALITY

In 1922, Albert C. Barnes established a nonprofit corporation in Pennsylvania to administer an art gallery and arboretum as an "educational experiment," primarily for the benefit of students of art. Barnes was described by one biographer as "… stubborn, strong-willed, doggedly opinionated, and totally unwilling to compromise." His will included instructions that no trustee of his foundation could be employed by Bryn Mawr, Haverford, the University of Pennsylvania Academy of Fine Arts, Swarthmore, or the University of Pennsylvania, nor could any student from any of those institutions be admitted to see his collection. Barnes personally denied access to his collection to several well-known people, including the poet T. S. Eliot and critic Alexander Woollcott. When Barnes penned a particularly angry letter, he often signed it with his dog's name instead of his own.

Who Has Access to Collections and Records?

Although public access to collections and their associated records is generally desirable, in practice museums don't have to give everyone the right to access anything at any time. While it is true that greater access will enhance the public's appreciation for the collections and may help increase financial support for the museum, to protect the collections the museum can provide safeguards that restrict access.

The public does have access to those collections on exhibit during regular hours of operation. Some institutions allow visitors to tour storage areas or see particular objects by appointment. Researchers and scholars generally are granted access to collections in storage by appointment. Some policies ensure that such access is granted in an objective, unbiased manner. Not all researchers and scholars have to be granted equal access to all collections. For example, an ongoing research project by a researcher or scholar could temporarily "pre-empt" others from using parts of the collections or their associated records. However, the policy can include safeguards to prevent an individual from tying up collections for long periods of time.

It is recommended that the access and use policy specify who has the authority to approve public and research access to collections and data, the level of supervision required, and restrictions on handling objects. The policy can establish hours of access that meet visitors' needs but are not a burden on the staff, as well as how much access staff, volunteers, and board members have to collections. Because most theft in museums is insider theft, the policy also can include appropriate record keeping and supervision requirements for anyone, whether an insider or an outsider, granted access to the collections.

Ideally, the policy will provide guidelines for allowing contractors and inspectors (e.g., building, fire, or safety inspectors) in the collections areas. Most museums require such individuals to be escorted by a designated staff member at all times.

Under the 1990 Americans with Disabilities Act (ADA), museums legally are obligated to make most areas accessible to people with disabilities. However, ADA requirements for access to collections storage can be satisfied in a number of ways. For example, a staff member could bring objects out to a handicapped-accessible area outside of the collections (Malaro, 1998). The application of the law depends on a number of factors: the nature and cost of the necessary action, overall financial resources of the museum, etc. Museums are advised to work closely with qualified specialists when retrofitting old or designing new space. ADA access for staff is another important issue; the museum's human resources personnel can help determine how to provide "reasonable accommodation" for work performed by staff with disabilities.

Access to Which Collections?

Museums restrict or deny access to some collections because those objects are culturally sensitive. According to some Native American traditions, for example, pregnant women cannot handle or even be near certain men's objects (Simpson, 2001), and Torah scrolls can be unrolled for exhibition only with the approval of a rabbi (Greene, 1992). Access also can be restricted to documentation as well as objects; the Makah Cultural and Research Center restricts access to its archive of recorded oral histories because some tribal knowledge cannot be shared with

non-tribal members (Simpson, 2001). The access and use policy often accommodates the museum's concerns for proper care, handling, and storage of such collections. Many museums find that the most effective way to handle access to culturally sensitive materials is to work with advisory committees that include members of the appropriate cultural groups to ensure that their concerns are addressed in the institution's policies and procedures.

Access to Collection Records

The access and use policy must be sensitive to the 1996 Federal Freedom of Information Act (see appendix C, "Laws and Legislation"), which permits public access to documentation that traditionally museums have restricted. Most states have similar laws, usually called "open records" acts.

Access to some museum records—for example, those concerning donations or valuations of objects—can raise privacy concerns. As nonprofit institutions, museums are committed to transparency and accountability. But they also must balance the public's right of access with a donor's privacy rights. The access and use policy can clear up any confusion by specifying which museum records are restricted.

Some policies state that the accuracy of the information provided is not guaranteed or warranted, although the museum makes every effort to ensure that it is correct; that use of object images must conform with copyright law (see chapter 15, "Intellectual Property"); and that all documents containing data with collections information, including object labels and tags, cannot be altered without written permission.

Methods of Access and Types of Use

Access and use policies often establish when, under what conditions, and where photography of objects in the collections is permitted (e.g., in the public galleries or storage areas). Some museum policies mandate that all photography must be done by museum staff; others allow researchers to take their own photographs. Policies also discuss associated issues such as ownership of copyrights and negatives; who, if anyone, can make photocopies or scanned images of two-dimensional

objects or collections records; and whether that person will be charged a fee. Most museum policies require staff to make copies for visitors.

Destructive Sampling

Destructive sampling refers to any use in which part of an object or specimen is removed permanently or other damage incurred (e.g., a paint sample removed from a chair for chemical analysis, a piece cut from a bone for carbon dating, or a tissue sample removed from a preserved bird skin to obtain DNA). Requests for destructive sampling have increased in recent years with the development of new technologies for studying museum collections.

The access and use policy typically states that destructive sampling of a collection element cannot be done without permission and provides guidelines for when and how destructive sampling is allowed. For example, the policy might state that the purpose of the sampling must be in keeping with the museum's mission and that requests for sampling be provided in writing with a sufficient level of detail to allow the staff to evaluate the merits of the proposal. It might restrict the use of samples to techniques likely to yield the intended results, and stipulate that the researcher must disseminate the results of testing within a reasonable period of time. It also might provide review criteria to guide the decision-making process, such as:

1. Will the sampling compromise the future utility of the object or specimen?

2. Are there alternative means of obtaining the needed data?

3. Does the expected information gain justify the damage caused the destructive sampling?

4. Is the researcher making the request competent to carry out the tests?

Access to Records on the Internet

One way of making collections and their associated records broadly available to the public and researchers is through the Internet. Many museums provide images of objects or complete online catalogs via a website; some museums require registration or charge a fee for access to or for certain uses of online records. Access and use policies often state that sensitive documents—for example,

donor records, appraisals, images of sacred objects, or locality records that reveal the presence of commercially important plant or animal species or critical archaeological sites—cannot be posted on the Internet.

As part of its commitment to collections care, the museum can ensure through its access and use policy that any data on the Internet is secure from manipulation, in a read-only format, and protected from hackers.

Use of Gallery Space

Many museums use their exhibit spaces for receptions, special events, and rentals. Because these spaces usually contain collections objects, the access and use policy often addresses which spaces can be used, in what way, for what purposes, and with what restrictions. For example, a museum might make an exhibit space available for a museum-sponsored reception but not for an event organized by an outside organization. Or the museum might make space available for rentals, but require special provisions for security or maintenance.

Usage of Collections and Collections Information

Many access and use policies clarify how collections and information about them can and cannot be used. For example, policies often state that use must conform to the museum's mission, be ethical and legal, and respect the integrity of the collections and the information (e.g.,

● WHEN POLICY MEETS REALITY

According to news reports the Egypt Centre of the University of Wales in Swansea had to cope with a large influx of visitors who came to worship the mummies on exhibit and conduct exorcism rites to free spirits trapped in certain artifacts. It got to the point that the unauthorized activities were interfering with non-exorcising visitors in the museum, and staff could not get their jobs done. Some of the visitors claimed to be possessed by Egyptian deities. One female visitor was convinced she was the mother of a 2,000-year-old mummified baby.

tags and numbers on objects cannot be removed). The policy might discuss whether collections can be used decoratively in the museum's non-public areas and, if so, under what conditions. It also might explain whether the collections can be used for commercial purposes. Some museums allow collections to be used only for scholarly and educational purposes; others allow commercial use of objects or images in return for fees. Some policies state that a copy of all reports, papers, or other published works produced using the collection or its associated information are to be given to the museum for deposit in its archives.

References

American Association of Museums. 2005. *A Higher Standard: Museum Accreditation Program Standards.* American Association of Museums, Washington, D.C. 40 pp.

Cato, P.S. 1993. Institution-wide policy for sampling. *Collection Forum* 9(1):27-39.

Chatwin, B. 1988. *Utz*. Penguin Books, London. 154 pp.

Greene, V. 1992. "Accessories of Holiness": defining Jewish sacred objects. *Journal of the American Institute for Conservation* 31(1):31-39.

Richoux, J.A., J. Serota-Braden, and N. Demyttenaere. 1981. A policy for collections access. *Museum News* 59(7):43-47.

Simpson, M.G. 2001. *Making Representations. Museums in the Post-Colonial Era.* Revised edition. Routledge, London, xi + 336 pp.

Singleton, H.R. 1987. Museum training: status and development. *Museum* 156:221-224.

TABLE 13.1. **Access to collections and collection information policy (after Malaro, 1998).**

CONCERN	POLICY CONSIDERATION
Care	Access and use cannot compromise collections care.
Mission	Those developing the policy share a common understanding of the museum, both its mission and the public it serves.
Resources	The museum has the physical and financial ability to implement its policies.
Risk	There is consensus regarding the acceptable risks to balance access and protection.
Security	The museum develops its access and use policy with advice from security experts.

TABLE 13.2. **Non-traditional options for providing public access to collections.**

MEANS OF ACCESS	COSTS AND/OR BENEFITS
Open storage and visible storage	Visitors can see the size and scope of collections.
Restricted database access	Visitors get more information on the object but do not see the actual objects.
Study and work spaces near collections storage	Staff time is needed to bring objects out to users; security can be compromised.
Tours of storage areas	Visitors see the size of collections; tour guides highlight staff roles and resource limitations.
Virtual museum access to digital images of collections	Although digitization has a high initial cost, Internet access to collections and their information can be an excellent long-term method for expanding the museum's audience.

TABLE 13.3. **Categories of collections users and collections use (after Richoux et al., 1981).**

CATEGORY	TYPE OF COLLECTION OR COLLECTION INFORMATION USE
Commercial users	Photographers, fashion designers, architects, filmmakers, writers, etc.; museum may charge access fees to recover resource use.
Cultural or ethnic groups	To confirm that collections are being properly cared for according to the group's particular requirements.
Donors and their families	May request access to specific objects to assure themselves that donated collections are well cared for and utilized appropriately.
Elementary and secondary students	Access through exhibits, tours, educational programs on site, and in the classroom (borrowed objects).
General public	Main access is through exhibitions, tours, or by special request.
Hobbyists and amateur collectors	Usually make special requests for access to particular objects or information.
Museum staff	Research access; use of collections and collection information for exhibits and public programs; documentation of collections care.
Teachers	May need special access to prepare for group exhibits, tours, or educational programs (on site or in classroom).
Undergraduates, graduate students, scholars, researchers	Research access; may include requests for destructive sampling.

TABLE 13.4. **Relative resource costs for collections access.**

AUDIENCE	LEVEL OF ACCESS	DEGREE OF SUPERVISION REQUIRED (CORRELATES TO RESOURCE COST)
Commercial users	Specific	High
Cultural or ethnic groups	Specific	High
Donors and their families	Specific	High
Elementary and secondary students	Medium	Low
General public	Low	Low
Hobbyists and amateur collectors	Medium	High
Museum staff	High	Very low
Teachers	Medium	Low
Undergraduates, graduate students, scholars, researchers	Moderately high to high	High

TABLE 13.5. **Requirements for access to the collections and associated information.**

ACTIVITY	POLICY CONSIDERATION
Permission to access collections or collections information	Advanced notification required; specify the amount of time needed.
	Fees for access.
	Evaluation and approval of research technique.
	Evaluation and approval of overall research project: Is it likely to be published? Will it contribute to knowledge? Is it worth the risk to the collection?
	Potential user's qualifications for access (professional training, affiliation with another institution, references).
Care	Access must comply with care and storage standards.
Collections use	Destructive sampling.
	Credit in publication.
	Commercial use and fair compensation.
	Reservation of parts of the collections or associated information for priority research.
	Photography or other image use.
	Intellectual property rights.
	Reproduction rights.

TABLE 13.6. **Factors to consider when evaluating how collections can and cannot be used.**

CATEGORY	CONSIDERATION
Purpose	Must conform with museum mission.
Stewardship	Use must respect the integrity of the objects.
	Use must respect the integrity of the associated collections information.
	Destructive sampling cannot be done without prior written permission.
Professionalism	Use must be ethical.
	Use must be legal.
	Use of images must comply with intellectual property rights.
	User cannot alter object data or information without written approval from a museum authority.
	The accuracy of the information provided with the object is not guaranteed or warranted by the museum.
	Commercial use or promotion of the collections can take place only under contract.
Documentation	Copies of all reports, papers, data generated, or other published information based on the collection must be provided to the museum.

SAMPLE POLICIES

Cleveland Museum of Natural History Collections and Research Manual, 1998

Electronic Access to Collections Data Policy

1. Access to computerized collections data through the internet.

 As departments computerize their collections data, basic, non-sensitive information about the collections can be posted on the Museum's Web page. Determinations [of] what constitutes non-sensitive data for a given collection will be made by the Curators of the individual departments.

2. Access to computerized collections data in-house.

 Access to non-posted computerized information about the collections for use by qualified individuals will be controlled by Curators/department head. Data access policies and restrictions are made on a department by department basis.

3. Generalized policies on computerized data use.

 Computerized collections data will be made accessible to non-museum users in copy form only. Editing, deleting, or any alterations with the Museum's original data files by unauthorized personnel is forbidden. Failure to comply with this rule will lead to loss of access to the computer database.

Consumers of computerized data who wish to apply it to commercial applications must obtain permission from the relevant Curator and the Museum Director and follow other restrictions for Museum data as outlined elsewhere in the Collections and Research Manual.

If computerized information obtained from the Museum is used in a publication of any kind, a reprint of the publication or a citation of the publication should be sent to the Curator. The Museum must be acknowledged as the provider of the data. Users of all computerized data are expected to report any data errors to the relevant department, either directly or through the Museum's Systems Operator.

Museum of New Mexico Collections Policy, 2002

7-B. Access to the Collections

The collections of the Museum of New Mexico System exist for the benefit of present and future generations. Therefore, the public shall be granted reasonable access, by appointment, to exhibited or stored collections, on a non-discriminatory basis for the purposes of research and other educational uses. Access to culturally sensitive collections will be governed by the provisions of the Museum System's policy. To safeguard the physical integrity of its collection, museum staff may limit the size of groups to storage and collection areas. Users may be liable for any damage caused to collections.

Collections areas should be monitored by professional staff at all times. Museum staff should work in pairs in the vaults whenever possible. Outside maintenance personnel, outside contractors, and researchers *must* be accompanied at all times in collections vaults.

7-E. Commercial Use of Museum Collections and Facilities

Use of Museum of New Mexico System collections and facilities for commercial purposes shall be allowed only when carefully controlled and monitored by Museum System staff. Written permission for commercial use of Museum System collections and facilities must be obtained from the Associate Director of the appropriate unit and the Division Director of the Museum of New Mexico System. Proof of adequate liability insurance with a fine arts rider is also required, as specified by State Risk Management. Permission to use collections and facilities will be withdrawn by the appropriate Division Director of the Museum of New Mexico if the Museum System collections are compromised.

Use of Museum System collections requires written permission from the Division Director of the appropriate unit, in consultation with the responsible curator and conservation staff who will provide written recommendations. A qualified staff member will be present at all times during the use of Museum System collections.

Use of Museum System facilities must not result in permanent alteration to grounds or structures. Facilities must be returned to their prior condition after use, and the user will be responsible for all cleaning and repairs, all security costs, and additional staff time if required. Visitor access shall not be disrupted.

Commercial media productions must not distort the purposes or historical integrity of the Museum System and its collections. No object, exhibit, or structure will be used in promotion of a product or service that implies endorsement by the State or the Museum of New Mexico System.

Museum of the Rockies, Montana State University, Collections Policy Manual, 1998

Access to Collections and Records

Access to Collections and Records for Research and Study

Tours through the Museum's collections storage ranges are given periodically for individuals or groups. These visits must be scheduled in advance with an appropriate Curator and while on tour, the party must be accompanied by the Curator or a designated surrogate. Approval for unplanned visits will be left to the discretion of the Curator.

The Museum makes its collections and records accessible to serious students and scholars for research contingent upon staff availability and consistent with accepted security and preservation practices. The primary considerations for access to items for examination are based upon condition and significance of the item(s) and availability of other sources: copies, duplicates, photographs, or other types of information, e.g., written descriptions.

Collections are available to researchers by appointment with the appropriate curator, with the following exceptions:

- specimens currently on exhibit
- specimens under current research
- unprocessed specimens
- specimens deemed too fragile for handling

Costs associated with research (such as copies) will be billed to the researcher. There is a standard schedule for costs associated with photo archives copies.

Procedures for access to the collections and records are:
- Individuals seeking access to the collections and records must seek approval of the Curator by completing a Collections/Records Access Application form. Information is sought on the purpose/need for access and the anticipated significance of the research.
- Access must be coordinated with the responsible Curator and authorization will be given or denied by that Curator and/or the appropriate Museum official. Collections/Records Access Application forms are filed in the appropriate curatorial section.
- Objects and records are normally accessible only during normal working hours and only if the visitor is accompanied by an authorized member of the staff. Every effort will be made to accommodate all reasonable requests.
- All persons granted access will be instructed by staff in the proper procedures.
- The Museum will comply with any reasonable request to duplicate records including field notes, photographs, analysis records, catalogs, maps, illustrations, and other data for a fee based on the number of or type of items. Requests for duplication must be submitted in writing to the Curator responsible for the material and be approved by the Museum Director.

William Hammond Mathers Museum Collections Management Policies & Procedures, 2003

Access Policy

Access to Materials on Display

The Museum's exhibit area is open to the university community and the general public on a regular schedule and is therefore subject to few restrictions on access. The Museum reserves the right to deny access to anyone behaving in an unruly or menacing manner or whose actions threaten the safety of the objects on exhibit.

Access to Materials Stored in Non-Public Areas

The Museum's responsibility to maintain its collections and records in a secure, orderly manner decrees that the Collections Storage Area and the Collections Workroom should not be open to the public. However, the Museum also recognizes that individuals who are not members of its staff can have a legitimate need for access to its stored collections and records, and the Museum will consent to requests for proper and appropriate uses of its resources. Proper and appropriate uses are deemed to be those that serve research projects and educational functions (teaching and exhibition), either at Indiana University, Bloomington, or at other institutions. The ultimate responsibility and authority for determining whether any specific request represents proper and appropriate use rests with the Director of the Museum.

Access to non-public areas by Mathers Museum staff and visitors is prioritized as follows:

Class One Unrestricted Access	Unlimited access via assigned keys/key sign-out to collections areas, remove artifacts from collections area [Permanent Staff]
Class Two Limited Access	Following training, access to collections area via sign-out key, no removal of artifacts from collections area [Work-Study, Practica Students, Volunteers, Associate Curators, Custodial Staff]
Class Three Supervised Access	Access to collections area with supervision, approved and supervised handling of artifacts [Researchers— Note: long-term researchers may receive training to qualify for class two access]
Class Four Restricted Access 2	Access to collections area with supervision, no handling of artifacts [Visitors, Classes, Tours]

Regulations

In accordance with the foregoing, access to materials in the Collections Storage Area and Collections Workroom is governed by the following regulations:

a. Requests for use of collections must be made in advance and directed to the Curator of Collections, who determines the validity of the request, and develops an appropriate schedule.

b. Priority in usage will be given to Indiana University faculty, staff, and students.

c. Usage of materials in non-public areas will normally be carried out in the Collections Workroom, and is subject to current procedures. The Museum reserves the right to deny access to collections to anyone in violation of said policies and procedures.

d. A copy of the research produced from the use of the collections must be left with the Museum, to be available for reference in the Museum's Documentation Files.

e. Requests that artifacts be removed temporarily from the Museum for use in other locations are governed by the Museum's Internal/External Loan policies.

f. Records may be photocopied for research purposes only, following procedures, but original records may not leave the premises.

g. All individuals working in the Museum must wear their identification badge at all times. Non-permanent staff such as work-study students, hourly staff, practica students, researchers, and volunteers sign out their identification badges at the security desk upon arrival at the Museum. These badges are to be returned to the reception desk at the end of their visit.

William Hammond Mathers Museum Collections Management Policies & Procedures, 2003

Photographic Policy

The Mathers Museum complies with U.S. Copyright Law in its photographic services and activities.

All photographs of the Mathers Museum collections intended for publication will be made by the Mathers Museum Photographer. Exceptions must be approved by

the Collections Committee. In the event that an outside photographer is brought in to photograph Mathers Museum collections, any negatives or slides so produced shall be the property of the Mathers Museum, and shall be returned to the Mathers Museum upon publication of the work.

Researchers may make photographs of the Mathers Museum collections for personal use, but not for publication.

Wisconsin Maritime Museum Collection Policy and Procedures Manual

Visual Image Duplication Policy and Procedure

The Wisconsin Maritime Museum collection of visual images is quite extensive. This collection contains original photographs, other photographs and negatives, photograph albums, blueprints and tracings. Use of this collection is requested by museum members, museum personnel, the business community, the general public, the media, as well as scholarly researchers. The collection items are available for duplication depending upon their condition, accessibility, donor conditions and restrictions and staff availability. Under no circumstances are non-museum personnel allowed in the collection. Staff must be present with the user in the Archives at all times. Priority use is given to the Wisconsin Maritime Museum.

a. Criteria for Collection Use and Duplication

Individuals (with the exception of museum staff) interested in using the collection or obtaining duplicates of collection material must:

1. Make an appointment with the collections department 5 business days prior to the visit.
2. Make known the specific area of interest at the time of the call for an appointment.

 All duplication is done through the Maritime Museum. Payment must be made in advance. Duplication may take 6-10 weeks for completion.

 Duplication of items which are originals or in fragile condition is at the discretion of the Registrar.

Blueprints cannot be copied. Tracings may be copied provided access to a large copy machine is available. An attempt to copy these on the copy machine may be made, however this is dependent upon the size and fragility of the blueprint and the needs of the user.

The use of photographs in printed material must be agreed to, in writing, by the Director, prior to publication. This request must be submitted in writing at least two weeks in advance stating the exact use and purposes of the duplicated material. During the two weeks the Director, or his designated assignee will make a decision regarding the appropriateness of the request. User will be notified promptly.

Fees will be determined by the type of publication in which they appear. Any photographs used for publication must carry a line of credit, such as "Photograph courtesy of Wisconsin Maritime Museum."

Duplication by those not directly associated with the Wisconsin Maritime Museum, including members, is strictly prohibited.

b. Photographic Services

1. Prints will be made only of materials in the Museum collections, which, in the opinion of the staff, are properly available for duplication. The Wisconsin Maritime Museum will not reproduce copyrighted material without signed authorization of the copyright owner. This authorization must be obtained by the user. The Collection Department merely provides the service of duplication and fees are paid exclusively for this service.
2. Duplication orders may be placed in person or through the mail. All sales are final.
3. Negatives will not be provided to the user.
4. Anyone requesting duplicates must state, in writing, the intended use of the material.

ALL DUPLICATION IS AT THE DISCRETION OF THE WISCONSIN MARITIME MUSEUM. Although the museum seeks to serve its members and the public, it also seeks to preserve and protect the integrity of the collection.

San Diego Natural History Museum Collections Policy, 1997

Sampling and Destructive Testing Policy

Sampling and destructive testing is the permanent alteration, removal, and/or destruction of part or all of a specimen in the course of scientific research. Some situations which require such processes include isotope dating, DNA and chemical contamination studies, pre-cleaning testing of solvents, X-ray diffraction and other powder-sample studies, cross-sections and thin sections, preparation of light-stage microscope slides, preparation of SEM stubs, dissection of specimens, ecto- and endo-parasite collections from host species, and other techniques specific to certain disciplines.

The San Diego Natural History Museum recognizes that the systematics disciplines represent the most valuable base of historic biological and geological information in existence, and further recognizes that judicious use of sampling and destructive testing may represent the most scientifically valuable use of some of its holdings.

Acceptable sampling and destructive testing practices are outlined in the procedures manual for each collection. Since these require the modification or loss of a part of the collection, however small, they should always be documented. Where possible, specimens, samples or residues, printouts of results, photographs, or other documents should be added to the permanent specimen record to show what was done and with what results. Specimens subjected to destructive sampling are not considered to have been deaccessioned.

The decision to permit destructive work should be made only by the curator in charge of the collection, not by the researcher or borrower. Conditions and limits must be agreed to in writing in advance of the work. Copies of the letter of permit should be routed to the Executive Director and the collections committee. If the collection has no curator, the director of collections care and conservation, with the advice of experts in the discipline, will evaluate the request and make recommendations. Permission for destructive work may be denied unless the SDNHM specimens can be fairly shown to be the only ones which can meet a particular research need, as determined by the collections committee and an advisory group established for a particular collection.

Certain specimens may not be subjected to such procedures without the permission of the Executive Director as well as the permission of the staff member in charge of the collection. These include specimens of extinct Recent taxa, type specimens, voucher collections, figured or illustrated specimens, items described in a professional or scientific publication, and items which are considered to be of archival importance.

RISK MANAGEMENT AND INSURANCE

"What is utterly absurd happens in the world."
—Nikolai Gogol, *The Nose*

Risk Management

If risk can be defined as "the chance of an undesirable change occurring" (Waller, 1995), risk management involves the use of resources to minimize undesirable changes to the collections. Museums practice risk management by analyzing potential dangers to their collections, developing avoidance strategies, mitigating the problems posed by the risks, and implementing emergency plans in case a disaster occurs.

◉ WHEN POLICY MEETS REALITY

Sometimes risks come from unexpected sources:

- Staff members in a Chicago museum discovered gunpowder and dynamite in their weapons collection. In addition to a few loaded muzzle loaders, the staff discovered powder horns that still contained black powder, which becomes increasingly unstable with age.

- During a collections move, a Canadian natural history museum discovered that several jars of preserved whale ovaries had dried out. Unfortunately, the specimens were in Bouin's solution, a preservative that contains picric acid. When dry, picric acid is highly unstable and may explode when exposed to even slight vibrations. The local bomb squad had to be called in to remove the whale ovaries and explode them in the parking lot.

- The B&O Railroad Museum suffered major damage in February 2004 when the roof of its 1828 building collapsed during a freak 28-inch snowfall. Tons of snow, ice, wood, and slate fell 200 feet onto a one-acre exhibit floor full of locomotives and train cars.

Determine the Risks to the Collections

Effective risk assessment begins with a determination of the particular hazards the collections face, the severity of those risks, and the steps needed to ameliorate those risks. Without a careful assessment process, a museum could expend a lot of resources on risks that rarely pose a threat to the collections and inadvertently ignore the real dangers. Types of potential risks to museum collections are listed in table 14.1. Assistance with risk assessment can be obtained from the museum's insurance agency or local fire and police departments.

Assess the Magnitude of the Risks

Determine how likely it is that each identified risk might occur—as well as the probable magnitude of the risk—and use that determination to establish priorities for risk management. Risks can be characterized according to their *frequency of occurrence* (which may be rare, sporadic, or constant), and the *severity of their effects* (which may be mild or gradual, severe, or catastrophic). The relationships between these factors is shown in table 14.2. Most risk factors in museums can be categorized as one of three broad types:

Type I. Risks that are rare in occurrence but have catastrophic effects. Examples include fire, floods, and earthquakes.

Type II. Risks that are sporadic in occurrence but have severe effects. These include leaking roofs, pests, dropping a drawer full of objects, using corrosive cleaning agents, and incorrect temperature in collections storage.

Type III. Risks that are constant in occurrence but have mild or gradual effects. These include the presence of atmospheric pollutants, constant vibration from a highway or railway, or damage to an object caused by poor support.

Risks in the lower right quadrant of table 14.2 are so infrequent in occurrence and have such a mild effect on collections that they are of little concern. An example is the effect of a particularly sweaty curator on the humidity in a storage room. The risks in the upper left quadrant of the table are constant, catastrophic, and severe; collections that are exposed to them would be destroyed

quickly. An example is a collection of sculpted butter kept in an un-air-conditioned building in Kuwait.

Table 14.3 lists several common situations in museums that can result in an increase in risk to the collections.

Amelioration of Risks

Once the risks to the collection have been determined and an evaluation made of their magnitude, develop plans to mitigate the risks. There are three basic ways of mitigating risks:

1. Eliminate the source of the risk.
2. Establish a barrier to block the risk.
3. Act on the agent responsible for the risk.

Risk Management Policy

Risk management policies vary in detail from general statements regarding the museum's responsibility to protect collections against various hazards to detailed expositions of how this will be accomplished.

The risk management policy often addresses the risks to the collections and how those risks can be avoided or ameliorated. Protective measures can include common building standards such as physical defenses, intruder alarm systems, fire detection and suppression systems, invigilation systems (guards or attendants), and internal security arrangements (e.g., collection object tracking systems, shelf lists, etc.). The policy also can address disaster preparedness, climate control, pest management, supervision of caterers and contractors, and inventories (see chapter 12, "Collections Care"). Institutions with living collections will develop policies that cover drought, detection and transmission of disease, and invasive species.

More information on the development of risk management policy can be found in Merritt (2005) and Waller (1995, 2003).

Physical Defense and Alarms

Some risk management policies list the kinds of protection, detection, and alarms systems the museum must use, who will monitor and respond to alarms, and in

⊙ **WHEN POLICY MEETS REALITY**

Though Benjamin Franklin founded the first insurance company in the Americas in 1752, fire losses (and lack of insurance) had a significant impact on early American museums. John Scudder founded a popular public museum in New York in 1810, which was purchased by Phineas T. Barnum in 1842. Barnum also acquired most of the holdings of Charles Willson Peale's museum in Philadelphia after it failed in 1845. At its peak, Barnum's American Museum in New York boasted 600,000 accessions, including live animals, portraits, waxworks, midgets, giants, bearded ladies, and serious collections of natural history, anthropology, history, and art. The American Museum was destroyed by fire in 1865, rebuilt, and burned down again in 1868. At that point, Barnum decided to take his show on the road as a circus instead, but he continued to collect and donate collections to museums all his life.

⊙ **WHEN POLICY MEETS REALITY**

Objects are stolen from museums by a variety of means but, surprisingly, most often through insider theft.

- A curator returning from vacation to the Walters Art Gallery in Baltimore thought that the galleries looked a bit sparse. An inventory showed that more than 80 objects, mostly Asian art, were missing. The entire staff and all of the volunteers came under suspicion and were subjected to polygraph tests. It turned out that a security guard on the night shift had helped himself to objects in the conservation lab for treatment; he also took 70 books. He got away with so many objects because he worked at night, took advantage of faulty communications between the conservation staff and the collections staff and the lack of a tracking system for objects, and removed only one object at a time in a backpack.

- An art collection at Brigham Young University in Provo, Utah, was administered by a committee comprised of art department faculty. One committee member, acting alone, deaccessioned not only numerous objects but also their accession files. He was able to deaccession and sell a total of 230 works before he was caught.

what manner. For example, the policy might require window alarms, motion detectors, or monitored alarms, or establish a staff security committee to coordinate security issues.

Fire Detection and Suppression

Risk management policies sometimes specify what kind of fire detection and suppression a museum will employ (e.g., heat and/or smoke detectors, wet or dry pipe sprinkler systems, delayed action systems). Historic houses and museums housed in historic structures often have to balance the historic preservation needs of the building with the need for prudent safeguards for fire control.

Security

The risk management policy usually assigns responsibility for implementing and supervising collection security functions; specifies whether volunteers or students can perform security functions and, if so, what training or supervision they should receive; and establishes monitoring of exhibit and storage areas for theft or vandalism.

⊙ **WHEN POLICY MEETS REALITY**

Two Stalin-era locomotives, weighing 40 metric tons each, were reported stolen from a museum in Igarka, a Russian town north of the Arctic Circle. A historic steam locomotive was stolen from an open air museum in Donetsk, in eastern Ukraine, as well. It was presumed in both cases that the thieves intended to sell the trains for scrap metal; thieves in Donetsk had stolen a 36-foot-long bridge the week before.

Food, Drink, Plants

To facilitate pest control in the collections, it is recommended that the risk management policy state that food, drink, and living plants cannot be brought into collec-

"The risk that mycotoxins might cause permanent mental impairment among scholars and literati is balanced by another, more fanciful possibility. Other classes of fungal metabolites have different pharmacological properties including the ability… to cause hallucinations…. The source of inspiration for many great literary figures may have been nothing more than a quick sniff of the bouquet of mouldy books. Coleridge may have been quite wrongly suspected of describing the delights of Kublai Khan's fun city under the influence of opium, a few hours breathing deeply among his books incubated in some dank Somerset air being quite sufficient to whirl him off to Xanadu in a trance." (Hay, 1995)

tions storage areas (unless, of course, the institution is a zoo or botanical garden). Some policies also impose restrictions on food, drink, and living plants in staff offices, public areas, and exhibit galleries. A food policy can be quite specific; for example, it might prohibit certain kinds of food or methods of preparation that are likely to increase risk to the collections.

Insurance

Insurance is one way the museum is compensated for damage to its collections. While prevention is always preferable to compensation, insurance can provide the funds to restore or replace lost or damaged collections.

Because few museums can afford insurance for the full market value of all their collections, the risk management policy addresses what method will be used to determine the level of coverage. Some strategies include insuring for:

- "maximum probable loss," the loss likely to result from a limited event that affects only part of the collection;
- an amount determined from a list of the museum's most valued objects.

Some museums "self-insure," but the meaning of this term varies from institution to institution. Generally, self-insurance means that sufficient funds are appropriated in advance to compensate for a loss. Very large museums, or those with parent organizations, often have self-insurance programs that include managed insurance funds, internal risk assessors, and loss adjustors. Other museums use the term self-insurance loosely, which means that they actually don't have insurance and plan to pay for any damages using operating, non-operating, or restricted funds. Since it's difficult to cover the costs of a large loss by self-insurance, consider whether self-insurance is consistent with the museum's stewardship responsibilities.

In addressing insurance, the risk management policy can specify:

- whether the museum is required to have insurance on collections it owns or borrows;
- who is responsible for negotiating and purchasing insurance, maintaining insurance records, and filing claims;
- what types of records must be maintained to document insurance claims;
- how loss or damage will be recorded, and to whom they will be reported; and
- what the museum will and will not insure (e.g., promised gifts, objects in custody).

The risk management policy also can specify when the museum will purchase supplemental coverage, such as for special exhibits or touring exhibits (see chapter 9, "Loans").

A 1997 article in the *New York Daily News* reported that a visitor was suing a museum in the city for $3 million "because she tripped and fell at an exhibition titled 'Endangered! Exploring a World at Risk.'" The visitor claimed that schoolchildren pushed her into a portable partition and that the exhibit lacked warning signs.

References

Griffith, E. 1995. Liability and risk management for museums. In Fahy, A. (editor). *Collections Management,* pp. 277-283. Routledge, London and New York, xii + 304.

Hay, R.J. 1995. Sick library syndrome. *The Lancet* 346 (8990):1573-1574.

Malaro, M.C. 1994. *Museum Governance.* Smithsonian Institution Press, Washington, D.C., viii + 183.

Merritt, E.M. (editor). 2005. *Covering Your Assets. Facilities and Risk Management in Museums.* American Association of Museums, Washington, D.C., 203 pp.

Museums and Galleries Commission. 1995. Museum and gallery security. In Fahy, A. (editor). *Collections Management,* pp. 239-243. Routledge, London and New York, xii + 304.

Waller, R.R. 1995. Risk management applied to preventive conservation. In C.L. Rose, C.A. Hawks, and H.H. Genoways (editors). *Storage of Natural History Collections: A Preventive Conservation Approach,* pp. 21-27. Society for the Preservation of Natural History Collections, x + 448 pp.

Waller, R.R. 2003. *Cultural Property Risk Analysis Model. Development and Application to Preventive Conservation at the Canadian Museum of Nature.* Göteborg Studies in Conservation, no. 13, xvi + 107 pp.

TABLE 14.1. **Some potential risks to museum collections.**

CATEGORY OF RISK	TYPE OF RISK
Security-related risks	Arson
	Terrorism
	Theft
	Vandalism
Natural disasters	Earthquake
	Fire
	Flood
	Heavy snowfall
	High wind
	Hurricane
	Prolonged periods of extreme heat, cold, or high relative humidity
	Tornado
Infrastructure risks	Failure of HVAC system
	Loss of power for a prolonged period
	Pests
	Structural deficiencies
	Water leaks
Societal related risks	Financial mismanagement
	Loss of institutional funding

TABLE 14.2. **Types of risk by frequency of occurrence and severity of effects (after Waller 1995).**

		FREQUENCY OF OCCURRENCE		
		Constant	Sporadic	Rare
SEVERITY OF EFFECTS	**Catastrophic**			Type I
	Severe		Type II	
	Mild/gradual	Type III		

TABLE 14.3. **Examples of situations resulting in increased risk to museum collections.**

SCALE OF RISK	EXAMPLES OF SPECIFIC SITUATIONS POSING RISK
High risk	Construction of new facilities (additions to the museum building)
	Renovation of existing museum spaces
	Removal of museum exhibits
	Installation of new museum exhibits
	Flood, high winds, tornados
Medium risk	Special events in the museum involving outside caterers, cooking or heating food in the museum, or insufficient security
	Improperly trained collections care staff
	Insufficient collections care staff
Low risk	Special events in the museum involving large numbers of people
	Undervaluation of the collections, leading to insufficient funding for collections care and management

SAMPLE POLICIES

Art Museum of Western Virginia Collections Management Policy, 1998

Insurance

Insurance is a further dimension of object care, providing for appropriate compensation to the Museum or a lender in the event of loss or damage. The Museum recognizes the financial impossibility of insuring the entire collection for its fair market value, and a need for balance between expenses of insurance and the obligation to provide protection against loss. With these factors in mind, AMWV shall not insure the permanent collection for less than the total value of the twenty-five most valuable objects in the collections, and shall strive to insure for the maximum probably loss. Outgoing and incoming loans must always be insured for their fair market value while off-premises, as determined by the lending party; custody loans shall be covered under the Museum's liability policy for gross negligence. Any deviations in established insurance policy or procedures may occur only with the director's approval and with the registrar's knowledge.

A. Documentation

The registrar shall keep records of the objects in the collection and their locations. Current market values for outgoing and incoming loans shall be recorded by the registrar in complete accessions or loan files, as shall records of any insurance claims.

B. Loss or Damage

Loss or damage of an object must be immediately reported to the registrar, curator, and director, and in the case of an incoming loan, the lender. Should the loss or damage be the result of theft or vandalism the head of security and Board president shall also be notified. The registrar is responsible for documenting the incident. If the director or lender decides an insurance claim should be filed, the registrar shall contact the insurance company. The registrar shall process all documentation necessary in filing the claim, and keep records in the object's file.

William Hammond Mathers Museum Collections Management Policies & Procedures, 2003

Security Policy

All collections of the Museum should be secure from vandalism and theft, whether in storage, on exhibit, or on loan to another institution. In addition, the Museum must provide its lenders with assurances of security for objects loaned for exhibition. Other policies and procedures regarding security are contained within the Museum's *Security Statement*.

Review of the exhibitions for safety concerns

A. It is the responsibility of all staff members to report exhibit situations that might lead to personal injury, object damage, or object theft.

B. The Registrar, in conjunction with Security reviews exhibitions for safety from theft and damage of objects owned by the Museum and objects on loan to the Museum.

C. If any objects are judged by the Registrar to be in unsafe exhibit situations, the Registrar has the authority to prohibit the exhibit of those artifacts and to close the exhibit until the artifacts are secure.

Risk Management Policy

Recognizing the public trust inherently placed in cultural institutions, the Museum has the responsibility to develop, implement, and maintain a disaster preparedness plan. This preparation is essential to recovery from potential hazards, including natural disasters, vandalism, theft, and mechanical system failure.

The plan seeks first to identify, and then eliminate or reduce risks to:

A. the Museum's visitors and personnel,

B. its permanent collections, and

C. its building.

James A. Michener Art Museum Collections Management Policy, 2001

Risk Management and Insurance

Prudent collections management requires identification and elimination of risks to the collections. JAMAM conducts periodic reviews of potential hazards including natural disasters, vandalism, theft, human error, mechanical or operational system failure, and deterioration. Insurance coverage is customary for collections on loan. Collections held in temporary custody, without a loan agreement or negotiated contract, are usually insured only while in the custody of the museum. Risk management and insurance are coordinated by the Registrar and the Director of Protective Services.

JAMAM has an established Emergency Preparedness Policy (EPP) that is updated annually by the Emergency Preparedness Committee. Personnel who are required to sit on the committee are the Director of Protection Services, Registrar, Preparator, and Curator of Collections. All JAMAM staff are provided with and are familiar with the EPP. The EPP outlines procedures and standards for collections security and safety, vulnerability assessment, and art handling procedures.

Incoming and outgoing registrarial processes are critical in controlling risks. They include inventory, condition reporting, and issuing receipts for every object upon entry and exit from museum premises or custody and before and after all transits. The museum has clear, accurate inventories of all artworks for which it is responsible.

The museum maintains a blanket fine-arts insurance policy. The policy is procured and administered by the registrar. The policy covers objects owned by JAMAM and on loan or deposit to JAMAM, a) on JAMAM premises, b) at any other location worldwide, and c) in transit worldwide, subject to certain limits. Objects are covered at fair market value. For high value exhibitions, additional insurance can be arranged if necessary to supplement the limits of the blanket policy.

INTELLECTUAL PROPERTY

Knowledge is now understood as the commodity that museums offer.

—Hooper-Greenhill (1992)

Intellectual property refers to products of human intelligence that are unique and have potential commercial value. This includes ideas, designs, inventions, literary works, unique names, industrial processes, computer programs, and so forth. Although museums always have had to protect their intellectual property, the popularity of the Internet has brought new attention to this issue. While the Internet provides museums with larger, worldwide audiences, it also greatly increases the speed and extent of the dissemination of information (particularly images), which increases the potential for misuse and abuse of intellectual property.

There are four general categories of intellectual property rights law:

- *Copyright* protects original works that exist in a tangible (e.g., physical) form, including literary, artistic, and architectural works. Copyright law governs the right to copy, distribute, and exhibit a protected work for a specific period of time. Although formal registration of copyright can facilitate its enforcement, it is not a prerequisite. Generally, the creator of a piece of intellectual property owns the copyright for a period of time. The particular copyright legislation the work comes under determines the time period that copyright is in effect. Copyright protections differ somewhat from one country to another.

- *Trademark* protects distinctive words, phrases, designs, or symbols (or combination of these) that identify and distinguish specific goods or services. Trademark protection varies from one country to another. Trademarks are acquired by commercial usage or by showing bona fide intent to use the mark in commerce.

- *Patent* law protects inventions, processes, and chemical compositions by granting to the patent holder the right to stop others from making, using, or selling the same thing without permission.

- *Trade* secret legislation protects information such as formulas, programs, or devices that confer value and competitive advantage in the marketplace.

Museums can have intellectual property in all four of these categories (see table 15.1), but are primarily concerned with copyright and trademark.

Creators of intellectual property can sell, license, or transfer all or a portion of their intellectual property rights to others, including museums. Because these rights are conveyed separately from the physical ownership of the work, a museum might own the intellectual property rights to a work but not the work, or own the work but not the intellectual property rights. A museum that does not own the intellectual property rights could have limited usage of the work. For example, it might be able to display an object in an exhibit without permission from the copyright holder but not to use its image in a catalog. Some of the most important intellectual property rights concerns regarding the use of museum collections include:

- Copyright
- Trademark
- Fair use
- Patents
- Trade Secrets
- Electronic use
- Images
- Licensing
- Reproductions
- Commercial use
- Credit lines
- Royalties and fees
- Privacy
- Visual Artists Rights Act

In general, copyright law gives the owner of the intellectual property control over the right of:

- adaptation (as a derivative work);
- reproduction (copying) of the work;
- distribution (of copies, sale, rental, loan, and so forth);
- performance;
- display or exhibition.

Copyright law includes provisions for *fair use* of copyrighted works. Fair use refers to ways that a copyrighted work can be used without obtaining permission from the copyright owner. Understanding fair use of copyrighted materials is important for properly managing information resources in museums. For example, if the nature of a copyrighted work is factual or conceptual, then fair use allows for:

- use of a small or insignificant portion of the work;
- usage for transformative purposes (such as scholarship, teaching, and exhibition); and
- usage that does not affect the market for the work.

Moral Rights

The Visual Artists Rights Act of 1990 (VARA) ensures that artists retain the right to have their works correctly attributed, maintained without alterations, and protected from destruction, even when another party owns the work. VARA rights cannot be transferred, but they can be waived, in part, by the artist, by means of a written and signed document.

Intellectual Property Rights Policy

Guidelines for developing an intellectual property rights policy are provided in table 15.2. In addition to these considerations, the policy usually balances the public's right to access the collections with legal restrictions on how works are used, particularly with regard to exhibition, the use of the facilities for commercial purposes, and who is allowed to photograph the collections and exhibits. Many policies address the ownership of copyright on writings produced by the staff, including papers, posters, creations, and constructions. In the absence of formal arrangements to the contrary, museums—like other employers—own copyright to all material produced by their staff members as part of their jobs. The policy might allow a staff member to retain copyright or routinely transfer it under certain circumstances (e.g., to share copyright on a scholarly article for a peer-reviewed journal).

Typically intellectual property rights policies also address:

- acquisition of copyright associated with objects that the museum accessions;
- specific permission for commercial use of objects or images of these objects that are borrowed from the museum; and
- the museum's commitment to respect and adhere to copyright, fair use, VARA, and other intellectual property rights laws.

References

Hooper-Greenhill, E. 1992. *Museums and the Shaping of Knowledge.* Routledge, London, ix + 232 pp.

Lind, R.C., R.M. Jarvis, and M.E. Phelan. 2002. *Art and Museum Law. Cases and Materials.* Carolina Academy Press, Durham, NC, xxiv + 718 pp.

Malaro, M.C. 1998. *A Legal Primer on Managing Museum Collections.* Second edition. Smithsonian Institution Press, Washington, D.C., xx + 507 pp.

Phelan, Marilyn E. 1982. *Museums and the Law.* AASLH, Nashville, TN, xi + 287 pp.

Phelan, Marilyn E. 1994. *Museum Law. A Guide for Officers, Directors, and Counsel.* Kalos Kapp Press, xiii + 471 pp.

Phelan, M. (editor). 1998. *The Law of Cultural Property and Natural Heritage: Protection, Transfer, and Access.* Kalos Kapp Press, 790 pp.

Shapiro, M., and B.I. Miller. 1999. *A Museum Guide to Copyright and Trademark.* American Association of Museums, Washington, D.C., 225 pp.

Vogt-O'Conner, D. 2000. Intellectual property rights chart. *Cultural Resource Management.* 23(5):61-65.

Zorich, D.M. 2003. *Developing Intellectual Property Policies: A How-to Guide for Museums.* Canadian Heritage Information Network, Ottawa. Available online at www.chin.gc.ca/English/Publications/developing_policies.html

TABLE 15.1. **Types of museum intellectual property a museum might own (after Zorich, 2003).**

COPYRIGHT	TRADEMARK	PATENT	TRADE SECRET
Educational materials	Public program name		
Images	Slogans	Hardware	Imaging techniques
Manuscripts, maps, and drawings	Publication name		
Multimedia works	Educational program name	Exhibit fabrication techniques	Business ventures
Museum website	Exhibit name	Designs	Computer programming
Objects in the collection	Museum name	Exhibit setups	Donor lists
Publications	Museum logo	Research processes	Marketing plans

TABLE 15.2. **Guidelines for developing an intellectual property rights policy (after Shapiro and Miller, 1999, and Vogt-O'Conner, 2000).**

ACTIVITY	APPLICATION IN A MUSEUM	POLICY GUIDELINES
Access to Collections	*Use of collections and reproduction of collections objects*	Require written permission for access to restricted objects.
		Alert researchers to copyright issues in the museum collections or collection information.
		Ensure that reproductions of collections objects are done in compliance with intellectual property right restrictions.
Collections Management	*Requirements for documentation*	Include in the deed of gift a statement regarding the status of any intellectual property rights received, particularly copyright.
		Document the intellectual property rights status of objects in the collections.
		Provide guidelines for researchers using the collections and collections information.
		Track down copyright owners to gain permission for use.
Contracts	*Development of intellectual property based on the museum collections*	Know copyright status of any work produced on contract in the museum.
		State any restrictions on the work in the contract.
Publishing and Exhibition	*Procedures*	Obtain permission to use material, if necessary (e.g., museums can exhibit copies of copyrighted works that they own).
		Be cautious about Internet distribution and access.
		Prohibit the exhibition, performance, or sale of unauthorized works in the museum.
Research	*Staff use of copyrighted material*	Avoid plagiarism.
		Avoid unnecessary copying.
		Avoid activities that do not comply with "fair use" standards.
		Acknowledge sources.
Rights Management	*Legal obligation of the museum*	Enforce the copyrights the museum owns or risk losing them.
		Notify users that the museum owns the copyright, where applicable.

SAMPLE POLICIES

James A. Michener Art Museum Collections Policy, 2001

[Under Acquisition section]

The Museum seeks to secure exclusive or non-exclusive copyright license on all acquisitions. Identifying copyright ownership often requires extensive research that JAMAM undertakes as an activity of the acquisition process. In general, the fair use doctrine of the 1976 Federal Copyright Act permits the museum to carry out its exhibition programs, even when the museum does not hold copyright or non-exclusive license. Unless the museum can document that it owns copyright, the museum cannot grant rights to reproduce objects in the collection for any other purpose. The acquisition of copyright is handled by the Registrar's Office when transfer documents are signed for new acquisitions.

New Mexico Museum of Natural History and Science Collections Policy, 1999

Museum Intellectual Property

Materials or items, including computer software, developed, written, designed, drawn, painted, constructed, or installed by staff while carrying out their responsibilities as employees of the Museum are considered to be the property of the Museum, with the Museum having the rights to all said property.

The Museum has the right to copyright, patent, or trademark materials produced by its staff while carrying out their job responsibilities as employees of the Museum when it deems it appropriate to do so.

The Museum is entitled to receive fees or royalties earned in conjunction with materials or items produced by staff while carrying out their job responsibilities as employees of the Museum.

The Museum actively encourages (and in the case of curators may require) publication of original, scholarly research results in peer-reviewed professional journals, books, and other media. In all cases, results of research conducted by Museum staff during Museum worktime will include the Museum's address as part of the author's affiliation.

The Museum's ownership of or rights to intellectual property that was created while an individual was affiliated with the Museum continues after the staff person leaves the Museum for any reason, including retirement.

Fair Use Policy

The New Mexico Museum of Natural History and Science is dedicated to providing knowledge and education through exhibitions, research, and educational outreach programs. The Museum is committed to complying with all applicable laws regarding intellectual property. This commitment includes full exercise of the rights granted to users of copyrighted works under the "Fair Use" provisions of federal copyright law.

A. The Museum will use due diligence in determining the copyright status of objects brought into the collections through gift, transfer, purchase, exchange, or objects lent for exhibition and will credit the copyright holder in all catalogs, pamphlets, press releases, or other educational publications.

B. The Museum shall inform and educate applicable staff concerning the guidelines of Fair-Use and the four factors contained in 17 U.S.C, Section 107, and legal decisions related thereto, which states that copyrighted material may be used or reproduced under special circumstances that constitute fair use. The Museum recognizes that determining fair use involves the weighing of interests. The interests relevant to fair use are:

1. The purpose and character of these, including whether such use is of a commercial nature or is for nonprofit educational purposes;

2. The nature of the copyrighted work;

3. The amount and substantiality of the portion used in relation to the copyrighted work as a whole; and

4. The effect of the use upon the potential market for or value of the copyrighted work.

The Museum reserves the right to evaluate requests for information and access to copyrighted collections on a case-by-case basis through the Curatorial Committee in conformity with State laws or regulations.

The Museum realizes the doctrine of fair use applies to the usage of intellectual property originating in the United States and may not be applicable in other countries.

ADDITIONAL COLLECTIONS STEWARDSHIP ISSUES

S everal collections stewardship issues are addressed in a museum's collections management policies. These include issues of rapid collection growth, repository agreements, acquisition of orphaned collections, and managing cultural property.

Management of Rapidly Growing Collections

The rapid growth of certain types of collections can lead to serious steward-ship issues. For example, a boom in field work—particularly from salvage archaeology contracts for the construction of highways or reservoirs—often generates a significant increase in archaeological materials. To ensure responsible stewardship for these collections, a museum can incorporate a number of measures in its collections management policies, including:

- establishing standard criteria for accepting collections;
- requiring grant-funded projects to pay for the storage and curation of the material they generate;
- requiring the transfer of some of the collections to government agencies;
- transferring some collections to Native American groups (see NAGPRA, below);
- prioritizing curation of material based on the significance of the collections (e.g., a prioritized listing of archaeological sites from which material will be accepted);
- identifying other institutions that might accept certain types of collections.

Repository Agreements

Some museums act as repositories for outside groups or agencies by agree-ing to accept and care for collections that belong to other institutions. For example, a government agency might make an agreement with a museum

to care for collections made on federal lands. There is a growing trend for foreign governments to retain ownership of biological specimens that are in a U.S. museum for curation, care, and research purposes under the terms of a repository agreement. Sometimes under the terms of the repository agreement, the museum catalogs the specimens so that they and their data can be used effectively.

Collections management policies require repository agreements to be based on a written contract. The contract establishes the time period that the repository agreement is in effect, describes the minimum standards for the collections' storage environment, care, and management; defines the required staffing level of the repository institution; and states what compensation (if any) the museum will receive for the services it provides.

Orphaned Collections

Orphaned collections are those that have been abandoned by their owner or have lost curatorial support. Some orphaned collections are ignored; others are locked out of sight in an obscure storage room or re-allocated to a dumpster. Collections become orphaned for a variety of reasons: for example, the person in charge of their care retires or quits and is not replaced or the collection's parent organization wants neither to pay for their upkeep nor to deaccession them.

Orphaned collections frequently languish in neglect for years before they are made available to another institution, so they should be evaluated carefully by a museum planning to adopt them. Many collections management policies require the costs of accessioning, cataloging, and storing orphaned collections to be calculated carefully, and some require that funding be obtained before the collections are accepted. It is recommended that the orphaned collections policy require evaluation of the:

- relevance of the collection to the museum's mission;
- preservation condition of the collections;
- quality of the marking of accession numbers or catalog numbers;
- quality of associated collections documentation;
- possible problems with title, cultural property issues, or intellectual property issues;

- availability of resources for the acquisition, processing, and housing of the orphaned collection.

Cultural Property

Some museums address the handling of cultural property in their collections management policies. Cultural property refers to objects that are designated by a nation or group as having unique importance for historical, cultural, or religious reasons, and can include sacred objects and human remains. Cultural property considerations affect:

- acquisition of collections;
- ownership of the objects in the collections;
- outgoing and incoming loans;
- deaccession decisions;
- repatriation of objects in the collections.

Cultural property concerns can be broadly divided into two issues; ownership and collections management.

Historically, ownership of cultural property was not a major concern of museums. Many objects currently in museum collections were acquired without proper regard for the rights or desires of other cultures. However, as the profession has developed, there have been sweeping changes in how cultural property is handled. In addition, many countries have enacted legislation to limit or prohibit the export of their cultural property and to repatriate cultural property in museums outside their borders. It is strongly recommended that the cultural property policy require provenance research to be conducted into the history of incoming acquisitions, loans, and objects being considered for deaccession to make sure the museum does not violate cultural property legislation (Yeide *et al.*, 2001).

The most significant legislation affecting the international movement of cultural property is the Convention on the Means of Prohibiting the Illicit Import, Export and Transfer of Ownership of Cultural Property (see appendix C, "Laws and Legislation"). This convention focuses on cultural property obtained without permission and later sold or imported into other countries (O'Keefe, 1998). Although it was ratified by the U.S. Senate in 1972, the implementing legislation was not passed until 1983. The

implementing legislation makes cultural property subject to seizure if imported into the United States in violation of the act; thus it can affect the import, export, loan, or transfer of objects between museums.

Some museum policies govern collection objects taken illegally from their owners during the Nazi era (American Association of Museums, 2001a), which has been identified by AAM as an ethics issue of paramount concern. It is strongly recommended that museums develop policies to address this issue in accordance with AAM's *Guidelines Concerning the Unlawful Appropriation of Objects During the Nazi Era* (American Association of Museums, 1999).

The most significant domestic cultural property legislation is the Native American Graves Protection and Repatriation Act or NAGPRA (American Association of Museums, 2001b). This legislation requires the repatriation of Native American human remains and some cultural property (see appendix C, "Laws and Legislation").

The cultural property policy ensures that the museum does not acquire objects prohibited by law and is sensitive to the requirements of the creators (or their descendants) about how certain objects are managed in the collections. For example, some Native American sacred objects require "spiritual care" such as periodic offerings of cornmeal or tobacco, or ritual cleansing with sage smoke. Some objects of cultural property have restrictions on their access and use. The Makah Cultural Research Center has an archive of recorded oral histories, but the recordings are only available with the specific permission of a tribal elder. This restriction is necessary because some tribal knowledge cannot be shared with non-tribal members (Simpson, 2001). At other museums, certain ethnographic objects must be handled in specific ways to show respect for their makers, to protect the community they came from, or to protect the museum staff. For example:

- Navajo medicine bundles cannot be exhibited;
- Hopi elders caution that it is dangerous for pregnant women to work with kachinas (Simpson, 2001).

References

American Association of Museums. 1999. *Guidelines Concerning the Unlawful Appropriation of Objects During the Nazi Era*. American Association of Museums, Washington, D.C.: www.aam-us.org/museumresources/ethics/nazi_guidelines.cfm.

American Association of Museums. 2001a. *Museum Policy and Procedure for Nazi-Era Issues*. Resource Report, American Association of Museums, Washington, D.C., 150 pp.

American Association of Museums. 2001b. *Implementing the Native American Graves Protection and Repatriation Act* (NAGPRA). Resource Report, American Association of Museums, Washington, D.C., 250 pp.

Lane, M.A. 2001. The homeless specimen: handling relinquished natural history collections. *Museum News* 80(1):60-63; 82-83.

O'Keefe, P.J. 1998. Museum acquisitions policies and the 1970 UNESCO Convention. *Museum International* 50(1):20-24.

Simpson, M.G. 2001. *Making Representations. Museums in the Post-Colonial Era*. Revised edition. Routledge, London, xi + 336 pp.

Thomson, R. 2000. The crisis in archaeological collection management. *Cultural Resources Management* no 5:4-6.

Yeide, N.H., K. Akinsha, and A.L. Walsh. 2001. *The AAM Guide to Provenance Research*. American Association of Museums, Washington, D.C., 304 pp.

SAMPLE POLICIES

Museum of the Rockies, Montana State University, Collections Policy Manual, 1998

Cooperative Curation Agreements

The Museum of the Rockies may serve as a repository for collections from public agencies or private corporations with government contracts who do not have curatorial facilities or staff trained to work with collections. Agreements may be arranged between such parties and the Museum of the Rockies to curate their collections. These agreements must be made in writing and bear the signature of the authorized institutional official and the Museum Director. Copies are filed in the appropriate section and the Museum Director's office.

Under terms of a cooperative curation agreement, the Museum of the Rockies may agree to:

- Inventory and function as a repository for materials and accompanying documentation resulting from research or other collecting activities that were carried out or sponsored by the applicant institution with the provision that the specified materials do not violate the Museum's acquisition policy. Unless specified otherwise, the collections become the property of the Museum of the Rockies and are managed according to the Museum's collections policies. If the agreement is with a Federal agency, ownership remains vested with the US government.

- Provide reasonable environmental storage conditions and security.

- Maintain the right to accept or reject any collection due to its size, nature, or lack of adequate documentation.

- Provide space for studying the collection with advance notification.

Under terms of the agreement, the applicant institution must agree (unless explicitly waived by the Museum Director) to:

- Transfer specimens or objects, field records, maps, photographic negatives, and/or other documentation pertaining to the collection and its context to the Museum of the Rockies.

- Provide all pertinent provenance and/or contextual data concerning the material to be curated, specifically including the date of acquisition, individual who acquired the item(s), specific legal locations, and any state registry designation (e.g., archaeological site number).

- Allow study and exhibition of the collections in accordance with the Museum of the Rockies policy.

- Supply the Museum of the Rockies with a copy of the final report of reconnaissance or investigation for the project from which the collection originated within not more than one year of the date of the receipt of the collection.

- Be responsible for the costs of entering the collection into the Museum's system. These costs include monies for accessioning, cataloging, boxing, filing, and maintaining environmental and security controls. Materials should arrive clean and clearly labeled or in containers that are clearly labeled.

Currier Museum of Art Collections Management Policy, 1997

[name change effective 2005; formerly Currier Gallery of Art]

Native American Graves Protection and Repatriation Act

The Gallery, as a museum holding Native American materials and which has received funding, direct and indirect from the federal government, willingly recognizes its responsibility to comply with Public Law 101-601, The Native American Graves Protection and Repatriation Act (NAGPRA), passed by Congress on November 16, 1990. Under this law, museums are obligated to inventory and summarize all human remains, "associated funerary objects, unassociated funerary objects, sacred objects and cultural patrimony." If such objects are held by a museum, the museum is required to return the objects to the appropriate tribe, if indeed the tribe desires their return.

As of this writing, the Gallery holds no Native American material which appears to be covered by NAGPRA. However, should the Gallery be the recipient of a gift of

a protected object in the future, it shall comply with all requirements of disclosure, consultation with Native American groups, and if necessary, repatriation.

See the full text of NAGPRA for specific descriptions of protected objects as well as federal requirements.

Sam Noble Oklahoma Museum of Natural History, University of Oklahoma Collections Management Policy, 2002

Policy on Culturally Sensitive Material Subject to NAGPRA and Repatriation

On November 16, 1990, Congress enacted Public Law 101-601, Native American Graves Protection and Repatriation Act (NAGPRA). The Act's purpose is to protect Native American burial sites and to regulate the removal of human remains, funerary objects, sacred objects, and objects of cultural patrimony that are located on federal, Indian, and Native Hawaiian lands. The Act provides a process for the return, upon request of certain cultural items to Native Americans, makes illegal the trafficking of those items, and sets forth procedures for the control of their excavation.

The Sam Noble Oklahoma Museum of Natural History (SNOMNH) is most affected by those sections of NAGPRA that establish a process for the repatriation of certain cultural items now held by federal agencies and museums that receive federal funds.

The SNOMNH is in full compliance with the Native American Graves Protection and Repatriation Act (NAGPRA). A comprehensive summary of the museum's cultural items of potential sacred objects, objects of cultural patrimony, and unassociated funerary objects was sent to all 331 federally recognized tribal contacts in the 48 contiguous states, plus 13 Native Alaskan Corporations, 7 Native Hawaiian Organizations, and the National Park Service by the federally mandated deadline of November 16, 1993. Inventories of human remains and associated funerary objects and initial consultations were completed and sent to the appropriate tribes and to the National Park Service by the federally mandated deadline of May 16, 1996. The SNOMNH

also is committed to take the initiative to compile any further inventories and document relevant data pertinent to its Native American materials.

The SNOMNH supports the purposes, objectives, and spirit of this Act, and affirms its resolve to abide by and work within the provisions as set forth in the law. The following will govern our work in compliance with NAGPRA:

1. The University of Oklahoma and the Sam Noble Oklahoma Museum of Natural History have a fiduciary responsibility for the care and interpretation of all the collections. The SNOMNH recognizes that respect for the human rights of Native Americans means it has an extra responsibility in regard to those collections that are considered sacred or of cultural patrimony by Native peoples, and for human remains and associated and unassociated funerary objects.

2. The SNOMNH will strive to resolve questions of the disposition and treatment of sensitive materials with consultations between the Museum and all interested Native American groups. Where issues remain after good faith consultations, an attempt will be made, to the extent permitted by the NAGPRA, to settle these issues through mutually agreed upon processes of mediation or arbitration.

3. The SNOMNH will not knowingly acquire any object whose ownership or legality in this state or country is questionable or whose circumstances of collection are unethical or contrary to the goals and/or good practices of the SNOMNH or the museum profession in general.

4. No culturally sensitive archeological or ethnographic materials, documented or undocumented, will knowingly be purchased by the Museum. Furthermore, all prehistoric materials offered to the Museum for donation will be scrutinized carefully in an attempt to avoid the encouragement of unethical collecting practices or the trafficking in the prehistoric materials and the illicit looting of prehistoric sites.

5. It is not the policy of the SNOMNH to collect or exhibit human remains of Native Americans. The SNOMNH will adhere to the provisions of Section 3(b), 3(c) and 3(d) of Public Law 101-601.

6. To the fullest extent possible, the SNOMNH will consult with the living cultural groups regarding ownership, consent, and treatment issues before deciding whether to acquire potentially sensitive material related to those groups. There may be cases where the Museum may be asked by a tribe to acquire sensitive materials (perhaps as a loan) in order to act as an agent for their return to the culturally affiliated group.

7. The SNOMNH will supply relevant information concerning cultural items on request to appropriate Native American authorities. If the requested information is estimated to require some time to compile, the SNOMNH will respond promptly with an indication of the estimated time frame. The SNOMNH also may provide physical access to objects in accordance with the Museum's Collections Management Policy regarding access to collections.

8. The repatriation of cultural items by the SNOMNH will be made in accordance with the provisions of Section 7 of Public Law 101-601.

9. The SNOMNH is interested in forming stewardship agreements on a case-by-case basis with tribes who have materials appropriate for repatriation, but who may wish the museum to maintain the materials in trust until such time as the tribe designates.

10. The SNOMNH recognizes the obligation to interpret/exhibit cultural items with accuracy, sensitivity, and respect for their relationship to the cultures of Native peoples. Dialogue with the appropriate NAGPRA representative of the culturally affiliated group(s), and the Museum's Native American Advisory Committee will occur as needs arise to attempt to represent fairly and objectively the beliefs and view points of Native peoples, especially where ceremonial and religious objects are concerned. The need for meaningful dialogue is especially critical when these sensitive materials are proposed for exhibit.

11. The SNOMNH recognizes that responsibility for NAGPRA-related items is one of co-curatorship. Loan requests involving such objects will not be granted without permission from the culturally affiliated group. The potential borrower must consult directly with the government appointed tribal NAGPRA representative for permission, and for any specific appropriate care and exhibition requirements. Further, the lender must meet SNOMNH's stringent guidelines for out-going loans in accordance with the Museum's Collections Management Policy.

CHAPTER 17

ETHICS

The concept of a standard of conduct or code of ethics for museum professionals was articulated first by Smithsonian Secretary George Brown Goode in 1892. Such a standard of conduct, Goode later wrote, would include "notions of correct and ethical behavior and duty" (Goode, 1901). However, it wasn't until 1925 that the American Association of Museum published its *Code of Ethics for Museum Workers*, which was based on practical wisdom and experience. The code was revised in 1987 and 1994 to reflect "the value system of the museum profession as it had developed from the late nineteenth century" (Macdonald, 1991). The most recent version, AAM's *Code of Ethics for Museums* (2000), states that "Museums and those responsible for them must do more than avoid legal liability, they must take affirmative steps to maintain their integrity so as to warrant public confidence. They must act not only legally but also ethically."

What Are Ethics?

Morals and ethics often are confused. *Ethics* are based on experience and concern the distinction between right and wrong and how that distinction is applied to language, behavior, and thought. Ethical codes evolve in response to changing conditions, values, and ideas, which is why professional codes are reviewed and revised periodically. By contrast, *morals* are based on an individual's abstract opinions or beliefs. It is possible to be moral without being ethical, and to be ethical without being moral. For example, a moral code might require not betraying a friend while an ethical code requires reporting the friend for including fraudulent information in an accession record.

The Role of Ethics in the Museum Profession

The primary purpose of a museum code of ethics is to raise the level of professional practice. Maintaining professional ethics strengthens the role

and responsibilities of museums in society; it has been said that a museum's values or standards are the same as its ethical values and standards. A professional code of ethics determines the common ground for maximizing shared values and provides a means for resolving differences. As Gary Edson notes in *Museum Ethics,* "In a practical sense, ethics is necessary as a moderating factor between the extremes of intellectual control and impulse."

Ethics guide the conduct of individuals. A group is only as ethical as its individual members choose to be. Likewise, a museum cannot be ethical, but its staff can be. However, it is important to remember that the behavior of individuals can have a dramatic effect on the perception of a group or an organization. An institution's reputation can be tarnished by just one or two staff members acting unethically. Because individuals identify with several different groups (the museum profession, their own specialty, the particular museum), different types of ethical codes affect collections management. In general, three types of ethical codes guide the behavior of museum professionals:

- Professional codes of ethics for museum staff, volunteers, and members of the governing authority, derived from a consensus of the general museum profession (e.g., AAM's *Code of Ethics for Museums,* or the *ICOM Code of Ethics*). These codes of ethics outline general principles for museum professionals.

- Codes of ethics for people practicing particular disciplines or professions, formed by a consensus of the profession, such as the *Code of Ethics for Registrars* (Buck and Gilmore, 1998).

- Institutional codes of ethics for the staff, volunteers, and members of the governing authority. These codes are consistent with the professional codes for museum professionals but are tailored to a museum's particular values and circumstances and approved by its governing authority. Institutional codes of ethics regulate the behavior of the members of the museum's governing authority, staff, and volunteers. To be accredited, a museum must have its own institutional code of ethics rather than merely adopt or endorse the field-wide professional codes of ethics (*The Accreditation Commission's Expectations Regarding Institutional Code of Ethics,* 2004). In

> ### ⊙ WHEN POLICY MEETS REALITY
>
> Ethics policies apply to volunteers as well as paid staff. A Los Angeles museum had to cope with a volunteer gallery guide who added her own interpretation to a sculpture consisting of a 1938 Dodge, a couple in passionate embrace, and some empty beer cans. The guide told a group of fifth-grade girls that the sculptor wanted to show that first sexual experiences should be meaningful, special, and beautiful. The administration's position was that the museum should not be teaching "religion or sex education".

addition to covering individual conduct (e.g., conflict of interest, personal collecting), the Commission specifies that the code of ethics must address the institution's basic ethical responsibilities as a museum and a nonprofit educational entity.

From time to time, there may be a conflict among codes of ethics for the general profession, the specific discipline, and the institution. For example, an institutional code of ethics allows the museum to rent an exhibition of artifacts salvaged from a shipwreck while the archaeologists' code of ethics does not. In such cases, it is recommended that the affected staff members meet as a group to discuss their respective codes of ethics and look for resolution or common ground on which to build resolution. In some cases, it may be appropriate to bring in an outside, neutral mediator or ethicist to facilitate the discussion.

The Ethics Policy

Each museum develops and adopts a code of ethics that is appropriate for its operations, addresses the circumstances and issues that it faces, and requires adherence from staff, volunteers, and all members of the governing authority. Most museums in the United States base their code of ethics on AAM's *Code of Ethics for Museums;* some also refer to relevant discipline-specific codes of ethics or combine parts of different codes. In any case, the ethics policy makes reference to and is in agreement with the code or codes adopted by the institution.

Some institutional codes of ethics include standards that are not in the professional or discipline codes of ethics. For example, the institutional code might:

- prohibit the sale of certain materials in the museum store (such as original artwork by artists represented in the museum's collection, or fossils and animal parts);

- mandate the confidentiality of collection records that would endanger sensitive habitats or endangered species;

- restrict the amount of restoration or conservation work that can be done on objects in the collection;

- or prohibit the commercial use of objects from the collection by for-profit entities.

Collections management issues addressed in the museum's ethics policy include:

- collecting
- conflicts of interest
- personal collecting and personal collections
- use of personal collections by staff, volunteers, or board members in museum exhibitions
- storage of personal collections in the museum
- acquisition by staff, volunteers, or board members of material deaccessioned from the collections
- appraisals and authentications
- personal activities

Collecting

The ethics policy ensures that collecting activities do not have undesirable consequences. For example, the policy might state that collecting cannot:

- harm the environment;

- damage the indigenous culture that made an artifact;

- influence the commercial market in an inappropriate way (e.g., some natural history museums will not purchase fossil material because that could encourage the commercial exploitation of fossils).

Conflicts of Interest

The code of ethics states that in matters relating to business and professional activities members of the governing authority, staff, and volunteers have an obligation

to put the organization's interest above their personal interests. In general, they are expected to act in a way that will benefit the organization. As part of the collections management policy, this means that the members of the governing authority, staff, and volunteers do not compete with the museum for limited resources or for acquisitions, or build the collections in a manner that serves their private interests rather than the institution's objectives.

◉ WHEN POLICY MEETS REALITY

Suppose a board member or volunteer from the Local County Historical Society attends an antique sale, and buys a clock that is documented as having been used in the former governor's mansion. The Local County Historical Society owns and interprets the mansion as a museum. The board member or volunteer now has collected an artifact that the museum may want or need for its collection; thus there is a conflict of interest. To resolve the situation, the historical society can offer to buy the clock at the same price the board member or volunteer paid or try to convince the person to donate it.

Personal Collecting

Most museums prohibit staff from collecting material that falls within the scope of their professional expertise or the scope of the museum. Other institutions allow certain staff members to build personal collections in their areas of expertise as a form of professional development. The policy on personal collecting must be handled carefully as personal collecting easily can lead to an actual or apparent conflict of interest. Policies at museums that allow personal collecting usually state that the institution must be given the right of first refusal on anything the staff member acquires; some require staff members to submit regular inventories of their personal collections to the governing authority. A number of museums extend these provisions on personal collecting to cover board members and volunteers.

Use of Personal Collections

Many policies stipulate whether and under what circumstances collections owned by members of the

governing authority, staff, and volunteers can be used in the museum, particularly for exhibition. For example, displaying a board member's personal collection can be seen as serving that person's personal interests, particularly if the exhibition enhances the collection's value. On the other hand, a board member or staff member might formally loan a personal collection to the museum for an exhibition that would be of great benefit to the institution. A clear policy on the use of personal collections establishes a framework for making these decisions and explaining them to the public.

Storage of Personal Collections

The policy usually states that members of the governing authority, staff, and volunteers cannot store their personal collections at the institution, with the possible exception of objects used for a museum-related purpose, such as education or exhibition. Allowing private collections to be stored at the museum puts it in the position of being liable for those collections, raises issues of conflict of interest, and is an inappropriate use of collections care resources. If exceptions must be made to this policy, the privately held objects can be documented and handled as an incoming loan.

Acquisition of Deaccessioned Collections

Most museums prohibit members of the governing authority, staff, and volunteers from acquiring material deaccessioned from the institution's collections or, at the very least, place limits on the conditions under which they can do so. For example, staff members might be allowed to acquire deaccessioned objects by participating in a public auction as long as they have no special advantage in the process. This prohibition also is in the policy dealing with the disposition of deaccessioned collections (see chapter 8, "Deaccessions and Disposal").

Appraisals and Authentication

Typically the ethics policy states that members of the governing authority, staff members, and volunteers cannot make appraisals or authentications of objects that the museum might acquire, other than internal appraisals that are part of the acquisition and accession processes. (See chapter 7, "Acquisitions and Accessions," and chapter 18, "Appraisals, Identifications, and Research Services.")

Personal Activities

Most ethics policies state that even when staff are acting on their own behalf and outside work hours, they must conduct themselves in a way that reflects well on the museum and the museum profession. Some policies set guidelines for staff that clearly differentiate their personal from their museum work activities, to avoid the impression that their personal activities carry the museum's sanction or endorsement.

References

The Accreditation Commission's Expectations Regarding an Institutional Code of Ethics. Washington, D.C.: American Association of Museums, 2004.

Buck, R.A and J.A. Gilmore (editors). 1998. *The New Museum Registration Methods.* American Association of Museums, Washington, D.C., xvii + 427 pp

Code of Ethics for Museums. Washington, D.C.: American Association of Museums, 2000; www.aam-us.org.

Edson, G. (editor). 1997. *Museum Ethics.* Routledge, London, xxiii + 282 pp.

Goode, G.B. 1901. A memorial of George Brown Goode with a selection of his papers. *Smithsonian Annual Report for 1897*, part II. Washington, D.C., 515 pp.

Guy, M.E. 1990. *Ethical Decision Making in Everyday Work Situations.* Quorum Books, London.

International Council of Museums. 2004. *ICOM Code of Ethics.* http://icom.museum/ethics.html

Macdonald, R.R. 1991. Developing a code of ethics for museums. *Curator* 34(3):178-186.

Malaro, M.C. 1998. *A Legal Primer on Managing Museum Collections.* Second edition. Smithsonian Institution Press, Washington, D.C., xx + 507 pp.

Rose, C. 1985. A code of ethics for registrars. *Museum News* 63(3):42-46.

SAMPLE POLICIES

Ella Sharp Museum Collections Policy, 1998

Ethics of Collecting

The Ella Sharp Museum endorses and is in compliance with all laws, regulations and policies governing the acquisition, ownership and maintenance of cultural property. The Ella Sharp Museum will not knowingly accept any artifact illegally imported or collected in the United States, or whose acquisition would encourage illegal traffic or damage to archaeological sites or cultural/natural monuments. The Ella Sharp Museum will not collect artifacts with unsatisfactory or questionable provenance.

Indiana State Museum and Historic Sites Collections Management Policy

Personal Collecting

The acquiring, collecting and owning of objects is not in itself unethical, and can enhance professional knowledge and judgment. Professional ethics preclude ISMHS representatives from purposefully interfering with its lines of communication leading to acquisition, or with the flow of artifacts to ISMHS, for their own personal or financial benefit. Furthermore:

1. No representative of ISMHS may compete with ISMHS in any personal collecting activity.

2. Employees must disclose, in writing, to the CRC all circumstances regarding personal collecting undertaken prior to employment and when any changes occur thereafter. This need not be an item-by-item inventory. A descriptive paragraph is sufficient.

3. ISMHS has the option, for a six-month period, to accept or acquire any objects purchased by an employee of ISMHS that is sought in collecting strategies (See acquisition policy). ISMHS may acquire the object at the same price plus any transportation costs incurred by the employee. The employee shall submit written notification to the chairperson of the CRC and the executive director within 30 days of purchase. The institution's option period shall commence with the actual reporting of the purchase. The executive director will make final disposition.

4. A representative of ISMHS who purchases or collects readily available retail items or otherwise acquires objects that appear to be generally available to ISMHS is not considered to be in competition with ISMHS for a limited resource.

5. Any specimen(s) derived from the personal studies of scientific staff shall be offered as a donation to ISM at the completion of that study. This will require a letter of intent to donate upon disclosure.

6. The right of ISMHS to acquire from employees objects collected personally shall not extend to objects that were obtained (a) prior to the date of affiliation with ISMHS or (b) prior to the date of the adoption of this policy.

7. Bequests and personal gifts to representatives of ISMHS from family members or close friends are exempt from the institution's option to acquire. However, this information should be disclosed if it could appear to be a conflict of interest.

8. Representatives of ISMHS are discouraged from receiving personal gifts from artists, gallery owners, dealers, vendors, private collectors, lenders, borrowers, donors, or any business associated with ISMHS. A representative of ISMHS who receives negligible promotional or complimentary items does so at the risk of an inquiry into a possible conflict of interest.

9. Once ISMHS has declined to acquire an object it may not again exercise an option to acquire the same object unless the owner wishes to dispose of it. Notification of declination shall be in writing from the CRC.

10. Representatives of ISMHS should confer with collections curators for details concerning collecting strategies.

Professional Relationships

1. Employees shall not use their title or affiliation with ISMHS to derive any profit or gain (including personal favors, gifts, or commissions) directly or indirectly.

2. Employees are prohibited from dealing in collection materials that are similar to ISMHS collections (dealing is defined as the regular buying and selling for personal profit). However, they are permitted the opportunity to improve or "upgrade" their personal

collections through occasional trades, sales and purchases, but these must be disclosed, as defined under personal collections.

Consulting

All employee-consulting activities should receive prior written approval from the director of collections and interpretation and the executive director (consulting is defined as performing professional services on one's own time with financial compensation). Other representatives of ISMHS are expected to notify their immediate supervisor of museum-related consulting activities.

Honoraria and Royalties

1. Employees of ISMHS cannot receive honoraria for speaking engagements or royalties from publication where: (1) the content is derived from the job, (2) the expertise was developed on the job, or (3) the representative is acting in an official capacity. If this activity is not undertaken on state time, and is not being reimbursed by the state, however, the employee may accept mileage and expense reimbursement from the sponsors.

2. The Indiana State Museum Foundation, historic sites friends groups and the Indiana State Museum volunteer organization accept contributions dedicated to the support of ISMHS activities.

Profit from Exhibition

Employees shall not use their position or privileged information to intentionally derive profit or gain to themselves, outside individuals, groups or businesses.

Plains Art Museum
Collections Management Policy, 2003

Ethics

The Plains Art Museum conforms to the Code of Ethics adopted by the American Association of Museums (AAM), several areas of which pertain to collections management; refer to Section 6.6, appraisals; and section 2.2 and 3.1), accessioning and deaccessioning. As a non-profit institution, the museum also complies with applicable local, state, and federal laws, international conventions, and specific legal standards governing trust responsibilities.

.1 Staff Obligations to the Museum Collection
Members of the staff are obligated to the public which the museum serves to carry out their activities and responsibilities with the museum's ultimate purpose of public service in mind and will not use the museum or its collection for personal profit or advancement of personal pursuits outside of the museum.

.a Personal Collecting
All staff members will not compete with the museum's collecting activities and will conduct their personal collecting activity in an ethical manner.

(1) It will be the responsibility of the museum to put forth a list of art works which it is trying to collect so that staff, board and advisory group members are adequately informed. A written plan will be distributed annually (at the beginning of the fiscal year) by the Vice President of Collections and Public Programs.

(2) Once informed, it will be the responsibility of staff, board, and advisory group members to inform the Vice President of Collections and Public Programs or President/CEO of potential acquisition conflicts and allow the museum the right of first refusal.

.2 Personal Objects Brought in the Museum

Museum staff are discouraged from bringing original works of art from their personal collections into the museum for storage or other non-museum related purposes. Personal collection works are allowed in the museum for the following purposes: gift approval, special exhibitions, display, study and/or office decoration. Personal collection objects brought in for gift approval, special exhibitions, or display may be kept in the designated art storage areas. Personal collection works brought in for office decoration or study purposes may not be kept in designated art storage areas.

The museum will insure only those personal collection objects that are on the premises for gift approval, display or special exhibitions. The museum will not insure works brought in for study or office decoration.

Sam Noble Oklahoma Museum of Natural History, University of Oklahoma Collections Management Policy, 2002

Ethics

All Museum staff must adhere to the Code of Ethics of the Museum (1998). Staff with faculty appointments must comply with restrictions in the Faculty Handbook of the University of Oklahoma. Other staff must comply with the Staff Handbook of the University of Oklahoma.

A. Personal Collecting

Personal collecting is a special case within the Museum's Code of Ethics. Acquiring, collecting, and owning items is not in itself unethical, and can enhance professional knowledge and judgment. However, acquisition, maintenance, and management of a personal collection can represent a conflict of interest. Therefore, the Museum prohibits active acquisition of items that compete with collection priorities within a staff member's discipline for personal use through purchase, gift, trade, sale, loan, exchange, field collection, or other means unless such acquisitions are approved in writing by the Director.

The process of approval requires recommendations to the Director by the Associate Director of Collections and Research and could be subject to approval by the Board of Regents. The Museum affiliation cannot be used to promote personal collecting activities. Trafficking for profit of items similar to collection items is strictly prohibited. This policy is intended to eliminate competition between the Museum and its collections staff for acquisition of items.

This policy does not prohibit possession of personal collections acquired prior to accepting employment with the Museum. However, the following restrictions apply:

a. An appropriate inventory of private collections must be made and provided to the Associate Director of Collections and Research within 90 days of accepting employment. This inventory will be placed in the personnel file of the individual.

b. Private collections cannot be maintained on Museum property without permission of the Director.

c. Museum supplies, equipment, and paid staff time cannot be devoted to private collections.

APPRAISALS, IDENTIFICATIONS, AND RESEARCH SERVICES

❝For what is worth in anything, But so much money as 'twill bring. ❞
—Samuel Butler, *Hudibras*

To obtain information about objects they own, members of the public often seek access to museum expertise in the form of:

- appraisals (what is this worth?)
- authentication (is it real?)
- research (what is it? what is its significance?)
- the information in its library or archives

A museum has to balance making its staff expertise available to the public against people using its information inappropriately or taking up too much of the staff's time.

Appraisals

An appraisal is a judgment about what something is worth. Museums use appraisals to establish value for insurance, an object going out on loan, a damaged object, a potential purchase, or to advise a donor about the tax deductibility of a donation (see chapter 7, "Acquisitions and Accessions."). The collections management policy specifies who within the museum can perform appraisals, for whom, and for what purpose. This policy is shaped by several legal and ethical constraints.

Appraisals for outside parties other than donors. Some professional codes of ethics prohibit museum staff from making appraisals for any outside party, even those who are not donating to the museum. The *Curators Code of Ethics,* for example, says that while curators can estimate value for insurance purposes and internal use, they must not "prepare appraisals for gifts, objects to be deaccessioned, private purchase and sale, or any other reason." On the other hand, the *College Art Association Code of Ethics for Art Historians and Guidelines for the Professional Practice of Art History* (1995) does not prohibit art historians from conducting appraisals, though it does warn about the hazards of providing appraisals and specifies what kinds

of fees may be charged. It is a good idea for a museum developing a policy concerning appraisals for outside parties to refer to the ethical standards that govern its particular discipline and professional staff.

Internal appraisals are less controversial, as they are necessary for the day-to-day management and proper stewardship of the collections. A museum might need an internal appraisal, for example:

- when the value of an object is in question;
- when two or more appraisals of the same object vary widely;
- to determine the value of an object for insurance purposes;
- to determine the value of an object for loan purposes;
- where there is no previous evaluation of the worth of an object;
- when considering an object for deaccession or disposal. (Note, however, that the *Curators' Code of Ethics* categorizes appraisals for the purpose of deaccessioning as ethically suspect.)

The collections management policy usually establishes guidelines that determine when to use appraisals and how to hire appraisers. Some museum policies require:

- a written contract ("letter of commission") between the museum and an appraiser that governs the scope of the appraiser's duties and establishes conditions of performance;
- that the museum deal with accredited members of appraisal associations and follow the *Uniform Standards of Professional Appraisal Practice* (published by the Appraisal Foundation).

Authentication

Museums usually prohibit staff from rendering formal opinions about the authenticity of objects the institution does not own. This protects the museum from potential litigation. On the other hand, largely inspired by the popularity of the PBS program *Antiques Roadshow,* many museums hold events at which members of the public can receive informal (i.e., verbal) opinions regarding an object's identification and authenticity. It is prudent for

● WHEN POLICY MEETS REALITY

Appraised values can be very misleading or just outright wrong.

- In 1996, the pre-sale estimate for a collection of antiques, artwork, and personal objects that had belonged to Jackie Onassis was $5 million. The objects were by no means the best that Ms. Onassis had owned. At auction, the collection sold for a total of $34,457,470.

- There can be a fine line between priceless and worthless. A mollusk called *Strombus listeri* has long been popular with shell collectors. One *Strombus listeri* specimen was part of the original collection of Tradescant's Ark, which eventually became the collection at Oxford University. It was illustrated for the first time in 1685 and became the type specimen for the species when it was named by Thomas Gray in 1852. When this rare and valuable specimen was exhibited during a convention of malacologists (people who study sea shells) in the 1980s, it was crushed when the exhibit case was knocked over. How much was the shell worth? At one time, it was considered one of the rarest sea shells in the world but it is now common on the market. On the other hand, its historical value made it irreplaceable. The insurance settlement determined that its value as example of the species was $15; its value as a holotype was $150; its historical value was $5,835 dollars; and the charge for restoration was $1,500. Thus an object of "irreplaceable value" came to be worth $7,500.

museums to distribute disclaimers, or require participants to sign disclaimers, regarding the nature and accuracy of information provided in this way. Likewise, the policy can state clearly whether the museum staff is allowed to do authentications for the public and, if so, under what restrictions (e.g., verbal authentications only; authentications only at authorized museum events, etc.).

Research Services

Some museums provide research services for the public (e.g., staff conduct research in the museum's library or archives to answer specific questions from the public). The policy can specify whether such services are offered and, if so, whether there are constraints on who can receive these services (e.g., museum members, members of groups affiliated with the museum, the general public). If research services are offered, the policy might address whether fees are charged and, if so, to whom.

References

American Association of Museums Curators Committee. 1996. *The Curators' Code of Ethics.* www.curcom.org/ethics.php.

Appraisal Foundation. 2005. *Uniform Standards of Professional Appraisal Practice.* http://appraisalfoundation.org/html/USPAP2005/toc.htm.

College Art Association. 1995. *Code of Ethics for Art Historians and Guidelines for the Professional Practice of Art History.* www.collegeart.org/caa/ethics/art_hist_ethics.html.

SAMPLE POLICIES

Henry Art Gallery, University of Washington Collections Management Policy

It is the policy of the Henry Art Gallery to advise donors to seek counsel on current federal tax regulations for non-cash gifts. Appraisals are the responsibility of the donor. Staff, trustees or others closely related to the museum are prohibited from making any appraisals.

Indiana State Museum and Historic Sites Collections Management Policy

Appraisals

1. No monetary or valuation appraisals, written or verbal, will be given by employees, except for internal ISMHS use (a) in providing an estimated value for objects to be purchased or deaccessioned or (b) for insurance loaned valuations of ISMHS artifacts.

2. Information on authenticity and quality may be offered but this service must be available equally to the public, other museums, and the business sector.

Sam Noble Oklahoma Museum of Natural History, University of Oklahoma Collections Management Policy, 2002

Appraisals and Identifications of Acquisitions and other Materials

An inherent conflict of interest exists if the Museum, its employees, or its representatives provide estimates to donors or potential donors of a donation's monetary value. Therefore, no staff will give appraisals for the purpose of establishing fair-market value of gifts offered to the Museum. Donors desiring to take an income tax deduction must have an independent appraisal made of the value of their gift.

The Registrar and/or appropriate Curator may assist donors in locating appraisers. Two or more professional appraisers must be identified.

Staff will not identify or otherwise authenticate any natural history specimens or cultural artifacts for other persons or agencies under circumstances that could encourage or benefit illegal, unethical, or irresponsible traffic in such materials. Identification and authentication may be given for professional or educational purposes and in compliance with the legitimate requests of professional or governmental bodies or their agents.

As a service to the public, Curators and staff may identify or authenticate items brought to the Museum by the general public.

Individuals wishing to leave items for identification on a temporary basis must first read and sign a form entitled "Receipt for Temporary Deposit." While the Museum will attempt to give the items the same care as items in the collections, the Museum will not guarantee the item(s) against damage, destruction, deterioration, loss, or any other deleterious change.

At the time of deposit, the Museum will set a reclamation date. Items must be reclaimed by the specified reclamation date. Items not claimed within 60 days after written notice from the Museum will be considered abandoned property and may be added to the collections or otherwise disposed of in accordance with Museum policy and the laws of the state of Oklahoma.

William Hammond Mathers Museum Collections Management Policies & Procedures, 2003

Temporary Custody Policy

The Mathers Museum accepts temporary custody of artifacts primarily for acquisition consideration, but also for other activities, including identification and conservation review.... Museum staff members are prohibited from authenticating and/or providing appraisals.

CHAPTER 19

POLICY REVIEW AND REVISION

Museums change as they grow and thrive, and their collections management needs evolve with those changes. Ideally, a museum will review its collections management policy thoroughly from time to time and revise it when necessary.

The policy revision process is similar to the process used to develop a new policy. The first step is to assemble a team that represents diverse viewpoints among the staff. A diverse team will best be able to conduct a thorough examination of a now-inadequate policy and make the necessary corrections.

Policy revisions are needed when:

- The policy is inadequate.
- The policy is no longer appropriate (it does not do what it is supposed to do).
- Professional standards change.
- New professional standards are recognized.
- The museum's mission changes.
- The museum changes its collections plan.
- The museum initiates new programs or activities that raise new policy issues.

Many museums regularly monitor how well the members of the governing authority, staff, and volunteers comply with policies. This is best done by analyzing the museum functions to detect any problems with acquisition, accession, loans, collections management, and so forth. Then when problems or failures occur, they are investigated to determine whether the policy or procedures are inadequate.

Policy Review and Revision

Typically the policy specifies who is responsible for monitoring compliance with collections management policies, how compliance is measured, and

how it is documented and reported. It calls for periodic reviews of museum policies on a regular, chronological basis (e.g., once every three years) or whenever a problem is detected. The policy also can specify who has the authority to assemble a review team and how the review and revision process will be conducted.

SAMPLE POLICIES

James A. Michener Art Museum
Collections Management Policy, 2001

Monitoring the Collections Management Policy

The Director designates that the Curator of Collections and the Registrar monitor compliance with the CMP. The Curator of Collections and the Registrar will collaborate with appropriate staff and periodically review the policy for effectiveness and flexibility, consider the changing nature of museum work and accommodate the variations as well as the routine applications of collections management. As appropriate, policy improvements are recommended to the Director, reviewed and approved by the Collections Committee.

Revising the Collections Management Policy

The Curator of Collections and Registrar identify when a formal CMP review and revision is warranted—usually every three years. Working with appropriate staff, volunteers, trustees and outside experts as necessary, the Curator of Collections and the Registrar submit proposed revisions to the Director.

Resource shortages are inappropriate grounds to recommend revisions to the CMP. Compliance is a professional obligation. If necessary, the Museum will reprogram allocations to meet CMP mandates

Reporting on Compliance with the CMP

The Curator of Collections and Registrar make a written report annually by January 31 to the Director on JAMAM's ability to comply with CMP mandates and distribute statistics related to collections activities in the museum. The report is reviewed by the Collections Committee, which recommends action on behalf of the Board of Trustees.

Internal Controls

The CMP, implemented by procedures, becomes the primary vehicle for internal control over collections activities.

Staff Responsibility

The Director ensures that the staff implements and complies with the CMP. Questions concerning the implementation of the CMP should be brought to the attention of the Curator of Collections and the Registrar in an appropriate and timely manner. High standards of integrity, competence, experience, and dedication to assigned duties are qualities expected of JAMAM's staff. The museum is committed to ongoing professional development activities that will allow staff members to expand their skills and knowledge of the vital discipline of collections management.

Currier Museum of Art
Collections Management Policy, 1997

[name change effective 2005; formerly Currier Gallery of Art]

Review and Compliance

Review of the CMP is necessary to maintain its validity and usefulness as guidance for the Gallery's staff and the Board of Trustees.

The Registrar shall recommend a review of the CMP by the CMP Committee (Director, Curator, Registrar and a member of the Board invited by the Director) when circumstances warrant action. In considering changes/additions to the Policy, the Committee shall be guided by current AAM guidelines. Any desired changes to the CMP should be submitted to the Registrar prior to the scheduled review.

The Registrar is responsible for monitoring the Gallery's compliance with the CMP and for annually reporting, in writing, to the Director the Gallery's ability to comply with the CMP mandates (no later than February 1 of each year).

Putnam Museum of History and Natural Science Collections Management Policy, 1998

Provisions for Changes in Policy

The Collections Management Policy will be formally reviewed once every five years by the Museum Services Committee of the Board of Trustees.

Comments, suggestions and criticisms of the Collections Management Policy may be directed in writing to the Chief Curator at any time. Such statements may be submitted by any staff member, trustee, member, donor or other individuals or institutions affected by the provisions of this document. Such statements will be acknowledged in writing within one month of receipt.

The Chief Curator shall submit a summary report of all such statements in writing to the Director/CEO not less than once each year. The Director/CEO is authorized to request a review of the Collections Management Policy by the Board of Trustees Museum Services Committee at any time regardless of the schedule outlined above.

Exceptions to the Collections Management Policy may only be made by the Director/CEO. Any such action must be reported immediately to the Chairperson of the Board of Trustees Museum Services Committee, who will report such action to the full Board of Trustees at its next regularly scheduled meeting.

Staff members who believe that serious exceptions have been made to the provisions of the Collections Management Policy may report such concerns in writing to the Chairperson of the Museum Services Committee of the Board of Trustees but only with full disclosure and copies of any such complaint to the Director/CEO, following efforts to resolve such issues with same.

The Plains Art Museum Collections Management Policy, 2003

Monitoring, Compliance, Revisions

.1 Monitoring

Monitoring the implementation of these policies is an implied responsibility of the entire museum professional staff. Any major deviation from the Collections Management Policy without prior authorization will be reviewed by the appropriate staff and the CAAG of the Board and may result in restricted access to the collections if the collections are deemed to be at risk.

.2 Compliance

Assuring compliance with the policies and procedures specified in this document is the responsibility of the Collections and Public Programs division. Exceptions to stated policies and procedures may be made at the discretion of the Vice President of Collections and Public Programs or registrar in consultation with members of the Collections and Public Programs division and the CAAG of the Board.

.3 Revisions

Revisions to the Collections Management Policy, proposed by the registrar or professional staff, are reviewed by CAAG. If approved by the CAAG, and the Program Committee of the Board, the proposed revisions are presented to the full Board of Trustees for final approval.

CHAPTER 20

EPILOGUE: WHEN POLICY MEETS REALITY

When I teach collections management, I like to pose scenarios for my students and ask them what they would do in a particular situation. Here is an example:

Thanks to your spiffy new museum studies degree, you have landed the very first high-paying registrar position for which you applied. You scarcely find a place on your new solid walnut desk for your souvenir gilt-edged alumni coffee mug when you discover that some objects in the building have been left at the museum without signed gift agreements, letters of intent, deeds of gift, loan forms, or any other documentation of transfer of title. In fact, the museum has many of these objects. It is understood by staff with authority over you (which is almost everyone in the museum except the custodian) that the objects have been "given" to the museum and are to become part of the collections. Without proper documentation, you cannot accession the objects, but those in authority do not want to give the objects back to the donors. What do you do?

Of course, just like in real life, there are no good solutions to this problem or most others that I pose to the students. The point of these exercises is not to frustrate the students (although I have to admit, it is fun). Rather the goal is to help them understand that there is often a gap between theory and practice and we frequently must find ways to bridge that gap in real life. The solutions are never easy and sometimes not very pretty, either. I have found that students tend to be resourceful and creative, but they are often unsure how far they can go in applying theory to practice in real life. Some of the solutions they have proposed over the years for dealing with the above situation include:

- Go through the records and see how widespread the problem is in the museum.

- Check to see if this situation can be resolved using the museum's code of ethics.

- Document what you are told to do by those in authority; then just do it.

- Go back to the donors to get more paperwork.

- Utilize "old loan" legislation to make the stuff legal.

- Take more Valium.

- Quit.

The students are usually quick to note that most problems in museums could be avoided if the museum staff had clear policy guidelines and followed them.

Why are some policies successful while others are not? In his analysis of policy theory (and why policies so often fail), Stephen L. Williams (2005) wrote "It is important to get back to basics and recognize that the primary purpose of policies is to manage people so that organizational goals are achieved." Williams proposed that policies may be ineffective due to inappropriate concern, process, or product.

Inappropriate *concern* includes policies that are not implemented, policies that are enforced inconsistently, or a complete lack of policies. Policies can be ineffective because of problems with the *process* used to develop them—for example, the failure to include all sectors of the museum staff in policy development, or a lack of support from the governing authority. One of the most common process errors is to use the policies of another organization as if they are your own, without considering your museum's characteristics and needs. Inappropriate policy *products* include policy manuals that are too large, too complex, or too obfuscated to be easily understood and implemented. Policy products also fail because they contain gaps, redundancies, contradictions, or because they have become outdated.

The purpose of the collections management policy is to help the institution achieve its mission and goals; when mission and goals change, policies need to be reviewed and revised (see chapter 19, "Policy Review and Revision"). Ideally, policies will apply to everyone in the organizational structure and have the full support of the governing authority. But in the real world, not everything is perfect, including the collections management policy. From time to time, situations arise in which policy meets reality and fails. Approach these situations with an attitude of creative compromise, in which the spirit of the law takes precedence over the letter of the law. Once the situation is resolved, conduct a review to determine how the policy can be improved and made more effective.

The review can include an examination of the policy in terms of professional museum standards. Consider, for example, a museum's governing authority that decides to suspend or radically change a policy contrary to the opinions of the professional staff. Depending on the situation, this may be contrary to ethical standards or professional standards such as those of AAM's Accreditation Program. A 75-year-old museum lost its accreditation when objects from the collections were sold to fund operating expenses during a financial crisis. According to an article published in the *Arizona Daily Sun* in June 2003, to sell the objects the trustees suspended the museum's collections policy. The sale was a breach of ethical and professional standards because museum collections are held in the public trust and are not disposable assets. A governing authority that decides to sell collections to raise general operating funds or otherwise act contrary to professional ethics or standards also runs the risk of losing public support, its nonprofit status, and, in some instances, could be held legally liable for violations of the public trust.

In the case of the museum that lost its accreditation, the crisis and criticism was so severe it eventually led to the resignations of the director and trustees. Press reports quoted the new director as saying that although legally the loss of accreditation did not affect the way the museum functioned, it did make the museum look bad. He vowed to lead the effort to have the museum reaccredited, recognizing that adhering to professional standards is good policy.

Policies can fail when they meet reality if they are misinterpreted by the museum staff as well. In one instance, the curator of a history museum wanted to deaccession several hair wreaths from the collection. The curator assumed that because a hair wreath is made from woven

human hair it was a culturally sensitive artifact and had to be treated similar to human remains or a sacred object. That greatly complicated the deaccession and disposal process. After consulting with colleagues the curator was assured that hair wreaths were decorative objects and could be deaccessioned and disposed of according to the museum's existing policies. In this case, the misinterpretation came from projecting contemporary values on an historic object.

We should not expect our policies to be perfect, although we should strive to make them as close to perfect as we can. We also can expect policies to evolve along with the organization, changing as necessary to meet the institutional mission and goals. As with any profession, museum professional standards must evolve with the profession and change to accommodate new innovations in practice and technology. In the end, the ultimate test of a policy is whether it helps staff, volunteers, and governing authority fulfill the museum's mission.

References

American Association of Museums. 2005. *A Higher Standard: The Museum Accreditation Handbook.* American Association of Museums, Washington, D.C., 53 pp.

American Association of Museums. 2005. *A Higher Standard: Museum Accreditation Program Standards.* American Association of Museums, Washington, D.C., 40 pp.

Williams, S.L. 2005. Policy theory and application for museums. *Collection Forum* 19(1-2):32-44.

GLOSSARY

Abandoned property—Property left by a former owner who relinquishes ownership by not claiming the property within a reasonable length of time.

Access—The right, opportunity, or means of finding, using, or approaching collections or information.

Accession (n)—A set of one or more artifacts, objects, specimens, etc., received from the same source at the same time; an acquisition that a museum has taken ownership of and holds in the public trust.

Accession (v)—The process of taking legal ownership of an object or set of objects to hold in the public trust; the process of assigning a unique place in the list of contents of a collection to the components of an accession.

Accession number—A unique number that is assigned to an accession.

Accession record—A serial list of museum accessions, including source and description.

Accession register—A paper or electronic record of accession information; a document that includes, among other data, the accession number; date and nature of acquisition (gift, excavation, expedition, purchase, bequest, etc); source; brief identification and description; condition; provenance; value; and name of staff member recording the accession.

Accessioning—The formal process used to accept legally and to record a specimen or object as part of a collection; the act of accepting objects into the category of materials that a museum holds in the public trust; the creation of an immediate, brief, and permanent record utilizing a control number for an object or group of objects added to the collection from the same source at the same time, and for which the museum has custody, right, or title.

Accreditation—Recognition of conformance with established professional standards.

Acquisition (n)—Something acquired by a museum (but not necessarily involving the transfer of ownership).

Acquisition (v)—The process of obtaining custody (physical transfer) of an object or collection.

Agent of deterioration—Something that causes damage to collections.

All risk—An insurance policy that covers damage by all perils except those specifically included in the policy.

Appraisal—A judgment of what something is worth; an expert or official valuation, as for taxation; the process of determining the monetary value of something.

Archival quality—Materials manufactured from inert materials specifically designed to extend the life of artifacts and records by protecting them from agents of deterioration.

Archives—The non-current records of an organization or institution preserved because of their continuing value; the agency responsible for selecting, preserving, and making available records determined to have permanent or continuing value.

Artifact—Something made by or modified by a human being.

Artists rights—Rights that tie the artist, the artist's reputation, and a work of art together, as defined in the Visual Artists Rights Act of 1990 (VARA).

Associated record—Any documentation providing information about or related to a component of the collection.

Authentication—To establish the authenticity of something; to prove genuine.

Bailee—The legal term for a borrower.

Bailment—A legal relationship created between a lender and a borrower of property whereby the borrower keeps the property until the lender reclaims it.

Bailment contract—The legal term for a loan agreement.

Bailor—The legal term for a lender.

Bequest—Transfer of property to an institution under the terms of a deceased person's will; the gift of personal property under the terms of a will. Bequests may be conditional upon the happening or non-happening of an event (such as marriage), or executory in which the gift is contingent upon a future event. Bequests can be of specific assets or of the residue (what is left after specific gifts have been made).

Blanket insurance policy—An insurance contract that covers several classes of property at a single location or at multiple locations.

Bylaws—The written rules for conduct of a corporation, association, partnership, or any organization.

Catalog (n)—The list of the contents of a collection.

Catalog (v)—To organize the information about accessioned collection elements into categories; creation of a record of information specific to an object, assembly, or lot, cross-referencing other records and files.

Catalog number—a number assigned to an individual collection element during the cataloging process (may be used as a synonym for *registration number*).

Catalog record—a paper or electronic record created during the cataloging process.

Cataloging—The process of organizing the information about an accession by creating records of specific information; the creation of a full record, in complete descriptive detail, of all information about an object,

assembly, or lot, cross-referenced to other records and files, and often containing a photograph, sketch, film, sound, or other electronic data.

Certificate of insurance—A document, signed by the insurance company or its agent, that is written evidence of insurance in force at the time of issuance.

Collecting plan—A written document, approved by the governing authority, that details the scope of collecting by the museum, and helps inform decisions regarding acquisition and deaccession.

Collection—An organized accumulation of objects or specimens that have intrinsic value; a group of specimens or objects with like characteristics or a common base of association (e.g., geographic, donor, cultural); objects or specimens that the museum holds in trust for the public.

Collections documentation—Records pertaining to the provenance, identification, significance, status, and location of the museum's collections, in accordance with accepted standards in the field.

Collections management—The activities that relate to the administration of collections, including planning, development, care, conservation, and documentation; caring for collections and making them available for use.

Collections management policy—A written document, approved by the institution's governing authority, that specifies how collections will be acquired, accessioned, documented, stored, used, cared for, and disposed of.

Collections management procedures—Guidelines that provide directions for implementing the collections management policy.

Collections plan—A plan defining the contents of the collections that guides the staff in a coordinated and uniform direction to refine and expand the collections in a way that gives the museum intellectual the control over collections.

Collections stewardship—The careful, sound, and responsible management of collections that are entrusted to the museum's care, including the legal, social, and ethical obligations to provide proper physical storage, management, conservation, and care for the collections and associated documentation.

Commercial use—Use of a component of a collection or its associated documentation for sale, resale, purchase, trade, barter, or actual or intended transfer for gain or profit.

Common law—Legal principles that are not based on any express statute, but rather upon statements of principle found in court decisions.

Condition report—An accurate, informative descriptive report of an object's or a document's state of preservation at a moment in time.

Conditional gift—see *restricted gift*

Conservation—Maximizing the endurance and minimizing the deterioration of an object or specimen through time, with as little change to it as possible.

Contract—An agreement between two or more parties that can be enforced in court. Sometimes this term is used to refer to the written document on which the agreement of the parties is recorded.

Copyright—Legal recognition of special intellectual property rights, distinct from the right of possession, that a creator may have for a work. Copyright exists for original works in tangible media and covers the rights to reproduce, adapt, distribute, perform, or display the work.

Copyright—The exclusive right of the author or creator of a literary or artistic property to print, copy, sell, license, distribute, transform to another medium, translate, record or perform or otherwise use (or not use) and to give it to another by will.

Copyright law—The body of law that governs the exploitation of literary, musical, artistic, and related works. In the United States, this is contained in Title 17 of the U.S. Code, in combination with the regulations of the Copyright Office and the cases that have interpreted Title 17 and those regulations.

Country of export—The last country from which an animal, plant, or object was exported before importation to the United States.

Country of origin—The country where a plant or animal was collected, or an object was made.

Courier—An individual, usually a representative of an object or document owner or a repository, who travels with it to ensure its proper care and safe arrival at a venue.

Credit line—Information that details the source of an object and may reference the donor or lending institution.

Culling—The process of selecting and removing objects from a group.

Cultural affiliation—A relationship of shared group identity which can be reasonably traced historically or prehistorically between a present day Indian tribe or Native Hawaiian organization and an identifiable earlier group (NAGPRA, 25 U.S.C 3001.2(3)); association of an object with the culture that produced or used it.

Cultural patrimony—An object having ongoing historical, traditional, or cultural importance central to the American Indian group or culture itself, rather than property owned by an individual Native American, and which, therefore, cannot be alienated, appropriated, or conveyed by any individual regardless of whether or not the individual is a member of the Indian tribe or Native Hawaiian organization and such object shall have been considered inalienable by such Native American group at the time the object was separated from such group (NAGPRA, 25 U.S.C 3001.2(3)(D)); objects of historical importance to a particular cultural entity.

Cultural property—Materials or remains, including historic and archaeological objects, that compose a culture's non-renewable heritage, including ethnographic objects, historic and prehistoric buildings, structures, sites, and landscapes.

Culturally sensitive object—a collection element that requires special handling or use restrictions due to its importance to a particular culture.

Curation—The process of managing and preserving a collection according to professional museum standards and archival practices (36 CFR 79.4(b)).

Curation agreement—A contract between two parties detailing the curation of a collection, including details on the state of the collection when given to the repository, work to be done at the repository,

responsibilities to the collection for both parties, costs, ownership, and access and use of the collection.

Customs broker—An individual or firm that arranges customs clearance of objects traveling between countries; frequently employed also as a freight-forwarding agent for international shipments.

Cy pres—The doctrine in the law of charities whereby when it becomes impossible, impracticable, or illegal to carry out the particular purpose of the donor, a scheme will be framed by a court to carry out the general intention of applying the gift to charitable purposes that are closely related or similar to the original purposes.

Deaccessioning—The formal process of removing an accessioned object or group of objects from the museum's permanent collection.

Deed of gift—A contract that transfers ownership of an object from a donor to an institution and describes the conditions of the gift.

Deferred donation—A donation in which a donor retains ownership of an object for a specified period of time, but wants assurance that the object will be accepted by the museum at the termination of the retention period (a synonym is *promised gift*).

Derivative work—Variant or alternative version of an original piece of work, such as posters, postcards, T-shirts, or artwork using original photographs, graphic designs, maps, or the like.

Destructive sampling—Any type of analysis that destroys or alters a sample during the process.

Disaster—An unexpected occurrence inflicting damage and having a long-term adverse effect on museum operations.

Disposal—The process of physically removing a deaccessioned object from the museum's custody.

Documentation—The supporting evidence, recorded in a permanent manner and using a variety of media, of the identification, condition, history, use, or value of a specimen, object or collection.

Element—A constituent part of a whole; a member of a set (e.g., an artifact, object, or specimen in a museum collection).

Endorsement—In insurance, a form attached to the basic insurance contract that alters certain provisions in the policy.

Exchange—To trade or barter property, goods and/or services for other property, goods and/or services, unlike a sale or employment in which money is paid for the property, goods or services.

Ethics—A set of principles or values to govern the conduct of individuals.

Facility report—A report prepared by an institution that outlines its facilities, environmental controls and monitoring, and collections management procedures.

Fair use—Use by reproduction of a copyrighted work for criticism, comment, news reporting, teaching (including multiple copies for classroom use), scholarship, or research.

Fiduciary—relating to or involving a trust; of or relating to holding something in trust for another; held in trust.

Fiduciary obligation—The responsibility of an organization to the collections it holds in trust for the public.

Fractional gift—A donation of an object to which the museum does not receive full title. A fractional interest gift is one in which the museum is given a present fractional interest and the donor retains the remaining fractional interest. The museum is entitled to possession of the object for that portion of the calendar year equal to its fractional interest in the property.

Forgery—A document, signature, mark, or created work that is falsely created or altered.

Funerary objects—Items that, as part of the death rite or ceremony of a culture, are reasonably believed to have been placed intentionally with or near individual human remains at the time of death or later.

Gift—The voluntary transfer of ownership of property completely free of restrictions.

Governing authority—The executive body to which the director reports and is responsible, charged with the legal and fiduciary responsibility for the museum (e.g., board, trustees, regents, commission).

Historic preservation—Management and preservation of buildings, sites, structures, objects, and landscapes that have historical or cultural significance.

In perpetuity—Continuing forever; used in reference to the curation of material remains and documents by a repository for the entire length of an object's life.

Incoming loan—Objects, lots, specimens, or archival materials to which the museum does not have legal title but for which it is legally responsible while they are in its possession and used in a museum-sponsored activities.

Indefinite loan—A loan that has no set duration or termination date.

Information management—The development and maintenance of integrated information systems and the optimization of information flow and access.

Integrated pest management (IPM)—The coordinated use of biological and environmental information with selected control measures to reduce or eliminate pest damage; a holistic approach to pest management decision making, taking advantage of all appropriate pest management options, including chemicals.

Intellectual property—Unique products of human intelligence that have real or potential commercial value (e.g., designs, inventions, literary works, unique names, and industrial processes).

Intellectual property rights—Non-physical (intangible) rights to an object or record that exist independently from ownership of the physical item; intellectual property rights include copyright, images, and right to use.

International law—Treaties between countries; multilateral agreements; some commissions covering particular subjects, such as whaling or copyrights; procedures and precedents of the International Court of Justice ("World Court"), which only has jurisdiction when countries agree to appear; the United Nations Charter; and custom. However, there is no specific body of law that governs the interaction of all nations.

Inventory (n)—An itemized listing of objects, often including current location, for which the museum has responsibility.

Inventory (v)—The process of physically locating objects through an inventory.

IPM—see *Integrated pest management.*

Item—A statement or maxim; a saying with a particular bearing; a unit included in an enumeration or sum total.

Loan—A bailment; a temporary transfer of a collection object from a lender to a borrower; a loan does not involve change in ownership.

Loan agreement—A contract between a lender and a borrower of an object, specifying the object and outlining the conditions of the loan and the respective responsibilities of each party.

Loan fee—A fee charged to a borrowing institution by a lending institution for a loan. It is usually a charge in addition to the actual costs (conservation, packing, shipping, etc.) of handling a loan.

Location file—An instrument used to find a component of a collection in the collection storage array.

Long-term loan—A bailment contract of extended duration.

Material—Relating to, consisting of, or derived from matter.

Mission—Statement approved by the museum's governing authority that defines the purpose of the museum.

MOA—Memorandum of Agreement; a written document that details the responsibilities of all parties in a plan or procedure.

MOU—Memorandum of Understanding; a written document that details the responsibilities of all parties in a plan or procedure.

Museum—An organized, permanent, nonprofit organization, essentially educational and often aesthetic in purpose, with a professional staff, that owns or uses tangible objects, interprets them, cares for them, and exhibits them to the public.

NAGPRA—*Native American Graves Protection and Repatriation Act.*

Native American Graves and Repatriation Act (NAGPRA)—An act instigated in 1990 to protect human remains, funerary articles, and sacred objects

that can be affiliated with a Native American tribe (25 U.S.C 3001.2(3)).

Nazi era—The years 1933 through 1945.

Object—Something placed before the eyes; something capable of being seen, touched, or otherwise sensed; a material thing.

Object found in the collections—An object in the collections that lacks any useful documentation as to how it was acquired.

Object in custody—Any object that the museum is responsible for or is liable for, including both objects that the museum owns and those left in temporarily in its care.

Object in temporary custody—An object left temporarily in the museum for other than loan purposes (e.g., for attribution, identification, examination for possible gift, or purchase).

Off-site storage—Collections storage at a site that is separated from the museum.

Old loan—An expired loan or loan of unlimited duration left unclaimed by the lender (also referred to as an *unclaimed loan*).

Orphaned collection—a collection that has lost curatorial support or whose owner has abandoned it.

Outgoing loan—An object loaned by a museum to another institution. It is an outgoing loan from the perspective of the lending institution; such a loan would be an incoming loan to the borrowing institution.

Partial gift—see *fractional gift.*

Permanent loan—An oxymoron used in reference to a loan with no specified ending date.

Policy—A guideline that regulates organizational action. Policies control the conduct of people and thus the activities of systems.

Preventive conservation—Actions taken to detect, avoid, block, and mitigate agents of deterioration that affect museum collections.

Precatory restriction—Restriction on a gift that is the expressed wish of the donor.

Procedure—Specific instructions for enacting and carrying out a policy.

Promised gift—See *deferred donation.*

Provenance—For works of art and historical objects, the background and history of ownership. The more common term for anthropological collections is "provenience," which defines an object in terms of the specific geographic location of origin. In scientific collections, the term "locality," meaning specific geographic point of origin, is more acceptable.

Public domain—In copyright law, the right of anyone to use literature, music, or other previously copyrighted materials after the copyright period has expired.

Public trust—A relationship in which the museum holds property that is administered for the benefit of the public.

Publication—In U.S. Copyright Law, the distribution of copies of a work to the public by sale or other transfer of ownership (including gifts and donations), or by rental, lease, or lending. The offering to distribute copies can constitute publication, but a public performance or display of a work normally does not.

Records—All information fixed in a tangible (textual, electronic, audiovisual, or visual) form that was created by an organization as part of its daily business.

Records management—The process involved in determining the status, value, and disposition of administrative records throughout their lifetime.

Registration—The process of assigning the components of an accession to a unique place in a serial order list of the contents of a collection.

Registration number—A number assigned to the objects or specimens in an accession (may be used as a synonym for *accession number* or *catalog number*).

Religious use—"Use in religious rituals or spiritual activities. Religious remains generally are of interest to medicine men and women, and other religious practitioners and persons from Indian tribes, Alaskan Native corporations, Native Hawaiians, and other indigenous and immigrant ethnic, social and religious groups that have aboriginal or historic ties to the lands from which the remains are recovered, and have traditionally used the remains or class of remains in religious rituals or spiritual activities" (NAGPRA, 36 CFR 79.10(c)).

Repatriation—To return or restore the control of an object to the country of origin or rightful owner.

Repository—A facility that can provide long-term professional, systematic, and accountable curatorial services for a collection that it does not own.

Repository agreement—Agreement in which an institution provides long-term professional, systematic, and accountable curatorial services for a collection that belongs to another entity (e.g., a state government, federal government, or foreign government).

Restitution—The return of objects or payment of compensation to the object's original owner or legal successor.

Restricted gift—The voluntary transfer of ownership of property with conditions and/or limitations placed upon that ownership.

Risk—The chance of an undesirable change occurring.

Risk management—A program of risk control that includes analyzing the probability of risks to museum collections, facilities, visitors, and staff as well as planning and implementing appropriate preventative measures and response methods.

Sacred object—Specific ceremonial object which is needed by traditional religious leaders for the practice of traditional religions by their present-day adherents.

Sale—Transfer of title in return for money or other thing of value on terms agreed upon between buyer and seller.

Scope of collections—A statement that defines the purpose of a collection and sets agreed upon limits that specify the subject, geographical location, and time period for the collection. The statement also considers the uses to which a collection will be put, and states the types of objects that will be acquired to fulfill the purposes of the collection.

Security—Safeguarding the collections and museum grounds from theft and vandalism.

Specimen—A representative part of a whole, or a means of discovering or finding out; an experiment, a pattern, or model.

Stewardship—The careful, sound, and responsible management of that which is entrusted to a museum's care.

Taxonomy—Classification in an ordered system; division into ordered groups or categories; the science of naming, describing, and classifying organisms.

Thing—A spatial entity, an inanimate object.

Title—The possession of rights of ownership of personal property. Separate rights of possession include copyright interests, trademark rights, and any specific interests that the previous owner may have reserved.

Trademark—A distinctive design, picture, emblem, logo or wording (or combination) affixed to goods for sale to identify the manufacturer as the source of the product. Words that merely name the maker (but without particular lettering) or a generic name for the product are not trademarks. Trademarks are registered with the U.S. Patent Office to prove use and ownership.

Unclaimed loan—see *abandoned property, old loan.*

Undocumented objects—see *objects found in the collections.*

Waiver of subrogation rights clause—Endorsement to a policy whereby an insurer gives up the right to take action against a third party for a loss suffered by an insured. If a museum borrows a collection and someone else is providing the insurance for the loan, the borrower can require a waiver of subrogation clause in the policy.

Wall-to-wall coverage—Insurance that covers an object on loan from the moment it is removed from its normal resting place, incidental to shipping; through all phases of packing, transfer, consolidation, exhibition, and repacking; until it is returned to its original resting place, or a place designated by the owner.

Witnessed destruction—Disposal through destruction that is witnessed by a person (usually a disinterested third party).

Work (n)—Something produced by creative effort; an artistic production (e.g., a work of art).

Sources

American Association of Museums. 2001. *Guidelines concerning the Unlawful Appropriation of Objects during the Nazi Era.* www.aam-us.org/museumresources/ethics/nazi_guidelines.cfm.

American Association of Museums. 2005. *Accreditation Self-Study Questionnaire.* American Association of Museums, Washington, D.C.

Buck, R.A. & J.A. Gilmore (editors). 1998. *The New Museum Registration Methods.* American Association of Museums, Washington, D.C. xvii + 427 pp.

Campbell, N.J. 1998. *Writing Effective Policies and Procedures: A Step-by-Step Resource for Clear Communication.* American Management Association, New York. xiii + 397 pp.

Cato, P.S., J. Golden, and S.B. McLaren (compilers). 2003. *Museum Wise. Workplace Words Defined.* Society for the Preservation of Natural History Collections, Washington, D.C., 380 pp.

Griset, S. and M. Kodack. 1999. *Guidelines for the Field Collection of Archaeological Materials and Standard Operating Procedures for Curating Department of Defense Archaeological Materials.* Legacy Resource Management Project, Legacy Project, no. 98-1714, 163 pp.

Kozak, E.M. 1997. *Every Writer's Guide to Copyright and Publishing Law.* Second edition. Owlet, 144 pp.

Law.com's Real Life Dictionary of the Law, http://dictionary.law.com.

Malaro, M.C. 1998. *A Legal Primer on Managing Museum Collections.* Second edition. Smithsonian Institution Press, Washington, D.C. xx + 507 pp.

MAP Collections Management Assessment Self-Study Workbook. 2001. American Association of Museums, Washington, D.C.

Museum Accreditation Self-Study. 1997. American Association of Museums, Washington, D.C.

National Park Service Archaeology Program, www.cr.nps.gov/archeology.

Phelan, Marilyn E. 2001. *Museum Law. A Guide for Officers, Directors, and Counsel.* Second edition. Kalos Kapp Press, xiii + 471 pp.

Waller, R.R. 1995. Risk management applied to preventive conservation. In Rose, C.L., C.A. Hawks, and H.H. Genoways (editors). *Storage of Natural History Collections: A Preventive Conservation Approach,* pp. 21-27. Society for the Preservation of Natural History Collections, x + 448 pp.

Weil, S.E. 1990. *Rethinking the Museum and Other Meditations.* Smithsonian Institution Press, Washington, D.C. xviii + 173 pp.

APPENDIX B

AAM'S *CODE OF ETHICS FOR MUSEUMS* and *THE ACCREDITATION COMMISSION'S EXPECTATIONS REGARDING COLLECTIONS STEWARDSHIP*

Code of Ethics for Museums

Introduction

Ethical codes evolve in response to changing conditions, values, and ideas. A professional code of ethics must, therefore, be periodically updated. It must also rest upon widely shared values. Although the operating environment of museums grows more complex each year, the root value for museums, the tie that connects all of us together despite our diversity, is the commitment to serving people, both present and future generations. This value guided the creation of and remains the most fundamental principle in the following *Code of Ethics for Museums.*

Code of Ethics for Museums

Museums make their unique contribution to the public by collecting, preserving, and interpreting the things of this world. Historically, they have owned and used natural objects, living and nonliving, and all manner of human artifacts to advance knowledge and nourish the human spirit. Today, the range of their special interests reflects the scope of human vision. Their missions include collecting and preserving, as well as exhibiting and educating with materials not only owned but also borrowed and fabricated for these ends. Their numbers include both governmental and private museums of anthropology, art history and natural history, aquariums, arboreta, art centers, botanical gardens, children's museums, historic sites, nature centers, planetariums, science and technology centers, and zoos. The museum universe in the United States includes both collecting and non-collecting institutions. Although diverse in

their missions, they have in common their nonprofit form of organization and a commitment of service to the public. Their collections and/or the objects they borrow or fabricate are the basis for research, exhibits, and programs that invite public participation.

Taken as a whole, museum collections and exhibition materials represent the world's natural and cultural common wealth. As stewards of that wealth, museums are compelled to advance an understanding of all natural forms and of the human experience. It is incumbent on museums to be resources for humankind and in all their activities to foster an informed appreciation of the rich and diverse world we have inherited. It is also incumbent upon them to preserve that inheritance for posterity.

Museums in the United States are grounded in the tradition of public service. They are organized as public trusts, holding their collections and information as a benefit for those they were established to serve. Members of their governing authority, employees, and volunteers are committed to the interests of these beneficiaries. The law provides the basic framework for museum operations. As nonprofit institutions, museums comply with applicable local, state, and federal laws and international conventions, as well as with the specific legal standards governing trust responsibilities. This *Code of Ethics for Museums* takes that compliance as given. But legal standards are a minimum. Museums and those responsible for them must do more than avoid legal liability, they must take affirmative steps to maintain their integrity so as to warrant public confidence. They must act not

only legally but also ethically. This *Code of Ethics for Museums,* therefore, outlines ethical standards that frequently exceed legal minimums.

Loyalty to the mission of the museum and to the public it serves is the essence of museum work, whether volunteer or paid. Where conflicts of interest arise—actual, potential, or perceived—the duty of loyalty must never be compromised. No individual may use his or her position in a museum for personal gain or to benefit another at the expense of the museum, its mission, its reputation, and the society it serves.

For museums, public service is paramount. To affirm that ethic and to elaborate its application to their governance, collections, and programs, the American Association of Museums promulgates this *Code of Ethics for Museums.* In subscribing to this code, museums assume responsibility for the actions of members of their governing authority, employees, and volunteers in the performance of museum-related duties. Museums, thereby, affirm their chartered purpose, ensure the prudent application of their resources, enhance their effectiveness, and maintain public confidence. This collective endeavor strengthens museum work and the contributions of museums to society—present and future.

Governance

Museum governance in its various forms is a public trust responsible for the institution's service to society. The governing authority protects and enhances the museum's collections and programs and its physical, human, and financial resources. It ensures that all these resources support the museum's mission, respond to the pluralism of society, and respect the diversity of the natural and cultural common wealth.

Thus, the governing authority ensures that:

- all those who work for or on behalf of a museum understand and support its mission and public trust responsibilities
- its members understand and fulfill their trusteeship and act corporately, not as individuals

- the museum's collections and programs and its physical, human, and financial resources are protected, maintained, and developed in support of the museum's mission
- it is responsive to and represents the interests of society
- it maintains the relationship with staff in which shared roles are recognized and separate responsibilities respected
- working relationships among trustees, employees, and volunteers are based on equity and mutual respect
- professional standards and practices inform and guide museum operations
- policies are articulated and prudent oversight is practiced
- governance promotes the public good rather than individual financial gain.

Collections

The distinctive character of museum ethics derives from the ownership, care, and use of objects, specimens, and living collections representing the world's natural and cultural common wealth. This stewardship of collections entails the highest public trust and carries with it the presumption of rightful ownership, permanence, care, documentation, accessibility, and responsible disposal.

Thus, the museum ensures that:

- collections in its custody support its mission and public trust responsibilities
- collections in its custody are lawfully held, protected, secure, unencumbered, cared for, and preserved
- collections in its custody are accounted for and documented
- access to the collections and related information is permitted and regulated
- acquisition, disposal, and loan activities are conducted in a manner that respects the protection and preservation of natural and cultural resources and discourages illicit trade in such materials

- acquisition, disposal, and loan activities conform to its mission and public trust responsibilities

- disposal of collections through sale, trade, or research activities is solely for the advancement of the museum's mission. Proceeds from the sale of nonliving collections are to be used consistent with the established standards of the museum's discipline, but in no event shall they be used for anything other than acquisition or direct care of collections.

- the unique and special nature of human remains and funerary and sacred objects is recognized as the basis of all decisions concerning such collections

- collections-related activities promote the public good rather than individual financial gain

- competing claims of ownership that may be asserted in connection with objects in its custody should be handled openly, seriously, responsively and with respect for the dignity of all parties involved.

Programs

Museums serve society by advancing an understanding and appreciation of the natural and cultural common wealth through exhibitions, research, scholarship, publications, and educational activities. These programs further the museum's mission and are responsive to the concerns, interests, and needs of society.

Thus, the museum ensures that:

- programs support its mission and public trust responsibilities

- programs are founded on scholarship and marked by intellectual integrity

- programs are accessible and encourage participation of the widest possible audience consistent with its mission and resources

- programs respect pluralistic values, traditions, and concerns

- revenue-producing activities and activities that involve relationships with external entities are compatible with the museum's mission and support its public trust responsibilities

- programs promote the public good rather than individual financial gain.

Promulgation

This *Code of Ethics for Museums* was adopted by the Board of Directors of the American Association of Museums on November 12, 1993. The AAM Board of Directors recommends that each nonprofit museum member of the American Association of Museums adopt and promulgate its separate code of ethics, applying the *Code of Ethics for Museums* to its own institutional setting.

A Committee on Ethics, nominated by the president of the AAM and confirmed by the Board of Directors, will be charged with two responsibilities:

- establishing programs of information, education, and assistance to guide museums in developing their own codes of ethics

- reviewing the *Code of Ethics* for Museums and periodically recommending refinements and revisions to the Board of Directors.

Afterword

In 1987 the Council of the American Association of Museums determined to revise the association's 1978 statement on ethics. The impetus for revision was recognition throughout the American museum community that the statement needed to be refined and strengthened in light of the expanded role of museums in society and a heightened awareness that the collection, preservation, and interpretation of natural and cultural heritages involve issues of significant concern to the American people.

Following a series of group discussions and commentary by members of the AAM Council, the Accreditation Commission, and museum leaders throughout the country, the president of AAM appointed an Ethics Task Force to prepare a code of ethics. In its work, the Ethics Task Force was committed to codifying the common understanding of ethics in the museum profession and to establishing a framework within which each institution could develop its own code. For guidance, the task force looked to the tradition of museum ethics and drew inspiration from AAM's first code of ethics, published in 1925 as *Code of Ethics for Museum Workers,* which states in its preface:

Museums, in the broadest sense, are institutions which hold their possessions in trust for mankind and for the future welfare of the [human] race. Their value is in direct proportion to the service they render the emotional and intellectual life of the people. The life of a museum worker is essentially one of service.

This commitment to service derived from nineteenth-century notions of the advancement and dissemination of knowledge that informed the founding documents of America's museums. George Brown Goode, a noted zoologist and first head of the United States National Museum, declared in 1889:

The museums of the future in this democratic land should be adapted to the needs of the mechanic, the factory operator, the day laborer, the salesman, and the clerk, as much as to those of the professional man and the man of leisure. . . . In short, the public museum is, first of all, for the benefit of the public.

John Cotton Dana, an early twentieth-century museum leader and director of the Newark Museum, promoted the concept of museum work as public service in essays with titles such as "Increasing the Usefulness of Museums" and "A Museum of Service." Dana believed that museums did not exist solely to gather and preserve collections. For him, they were important centers of enlightenment.

By the 1940s, Theodore Low, a strong proponent of museum education, detected a new concentration in the museum profession on scholarship and methodology. These concerns are reflected in Museum Ethics, published by AAM in 1978, which elaborated on relationships among staff, management, and governing authority.

During the 1980s, Americans grew increasingly sensitive to the nation's cultural pluralism, concerned about the global environment, and vigilant regarding the public institutions. Rapid technological change, new public policies relating to nonprofit corporations, a troubled educational system, shifting patterns of private and public wealth, and increased financial pressures all called for a sharper delineation of museums' ethical responsibili-

ties. In 1984 AAM's Commission on Museums for a New Century placed renewed emphasis on public service and education, and in 1986 the code of ethics adopted by the International Council of Museums (ICOM) put service to society at the center of museum responsibilities. ICOM defines museums as institutions "in the service of society and of its development" and holds that "employment by a museum, whether publicly or privately supported, is a public trust involving great responsibility."

Building upon this history, the Ethics Task Force produced several drafts of a *Code of Ethics for Museums*. These drafts were shared with the AAM Executive Committee and Board of Directors, and twice referred to the field for comment. Hundreds of individuals and representatives of professional organizations and museums of all types and sizes submitted thoughtful critiques. These critiques were instrumental in shaping the document submitted to the AAM Board of Directors, which adopted the code on May 18, 1991. However, despite the review process, when the adopted code was circulated, it soon became clear that the diversity of the museum field prevented immediate consensus on every point.

Therefore, at its November 1991 meeting, the AAM Board of Directors voted to postpone implementation of the *Code of Ethics* for at least one year. At the same meeting an Ethics Commission nominated by the AAM president was confirmed. The newly appointed commission—in addition to its other charges of establishing educational programs to guide museums in developing their own code of ethics and establishing procedures for addressing alleged violations of the code—was asked to review the code and recommend to the Board changes in either the code or its implementation.

The new Ethics Commission spent its first year reviewing the code and the hundreds of communications it had generated, and initiating additional dialogue. AAM institutional members were invited to comment further on the issues that were most divisive—the mode of implementation and the restrictions placed on funds from deaccessioned objects. Ethics Commission members also met in person with their colleagues at the annual and regional meetings, and an ad hoc meeting of museum directors was convened by the board

president to examine the code's language regarding deaccessioning.

This process of review produced two alternatives for the board to consider at its May meeting: (1) to accept a new code developed by the Ethics Commission, or (2) to rewrite the sections of the 1991 code relating to use of funds from deaccessioning and mode of implementation. Following a very lively and involved discussion, the motion to reinstate the 1991 code with modified language was passed and a small committee met separately to make the necessary changes.

In addition, it was voted that the Ethics Commission be renamed the Committee on Ethics with responsibilities for establishing information and educational programs and reviewing the *Code of Ethics for Museums* and making periodic recommendations for revisions to the board. These final changes were approved by the board in November 1993 and are incorporated into this document, which is the AAM *Code of Ethics for Museums*.

Each nonprofit museum member of the American Association of Museums should subscribe to the AAM *Code of Ethics for Museums*. Subsequently, these museums should set about framing their own institutional codes of ethics, which should be in conformance with the AAM code and should expand on it through the elaboration of specific practices. This recommendation is made to these member institutions in the belief that engaging the governing authority, staff, and volunteers in applying the AAM code to institutional settings will stimulate the development and maintenance of sound policies and procedures necessary to understanding and ensuring ethical behavior by institutions and by all who work for them or on their behalf.

With these steps, the American museum community expands its continuing effort to advance museum work through self-regulation. The *Code of Ethics for Museums* serves the interests of museums, their constituencies, and society. The primary goal of AAM is to encourage institutions to regulate the ethical behavior of members of their governing authority, employees, and volunteers. Formal adoption of an institutional code promotes higher and more consistent ethical standards. To this end, the Committee on Ethics will develop workshops, model codes, and publications. These and other forms of technical assistance will stimulate a dialogue about ethics throughout the museum community and provide guidance to museums in developing their institutional codes.

2000

The Accreditation Commission's Expectations
Regarding
Collections Stewardship

Approved December 17, 2004[1]

Effective January 1, 2005

The Accreditation Commission's expectations reflect the evolving nature of standards and practices in museums. During its review of over 100 institutions a year, the Commission discusses how current practices in museums relate to the existing eligibility criteria and Characteristics of an Accreditable Museum. These Expectations support and elaborate on the Characteristics of an Accreditable Museum. Periodically, after thorough deliberation, the Commission revises its expectations to stay current with evolving standards. The Commission focuses on presenting desired outcomes, rather than on prescribing methods by which these outcomes must be achieved.

Why does the Commission consider collections stewardship important?

Stewardship is the careful, sound, and responsible management of that which is entrusted to a museum's care. Possession of **collections**[2] incurs legal, social, and ethical obligations to provide proper physical storage, management, and care for the collections and associated documentation, as well as proper intellectual control. Collections are held in trust for the public and made accessible for the public's benefit. Effective collections stewardship ensures that the **objects** the museum owns, borrows, holds in its custody, and/or uses are available and accessible to present and future generations. A museum's collections are an important means of advancing its mission and serving the public.

What are the Accreditation Commission's expectations regarding collections stewardship?

Per Program Eligibility Criteria:

 ◆ An accredited museum, either collecting or non-collecting, is required to have a formal and appropriate program of documentation, **care**, and use of collections.

 ◆ An institution that owns collections (including living organisms), whether actively collecting or not, is required to have **accessioned** at least 80 percent of its permanent collections.

[1] First issued by the Accreditation Commission in June 2001 This revised version supercedes the 2001 version.
[2] See Glossary at the end for definitions of bolded terms.

Per the Characteristics of an Accreditable Museum, an accreditable museum must demonstrate that it:
- owns, exhibits, or uses collections that are appropriate to its mission
- legally, ethically, and effectively manages, documents, cares for, and uses the collections
- conducts collections-related research according to appropriate scholarly standards
- strategically plans for the use and development of its collections
- guided by its mission, provides public access to its collections while ensuring their preservation
- allocates its space and uses its facilities to meet the needs of the collections, audience, and staff
- has appropriate measures in place to ensure the safety and security of people, its collections and/or objects, and the facilities it owns or uses
- takes appropriate measures to protect itself against potential risk and loss

The Commission also expects an institution to:
- plan strategically and act ethically with respect to collections stewardship matters
- legally, ethically, and responsibly acquire, manage, and dispose of collection items as well as know what collections are in its ownership/custody, where they came from, why it has them, and their current condition and location
- provide regular and reasonable access to, and use of, the collections/objects in its custody

This requires thorough understanding of collections stewardship issues to ensure thoughtful and responsible planning and decision-making. With this in mind, the Commission emphasizes systematic development and regular review of policies, procedures, practices, and plans for the goals, activities, and needs of the collections.

How does the Commission assess whether the institution's collections and/or objects are appropriate for its mission?
The Commission compares the institution's mission—how it formally defines its unique identity and purpose, and its understanding of its role and responsibility to the public—to two things:
- the collections used by the institution, and
- its policies, procedures, and practices regarding the development and use of collections

(See also the *Accreditation Commission's Expectations Regarding Institutional Mission Statements*.)

In its review, the Commission examines whether:

- the mission statement or collections documents (e.g., collections management policy, collections plan, etc.) are clear enough to guide collections stewardship decisions
- the collections owned by the museum, and objects loaned and exhibited at the museum, fall within the scope of the stated mission and collections documents.
- the mission and other collections stewardship related documents are in alignment and guide the museum's practices.

How does the Commission assess whether the institution effectively manages, documents, and cares for its collections and/or objects?

The Commission recognizes that:

- there are different ways to manage, house, secure, document, and conserve collections, depending on their media and use, the museum's own discipline, size, physical facilities, geographic location, and financial and human resources. Therefore, the Commission considers many facets of an institution's operations that taken together, demonstrate the effectiveness of its collections stewardship policies, procedures, and practices. The Commission considers the museum's collections stewardship policies, procedures, and practices in light of these varying factors.

- museums may have diverse types of collections categorized by different levels of purpose and use—permanent, educational, archival, research, study, to name a few—that may have different management and care needs. The Commission expects these distinctions to be articulated in collections stewardship-related policies and procedures.

- different museum disciplines may have different collections stewardship practices, issues, and needs related to their specific field. The Commission expects museums to follow the standards and best practices appropriate to their respective discipline and/or museum type as applicable.

In its review, the Commission expects that:

- a current, approved, comprehensive **collections management policy** is in effect and actively used to guide the museum's stewardship of its collections
- 80 percent of the permanent collection is formally accessioned and an appropriate and reasonable percentage of the permanent collection is cataloged, inventoried, and visually documented
- the human resources are sufficient, and the staff have the appropriate education, training, and experience, to fulfill the museum's stewardship responsibilities and the needs of the collections
- staff are delegated responsibility to carry out the collections management policy
- a system of documentation, records management, and inventory is in effect to describe each object and its acquisition (permanent or temporary), current condition and location, and movement into, out of, and within the museum

Accreditation Commission's Expectations Regarding Collections Stewardship
1-1-05
Page 4 of 5

- the museum regularly monitors environmental conditions and takes pro-active measures to mitigate the effects of ultraviolet light, fluctuations in temperature and humidity, air pollution, damage, pests, and natural disasters on collections
- an appropriate method for identifying needs and determining priorities for conservation/care is in place
- safety and security procedures and plans for collections in the museum's custody are documented, practiced, and addressed in the museum's emergency/disaster preparedness plan
- regular assessment of, and planning for, collection needs (development, conservation, risk management, etc.) takes place and sufficient financial and human resources are allocated for collections stewardship
- collections care policies and procedures for collections on exhibition, in storage, on loan, and during travel are appropriate, adequate, and documented
- the scope of a museum's collections stewardship extends to both the physical and intellectual control of its property
- ethical considerations of collections stewardship are incorporated into the appropriate museum policies and procedures
- considerations regarding future collecting activities are incorporated into institutional plans and other appropriate policy documents

The Commission also reviews the following documents required to be submitted as part of the accreditation process:
- Repository agreement for objects in custody without title (required for some museums)
- Visual images that illustrate the scope of the museum's collections
- Collections management policy and loan policies (custodial care and borrowing policies for museums that do not own or manage collections, but borrow and use collections for exhibits, education, or research)
- Sample copy of completed collections documentation record(s) (with accession, catalog, and inventory information)
- If the museum is authorized to deaccession, a copy of a deaccession form or other written documentation used for deaccessioning purposes (a completed form if applicable, otherwise a blank form)
- Sample copy of a completed outgoing loan agreement
- Sample copy of a completed incoming loan agreement
- Sample copy of completed condition report form
- Emergency/disaster preparedness plan (covering staff, visitors, and collections)

In addition, the following documents are not required but should be provided if available:
- **Collections plan**
- Conservation plan
- Completed RC-AAM *Standard Facility Report*

Glossary

Accessioning: a) Formal act of accepting an object or objects to the category of materials that a museum holds in the public trust. b)The creation of an immediate, brief, and permanent record utilizing a control number for an object or group of objects added to the collection from the same source at the same time, and for which the museum has custody, right, or title. Customarily, an accession record includes, among other data, the accession number; date and nature of acquisition (gift, excavation, expedition, purchase, bequest, etc.); source; brief identification and description; condition; provenance; value; and name of staff member recording the accession.

Care: The museum keeps appropriate and adequate records pertaining to the provenance, identification, and location of the museum's holdings and applies current professionally accepted methods to their security and the minimization of damage and deterioration.

Collections: Objects, living or nonliving, that museums hold in trust for the public. Items usually are considered part of the museum's collections once they are **accessioned**. Some museums designate different categories of collections (permanent, research, educational) that functionally receive different types of care or use. These categories and their ramifications are established in the museum's collections management policy.

Collections management policy: A written document, approved by the governing authority, which specifies the museum's policies concerning all collections-related issues, including accessioning, documentation, storage, and disposition. Policies are general guidelines that regulate the activities of the organization. They provide standards for exercising good judgment.

Collections plan: A plan that guides the content of the collections and leads staff in a coordinated and uniform direction over time to refine and expand the value of the collections in a predetermined way. Plans are time-limited and identify specific goals to be achieved. They also provide a rationale for those choices, and specify how they will be achieved, who will implement the plan, when it will happen, and what it will cost.

Objects: Materials used to communicate and motivate learning and instruments for carrying out the museum's stated purpose.

Standard Facility Report: A standardized form developed by the AAM's Registrar's Committee (RC-AAM) to expedite the exchange of information critical to lenders and insurers. Museums fill in information about their physical specifications, and policies and procedures related to environmental controls, fire protection, security, handling/packing, and loans. Available only through purchase from the AAM Bookstore.

AMERICAN ASSOCIATION OF MUSEUMS
ACCREDITATION PROGRAM
1575 EYE STREET NW, SUITE 400
WASHINGTON, DC 20005
202.289.9116
FAX 202.289.6578
www.aam-us.org

APPENDIX C

LAWS AND LEGISLATION

A large body of domestic and international laws and regulations affect how museums are governed, how they acquire and manage collections, and how they fulfill their missions. The collections management policy ensures that the museum's staff are familiar with and respect the appropriate laws and regulations. A summary of the most important laws and regulations affecting museum collections management is provided in table C.1. For purposes of policy development, a brief discussion of some of these laws and regulations is provided below.

Americans with Disability Act, 1990

The Americans with Disability Act (ADA) of 1990 is intended to "provide the disabled with equal access to programs and activities." This act can be of particular concern for collections management due to the nature of collections storage and the fact that so many museums are in old buildings. A museum is obliged to follow ADA requirements because it is a "place of public accommodation." Malaro (1998) states "Quite simply, the ADA asks a museum to think creatively not only about ways to bring more disabled people into its facilities but also about ways to provide those who come with all reasonable means to participate in programs and activities." The act provides some flexibility in that it allows museums both to comply with ADA regulations and carry out their responsibility to preserve and maintain collections.

Copyright Law

A museum can own an object but not own the rights to reproduce or exploit it. On the other hand, copyright is time-sensitive, so those rights that the museum does or does not have may change. From the point of view of collections management, this situation generally arises when someone wants to make use of an image or a reproduction of objects from the collection.

The Copyright Act of 1976 imposed a single system of statutory protection for all copyrightable works, whether published or unpublished. Copyright protection "applies to an original work of authorship fixed in any tangible medium of expression. It does not extend to ideas, procedures, processes, systems, methods of operation, concepts, principles, or discoveries" (Phelan, 2001). Several forms of use of copyrighted material are permitted under the fair use clause principle. Fair use is "the use by reproduction of copyrighted works for criticism, comment, news reporting, teaching (including multiple copies for classroom use), scholarship, or research" (Phelan, 2001).

Internal Revenue Rules

Most nonprofit organizations are 501(c)(3) organizations. This designation means that an organization is tax-exempt, and that donors can take a tax write-off for their donations. There are many rules and regulations that 501(c)(3) organizations must follow, including some

that affect collections management because they deal with the acquisition and disposal of collections. These rules include limitations on how much a 501(c)(3) organization can receive as gifts, how much in tax credits an individual can take when making a gift, and whether or not a donor should be notified about deaccession and disposal of a gift (see chapter 8, "Deaccession and Disposal").

Other Important U.S. Laws and Regulations

In *Museum Law: A Guide for Officers, Directors, and Counsel,* Marilyn Phelan observes that "The United States has been somewhat dilatory in its efforts to preserve and to protect artistic, archaeological, and anthropological resources. As one court observed, the United States has had a 'short cultural memory'." Collections management policies must be particularly sensitive to the varying attitudes towards protection of cultural resources, as well as both domestic and international regulation of such property.

The Antiquities Act of 1906 protects historic ruins on public lands from being destroyed or damaged. Under this act, anyone who appropriates an object of antiquity from public lands without permission of the Department of the Interior may be held liable and subjected to fine or imprisonment. This act was passed in response to vandalism at the Casa Grande ruins in Arizona and because of concerns about the protection of Mount Vernon in Virginia. The act also authorized the president to set aside historic places, landmarks, and structures as national monuments. The Historic Sites Act of 1935 strengthened the 1906 Antiquities Act by making it a national policy "to preserve for public use historic sites, buildings, and objects of national significance for the inspiration and benefit of the people of the United States." The Archaeological Resources Protection Act of 1979 expanded the Antiquities Act further, providing protection for archaeological resources and sites on public land and Indian land. The act prohibits the sale, purchase, transport, exchange, or receipt of any archaeological resources removed without permission from public or Indian lands. The Pre-Columbian Art Act of 1972 was adopted to prohibit the importation into the United States of any pre-Columbian material without a certificate of exportation from the country of origin.

Most collections management policies stipulate that objects accessioned into the collections were collected both legally and ethically.

A number of laws and regulations affect biological specimens in collections, including parts of plants and animals that might be found in art, ethnographic, or history museums. For example, if a museum acquires an ethnographic artifact that contains any part of a biological organism—such as a feather from a songbird or a piece of skin from a protected mammal or reptile—the museum might have to comply not only with the legislation regulating ethnographic artifacts but also with regulations concerning protected species.

Permits now are required to collect almost any animal or plant (or animal part or plant part) as well as to import, export, or transport them. For example, a 3-177 declaration form must be filed with the U.S. Fish and Wildlife Service for any animal or animal part that is imported to or exported from the United States, even if the specimen (or object that contains an animal part) has been in a museum collection for decades. Specimens (or parts) of protected species must be brought in through a designated port unless special arrangements are made beforehand with the U.S. Fish and Wildlife Service.

The key piece of wildlife and plant legislation is the Lacey Act, passed in 1900 to control the trade in bird feathers. The act subsequently was extended to cover most animal and many plant species. It prohibits the import, export, transportation, sale, receipt, acquisition or purchase of any animal or plant that was obtained or transported in violation of any other law or regulation. In effect, the Lacey Act enforces the laws and regulations of other countries, preventing importation of an illegally obtained specimen or object. From the point of view of collections management policies, it is important to note that under the Lacey Act, any recipient of an animal or plant specimen (or an artifact with animal or plant parts on it) obtained illegally in the past might be held responsible and charged with a violation.

The Convention on International Trade in Endangered Species of Wild Fauna and Flora (CITES) established regulations to control the international traffic in species

threatened by commercial trade. From the point of view of collections management policies, museum staff must be aware that moving a specimen or part of a specimen on the CITES list across an international border requires special permits. This includes the initiation or receipt of a loan of an object containing ivory or feathers.

References

Malaro, M.C. 1998. *A Legal Primer on Managing Museum Collections.* Second edition. Smithsonian Institution Press, Washington, D.C., xx + 507 pp.

Phelan, M.E. 2001. *Museum Law. A Guide for Officers, Directors, and Counsel.* Second edition. Kalos Kapp Press, xiii + 471 pp.

TABLE C.1. **Important laws, regulations, and treaties affecting museum collections and collections management in the United States (after Malaro, 1998; Phelan, 2001).**

This list is not intended to be complete or comprehensive; consult with legal counsel when appropriate.

LAW, REGULATION, OR TREATY	INFORMATION SOURCE	PURPOSE
Abandoned Shipwreck Act	43 U.S.C. §§ 2101-06 Phelan 2001:195-201	Protects underwater archaeological treasures.
African Elephant Conservation Act	16 U.S.C. § 4201 Malaro 1998:124	Prevents the importation of raw ivory and restricts the importation and exportation of worked ivory.
Americans with Disabilities Act, 1990 (ADA)	42 U.S.C. §§ 12101 et seq. www.usdoj.gov/crt/ada/adahom1.htm	To "provide the disabled with equal access to programs and activities."
Antarctic Conservation Act of 1978	16 U.S.C. §§ 2401. et seq. Malaro 1998:124-125	Prohibits taking Antarctic native wildlife or plants.
Antiquities Act of 1906	16 U.S.C. §§ 431-33 www.cr.nps.gov/local-law/anti1906.htm www.cr.nps.gov/archeology/sites/antiquities/index.htm Malaro 1998:128-129 Phelan 2001:178-181	Protects historic and prehistoric ruins and monuments on public lands.
Archaeological Resources Protection Act of 1979	16 U.S.C. §§ 470aa-470mm www.cr.nps.gov/local-law/FHPL_ArchRsrcsProt.pdf Malaro 1998:129-131 Phelan 2001:179-181, 203	This act expands the Antiquities Act and further protects archaeological resources and sites on public land and Indian land by prohibiting the sale, purchase, transport, exchange, or receipt of archaeological resources removed without permission after 1979.
Architectural Works Copyright Protection Act	17 U.S.C. §§ 101, 120 Phelan 2001:187	Protects architecture as a form of artistic expression by providing protection through the Copyright Act.
Arts and Artifacts Indemnity Act, as Amended	Public Law 94-158 www.nea.gov/grants/apply/Indemnity/Advisory.html Malaro 1998:315-317, 500-502	Provides museum objects with immunity from seizure under certain circumstances.
Bald and Golden Eagle Protection Act	16 U.S.C. §§ 668, et seq. Malaro 1998:123 Phelan 2001:266-267	This act makes it illegal to take, sell, purchase, or barter eagles or eagle parts.
Convention on the Means of Prohibiting and Preventing the Illicit Import, Export and Transfer of Ownership of Cultural Property (UNESCO Convention), 1970	http://exchanges.state.gov/education/culprop/unesco01.html Malaro 1998:457-464 Phelan 2001:207-212	Parties to the convention oppose "all illicit import, export, and transfer of ownership of cultural property."
Convention on Cultural Property Implementation Act (CCPIA)	19 U.S.C. §§ 2601-13 http://exchanges.state.gov/culprop/97-446.html Malaro 1998:465-476 Phelan 2001:215-218	Makes cultural treasures subject to seizure if imported into the U.S. in violation of the laws of the country of origin.
Convention on International Trade in Endangered Species of Wild Fauna and Flora (CITES)	16 U.S.C. § 1538[c] http://international.fws.gov/cites/cites.html www.cites.org Malaro 1998:121	Controls the international traffic in species threatened by commercial trade.

LAW, REGULATION, OR TREATY	INFORMATION SOURCE	PURPOSE
Copyright Act of 1976	17 U.S.C. § 101-810 Phelan 2001:79-116	Imposed a single system of statutory protection for all copyrightable works, whether published or unpublished.
Curation of Federally Owned and Administered Archaeological Collections	http://www.cr.nps.gov/archeology/tools/36cfr79.htm Malaro 1998:477-497	Established standards for care of federally owned collections.
Endangered Species Act of 1973	16 U.S.C. §§ 1531-40 www.fws.gov/endangered/esq.html http://www4.law.cornell.edu/uscode/16/ch35.html Malaro 1998:122 Phelan 2001:262-265	Protects certain species of animals and plants.
Freedom of Information Act of 1966	5 U.S.C. § 552, as Amended by Public Law No. 104-231, 110 Stat. 2422	Established standards for determining which records must be disclosed and which records can be withheld; requires federal agencies to provide full disclosure of information.
Hague Convention for the Protection of Cultural Property in the Event of Armed Conflict, 1954	http://www.unesco.org/culture/legalprotection/war/html_eng/index_en.shtml Phelan 2001:205-212	Protects cultural property during wartime.
Historic Sites Act of 1935	16 U.S.C. §§ 461-471 Phelan 2001:181-182	Strengthens the Antiquities Act of 1906 by preserving historic sites, buildings, and objects of national significance for public use.
Immunity from Seizure Statute	22 U.S.C. § 2459 http://www.state.gov/www/global/legal_affairs/culture_index.htm www.state.gov/l/c3432.htm Malaro 1998:498-499	Provides artifacts with limited protection from seizure under particular circumstances.
Lacey Act of 1900	18 U.S.C. § 42 16 U.S.C. § 3371 http://invasives.fws.gov/Index.LaceyAct.html Malaro 1998:120-121 Phelan 2001:261-262	This act prohibits the importation, exportation, transportation, sale, receipt, acquisition or purchase of any animal or plant that was obtained or transported in violation of any other law or regulation.
Marine Mammal Protection Act	16 U.S.C. §§ 1361-1407 Malaro 1998:122-123 Phelan 2001:265	Bans the importation of marine mammals or marine mammal parts.
Migratory Bird Treaty Act	16 U.S.C. §§ 703-12 Malaro 1998:123 Phelan 2001:269	Prohibits killing, capture, collecting, possessing, buying, selling, transport, import and export of migratory birds, including nests and eggs.
National Environmental Policy Act	42 U.S.C. §§ 4321-70a Phelan 2001:185-186	Requires consideration of environmental and cultural values as well as economic and technological values in assessing proposed federal projects.
National Film Preservation Act of 1988	2 U.S.C. §§ 1791-n Phelan 2001:187-188	Established the National Film Registry to maintain and preserve significant films.
National Foundation on the Arts and Humanities	20 U.S.C. § 951 Phelan 2001:188-189	Provides support and protection for artists and artistic expression.
National Historic Preservation Act of 1966	16 U.S.C. §§ 470a-470w www.cr.nps.gov/local-law/nhpa1966.htm Malaro 1998:131-132 Phelan 2001:183-185	Provides a broad base of federal protection for significant domestic cultural resources.

LAW, REGULATION, OR TREATY	INFORMATION SOURCE	PURPOSE
National Stolen Property Act	18 U.S.C. §§ 2314-15	This act can be applied to encroachments on legitimate and clear ownership rights to imported objects.
National Trust for Historic Preservation	16 U.S.C. § 468 Phelan 2001:182-183	Established a private, nonprofit corporation to receive donated sites, buildings, and objects significant in U.S. history and culture to preserve and administer them for the benefit of the public.
Native American Graves Protection and Repatriation Act 1991 (NAGPRA)	25 U.S.C. §§ 3001-13 http://www.cr.nps.gov/nagpra/ Malaro 1998:112-117 Phelan 2001:203-205	This act empowers Native Americans and Native Hawaiians to claim custody of human remains, funerary objects, sacred objects, and objects of cultural patrimony that are in the control of federal agencies and museums.
Old Loan Legislation	Buck and Gilmore 1889:281-287	Legislation that allows museums to take possession of unclaimed objects (varies from state to state).
Pre-Columbian Art Act of 1972	19 U.S.C. §§ 1091-95 Malaro 1998:111-112 Phelan 2001:214-215	Prohibits the importation into the U.S. of any pre-Colombian material without a certificate of exportation from the country of origin.
Rights of Privacy and Publicity	http://www.law.cornell.edu/topics/publicity.html Malaro 1998:198-203	Prevents unauthorized commercial use of a person's name, likeness, or other recognizable aspects; gives an individual exclusive rights to use of his or her own identity for commercial purposes.
State preservation laws	Phelan 2001:189-191	Various state-level preservation programs have been enacted; these vary widely in scope.
Tax Reform Act of 1984	http://www.irs-offer-incompromise.com/rra-3103.html Malaro 1998:229-230, 384-393	Requires museums to notify donors and the Internal Review Service if certain donated property is sold, exchanged, or otherwise transferred within two years of the date of gift.
Unidroit Convention on Stolen or Illegally Exported Cultural Objects	www.unidroit.org/english/conventions/1995culturalproperty/main.htm Phelan 2001:254-260	Endorses the repatriation of cultural property.
Visual Artists Rights Act (VARA)	17 U.S.C. §§ 106A et seq. www.artslaw.org/VARA.htm. www.loc.gov/today/pr/1996/96-045.html Malaro 1998:184-197	Protects artists rights of attribution and integrity.
Wild Exotic Bird Conservation Act	16 U.S.C. § 4901 Malaro 1998:124	Prohibits the importation of exotic birds in violation of other laws and regulations.

APPENDIX D

RESOURCES

BIBLIOGRAPHY

General

Alexander, E.P. 1979. *Museums in Motion. An Introduction to the History and Functions of Museums.* American Association for State and Local History, Nashville, xii + 308 pp.

American Association of Museums. 1999. *Museum Job Descriptions and Organizational Charts.* American Association of Museums, Washington, D.C.

American Association of Museums. 1998. *Museum Mission Statements: Building a Distinct Identity.* American Association of Museums, Washington, D.C., 137 pp.

American Association of Museums Information Center Fact Sheet, *Outline for a Collections Plan.*

August, R.S. 1983. Museum: a legal definition. *Curator* 26(2):137-153

Boyd, W.L. 1991. Museum accountability: laws, rules, ethics, and accreditation. *Curator* 34(3):165-176

Buck, R.A and J.A. Gilmore (editors). 1998. *The New Museum Registration Methods.* American Association of Museums, Washington, D.C., xvii + 427 pp.

Burcaw, G.E. 1997. *Introduction to Museum Work.* AltaMira Press/American Association for State and Local History, Nashville, 240 pp.

Campbell, N.J. 1998. *Writing Effective Policies and Procedures: A Step-by-Step Resource for Clear Communication.* American Management Association, New York, xiii + 397 pp.

Carr, D. 2001. Balancing act: ethics, mission, and the public trust. *Museum News* 80(5):29-32; 71-81.

Case, M. 1988. *Registrars on Record. Essays on Museum Collections Management.* Registrars Committee of the American Association of Museums, Washington D.C., xiv + 257 pp.

Cato, P.S. and S.L. Williams. 1993. Guidelines for developing policies for the management and care of natural history collections. *Collection Forum* 9(2):84-107.

Cato, P.S. and S.L. Williams. 1998. Collection management policies. In Buck, R.A. & J.A. Gilmore (editors). 1998. *The New Museum Registration Methods,* pp. 221-223. American Association of Museums, Washington, D.C., xvii + 427 pp.

Dietrich, B., R. Etherington, and T. Laurenson. 1997. Policy writing: a blueprint for the future. *Museum International* 49(1):46-48.

Edson, G. and D. Dean. 1996. *Handbook for Museums.* Routledge, 320 pp.

Fahy, A. (editor). 1995. *Collections Management.* Routledge, London and New York, xii + 304 pp.

Fenton, A. 1995. Collections research: local, national, and international perspectives. In Fahy, A. (editor). *Collections Management,* pp. 224-232. Routledge, London and New York, xii + 304 pp.

Gardner, J.B. and E. Merritt. 2002. Collections planning. Pinning down a strategy. *Museum News* 81(4):30-33; 60-61.

Gardner, J.B., and E. Merritt. 2004. *The AAM Guide to Collections Planning. American Association of Museums,* Washington, D.C., viii + 93 pp.

Guthe, C.E. 1982. *The Management of Small History Museums.* Second edition. American Association for State and Local History, Nashville, 80 pp.

Hoagland, K.E. (editor). 1995. *Guidelines for Institutional Policies and Planning in Natural History Collections.* Association of Systematics Collections, Washington, D.C., vi + 120 pp.

Lord, B. and G.D. Lord. 1997. *The Manual of Museum Management.* Second edition. AltaMira Press, Walnut Creek, CA, xiii + 261 pp.

Lord, G.D. and B. Lord (editors). 1999. *The Manual of Museum Planning.* Second edition. AltaMira Press, Walnut Creek, CA, xvii + 462 pp.

Malaro, M.C. 1979. Collections management policies. *Museum News* 58(2):57-61.

Malaro, M.C. 1994. *Museum Governance: Mission, Ethics, Policy.* Smithsonian Institution Press, Washington, D.C., viii +183 pp.

Malaro, M.C. 1998. *A Legal Primer on Managing Museum Collections.* Second edition. Smithsonian Institution Press, Washington, D.C., xx + 507 pp.

Miller, Steven. 1985. Selling items from museum collections. *The International Journal of Museum Management and Curatorship* 4:289-294

Neal, A., K. Haglund, and E. Webb. 1995. Evolving a policy manual. In Fahy, A. (editor). 1995. *Collections Management,* pp. 29-34. Routledge, London and New York, xii + 304.

Nicholson, E.G. and S.L. Williams. 2002. Developing a working definition for the museum collection. *Inside Line* (Texas Association of Museums), fall 2002, pp. 1-4.

Nicks, J. 1999. Collections management. In Lord, G.D. and B. Lord (editors). *The Manual of Museum Planning,* pp. 109-123. Second edition. AltaMira Press, Walnut Creek, CA, xvii + 462 pp.

Pearce, S.M. 1993. *Museums, Objects and Collections: A Cultural Study.* Smithsonian Institution Press, Washington, D.C., 312 pp.

Reibel, D.B. 1997. *Registration Methods for the Small Museum.* Third edition. AltaMira Press/American Association for State and Local History, Nashville, 192 pp.

Roberts, D.A. (editor). 1988. *Collections Management for Museums.* Museum Documentation Association, xx + 237 pp.

Schlereth, T.J. 1984. Contemporary collecting for future recollecting. *Museum Studies Journal* 1(3):23-30

Searle, A. 1984. Museums and the public interest. *Museum News* 62:54

Simmons, J.E. and Y. Muñoz-Saba. 2003. The theoretical bases of collections management. *Collection Forum* 18(1-2):1-37.

Thompson, J.M.A. (editor). 1992. *Manual of Curatorship. A Guide to Museum Practice.* Butterworth-Heinemann, Oxford, vii + 756 pp.

Tri-State Coalition of Historic Places. 2000. *Standards and Practices for Historic Site Administration.* Tri-State Coalition of Historic Places, Philadelphia, PA.

Policy

Campbell, N.J. 1998. *Writing Effective Policies and Procedures: A Step-by-Step Resource for Clear Communication.* American Management Association, New York, xiii + 397 pp.

Cato, P.S. and S.L. Williams. 1993. Guidelines for developing policies for the management and care of natural history collections. *Collection Forum* 9(2):84-107.

Cato, P.S. and S.L. Williams. 1998. Collection management policies. In Buck, R.A. & J.A. Gilmore (editors). 1998. *The New Museum Registration Methods,* pp. 221-223. American Association of Museums, Washington, D.C., xvii + 427 pp.

Scope

Belk, R. 1994. Collectors and collecting. In Pearce, S.M. (editor). *Interpreting Objects and Collections,* pp. 317-326. Routledge, London and New York.

Belk, R. 1995. *Collecting in a Consumer Society.* Routledge, London, 224 pp.

Child, M. 1999. Collections policies and preservation. *Northeast Document Conservation Center Technical Leaflet, Planning and Prioritizing,* Section 1, Leaflet 5, pp. 1-4.

Child, M. 1999. Preservation assessment and planning. *Northeast Document Conservation Center Technical Leaflet, Planning and Prioritizing,* Section 1, Leaflet 1, pp. 1-8.

Elsner, J. and R. Cardinal (editors). 1994. *The Cultures of Collecting.* Reaktion Books, London, viii + 312 p.

Gardner, J.B. and E. Merritt. 2002. Collections planning. Pinning down a strategy. *Museum News* 81(4):30-33; 60-61.

Lynch, B. 1928. *Collecting. An Essay.* Harper and Brothers, New York, 81 pp.

Nicholson, E.G. and S.L. Williams. 2002. Developing a working definition for the museum collection. *Inside Line* (Texas Association of Museums), fall 2002, pp. 1-4.

Nicks, J. 1999. Collections management. In Lord, G.D. and B. Lord (editors). *The Manual of Museum Planning,* pp. 109-123. Second edition. AltaMira Press, Walnut Creek, CA., xvii + 462 pp.

Pearce, S.M. 1994. The urge to collect. In Pearce, S.M. (editor). *Interpreting Objects and Collections,* pp. 157-159. Routledge, London and New York.

Pearce, S.M. 1994. Collecting reconsidered. In Pearce, S.M. (editor). *Interpreting Objects and Collections,* pp. 193-204. Routledge, London and New York.

Pearce, S.M. 1998. *Collecting in Contemporary Practice.* Sage Publications, London, vii + 213 pp.

Schlereth, T.J. 1984. Contemporary collecting for future recollecting. *Museum Studies Journal* 1(3):23-30

Acquisitions and Accessions

Association of Systematic Collections. 1991. Guidelines: the ethics and responsibilities of museums with respect to acquisition and disposition of collection materials. *Association of Systematics Collections Newsletter* 19(6):77-79

Blackaby, J.R. and P. Greeno. 1988. *The Revised Nomenclature for Museum Cataloging: A Revised and Expanded Version of Robert G. Chenhall's System for Classifying Manmade Objects.* AltaMira Press/American Association for State and Local History, 520 pp.

Burcaw, G.E. 1997. *Introduction to Museum Work.* AltaMira Press/American Association for State and Local History, Nashville, 240 pp.

Carnell, C. and R. Buck. 1998. Acquisitions and accessioning. In Buck, R.A. & J.A. Gilmore (editors). 1998. *The New Museum Registration Methods,* pp. 157-165. American Association of Museums, Washington, D.C., xvii + 427 pp.

de Angelis, I.P., and L. Hersh. 2001. Object of appraisal: legal & ethical issues. *Museum News* 80(5):46-57

Gardner, J.B. and E. Merritt. 2002. Collections planning. Pinning down a strategy. *Museum News* 81(4):30-33; 60-61.

Malaro, M.C. 1998. *A Legal Primer on Managing Museum Collections.* Second edition. Smithsonian Institution Press, Washington, D.C., xx + 507 pp.

Nicks, J. 1999. Collections management. In Lord, G.D. and B. Lord (editors). *The Manual of Museum Planning*, pp. 109-123. Second edition. AltaMira Press, Walnut Creek, CA, xvii + 462 pp.

Reibel, D.B. 1997. *Registration Methods for the Small Museum.* Third edition. AltaMira Press/American Association for State and Local History, Nashville, 192 pp.

Segal, T. 1998. Marking. In Buck, R.A. & J.A. Gilmore (editors). 1998. *The New Museum Registration Methods,* pp. 65-93. American Association of Museums, Washington, D.C., xvii + 427 pp.

Thornes, R. 1999. *Introduction to Object ID: Guidelines for Making Records that Describe Art, Antiques, and Antiquities.* The Getty Conservation Institute, 61 pp.

Deaccessions and Disposal

Besterman, T. 1992. Disposals from museum collections. Ethics and practicalities. *Museum Management and Curatorship* 11:29-44.

Cron, R. 1999. Museum artifacts: deciding what to keep. *The Local Historian,* July/August, pp. 4-5.

Garfield, D. 1990. Unusual obstacles. Natural history museums and keepers of living collections face deaccessioning dilemmas distinct from those of other collections. *Museum News* 69(2):52-55.

Hennum, P. 1992. Get rid of it! Perspectives on the disposal of deaccessioned items. *Registrar's Quarterly,* winter, pp. 3-4, 14.

Lewis, G. 1992. Attitudes to disposal from museum collections. *Museum Management and Curatorship* 11:19-28.

Lewis, G. 2003. Deaccessioning and the ICOM code of ethics for museums. *ICOM News* 56(1):3

Malaro, M.C. 1988. Deaccessioning: The importance of procedure. *Museum News* 66(4):74-75

Malaro, M.C. 1998. *A Legal Primer on Managing Museum Collections.* Second edition. Smithsonian Institution Press, Washington, D.C., xx + 507 pp.

Malaro, M.C. 2003. Collection management and deaccessioning in the United States. *ICOM News* 56(1):4-5.

Miller, Steven. 1985. Selling items from museum collections. *The International Journal of Museum Management and Curatorship* 4:289-294

Miller, S.H. 1996. "Guilt-free" deaccessioning. *Museum News* 75(5):32; 60-61.

Robertson, I. 1995. Infamous de-accessions. In Fahy, A. (editor). *Collections Management,* pp. 168-171. Routledge, London and New York. xii + 304.

Smith, L.F. 1992. *Deaccessioning. Registrar's Quarterly,* winter, pp. 1-2.

Weil, S. 1987. Deaccession practices in American museums. *Museum News* 65(3):44-49. Also pp. 105-118 in Weil, S.E. 1990. *Rethinking the Museum and Other Meditations.* Smithsonian Institution Press, Washington, D.C., xviii + 173 pp.

Weil, S. 1990. Deaccessioning modern and contemporary art. Some notes on the American experience. In Weil, S.E. 1990. *Rethinking the Museum and Other Meditations,* pp. 119-126. Smithsonian Institution Press, Washington, D.C., xviii + 173 pp.

Weil, S.E. (editor). 1997. *A Deaccession Reader.* American Association of Museums, 320 pp.

Loans

American Association of Museums. 2000. Guidelines on exhibiting borrowed objects. *Museum News* 79(6):54-55.

American Association of Museums Registrars Committee. 1998. *Standard Facility Report.* Second edition, revised. American Association of Museums/ Registrars Committee, Washington, D.C., 32 pp.

Anon. 1991. Statement of practice for borrowing and lending. *Registrar* 8(2):3-10.

de Angelis, I.P. 1998. Old loans. In Buck, R.A. & J.A. Gilmore (editors). 1998. *The New Museum Registration Methods,* pp. 281-287. American Association of Museums, Washington, D.C., xvii + 427 pp.

Freitag, S. and C. Summers. 1998. Loans. In Buck, R.A. & J.A. Gilmore (editors). *The New Museum Registration Methods,* pp. 177-188. American Association of Museums, Washington, D.C., xvii + 427 pp.

Malaro, M. 1989. How to protect yourself from not-so-permanent loans. *Museum News* 68(5):22-25.

Museum Documentation Association. *Art Loan Information.* Museum Security Network. January 2002. www.museum-security.org/artloan2.html.

Reibel, D.B. 1997. *Registration Methods for the Small Museum.* Third edition. AltaMira Press/American Association for State and Local History, Nashville, 192 pp.

Objects in Custody

de Angelis, I.P. 1998. Old loans. In Buck, R.A. and J.A. Gilmore (editors). *The New Museum Registration Methods,* pp. 281-287. Washington, D.C.: American Association of Museums, xvii + 427 pp

Malaro, M.C. 1998. *A Legal Primer on Managing Museum Collections.* Second edition. Smithsonian Institution Press, Washington, D.C. xx + 507 pp.

Documentation

Anon. 1994. *Art and Architecture Thesaurus.* Second edition. Oxford University Press, New York.

Baron, R. 1991. The computerized accession ledger: a view from a computer expert. *Registrar* 8(2):41 ff. www.studiolo.org/MusComp/LEDGER.htm.

Fitzgerald, G.R. 1988. Documentation guidelines for the preparation and conservation of paleontological and geological specimens. *Collection Forum* 4(2):38-45.

Garrett, K.L. 1989. Documentation guidelines for the preparation and conservation of biological specimens. *Collection Forum* 5(2):47-51.

Museums and Galleries Commission. 1995. *Spectrum: The UK Museum Documentation Standard.* Cambridge. www.mda.org.uk/spectrum.htm

National Park Service. 1993. *Museum Property Handbook.* Volume II. Documentation of Museum Property. National Park Service, Washington, D.C.

Perry, K.D. (editor). 1999 *The Museum Forms Book.* Third edition. Texas Association of Museums, Austin, 461 pp.

Reibel, D.B. 1997. *Registration Methods for the Small Museum.* Third edition. AltaMira Press/American Association for State and Local History, Nashville, 192 pp.

Tooby, P. 2001. Preserving electronic records for posterity. Envision 17(4):6-7.

Collections Care

American Association of Museums. 1984. *Caring for Collections: Strategies for Conservation, Maintenance, and Documentation.* American Association of Museums, Washington, D.C., 44 pp.

Applebaum, B. 1991. *Guide to Environmental Protection of Collections.* Sound View Press, Madison, 270 pp.

Bachmann, K. (editor). 1992. *Conservation Concerns. A Guide for Collectors and Curators.* Smithsonian Institution Press, Washington, D.C., ix + 149 pp.

Butcher-Younghans, S. 1996. *Historic House Museums: A Practical Handbook for Their Care, Preservation, and Management.* Oxford University Press, New York, 269 pp.

Child, M. 1999. Collections policies and preservation. *Northeast Document Conservation Center Technical Leaflet, Planning and Prioritizing,* Section 1, Leaflet 5, pp. 1-4.

Child, M. 1999. Preservation assessment and planning. *Northeast Document Conservation Center Technical Leaflet, Planning and Prioritizing,* Section 1, Leaflet 1, pp. 1-8.

Frost, M. 1999. Planning for preventive conservation. In Lord, G.D. and B. Lord (editors). *The Manual of Museum Planning,* pp. 175-215. Second edition. AltaMira Press, Walnut Creek, CA., xvii + 462 pp.

Knell, S. 1994. *Care of Collections.* Routledge, London, 304 pp.

Malaro, M.C. 1998. *A Legal Primer on Managing Museum Collections.* Second edition. Smithsonian Institution Press, Washington, D.C., xx + 507 pp.

Michalski, S. 1994a. A systematic approach to preservation: description and integration with other museum activities. In Roy, A. and P. Smith (editors). *Preprints of the Ottawa Congress, 12-16 September 1994. Preventive Conservation, Theory and Research,* pp. 8-11. International Institute for Conservation of Historic and Artistic Works, London, 244 pp.

Michalski, S. 1994b. Leakage prediction for buildings, cases, bags and bottles. *Studies in Conservation.* 39:169-186.

Moore, B.P. and S.L. Williams. 1995. Storage equipment. In Rose, C.L., C.A. Hawks, and H.H. Genoways (editors). *Storage of Natural History Collections: A Preventive Conservation Approach,* pp. 255-267. Society for the Preservation of Natural History Collections, x + 448 pp.

Ogden, S. 1998. *Preservation Planning: Guidelines for Writing a Long-Range Plan.* American Association of Museums/Northeast Document Conservation Center, Washington, D.C., 150 pp.

Ogden, S. 1999. What is preservation planning? *Northeast Document Conservation Center Technical Leaflet, Planning and Prioritizing,* Section 1, Leaflet 1, pp. 1-3.

Rose, C.L. and C.A. Hawks. 1995. A preventive conservation approach to the storage of collections. In Rose, C.L., C.A. Hawks, and H.H. Genoways (editors). *Storage of Natural History Collections: A Preventive Conservation Approach,* pp. 1-20. Society for the Preservation of Natural History Collections, x + 448 pp.

Simmons, J.E. and Y. Muñoz-Saba. 2003. The theoretical bases of collections management. *Collection Forum* 18(1-2):1-37.

Society for the Preservation of Natural History Collections. 1994. Guidelines for the care of natural history collections. *Collection Forum* 10(1):32-40.

Thomson, G. 1986. *The Museum Environment.* Second edition. Butterworths, London, 308 pp.

Waller, R. R. 1995. Risk management applied to preventive conservation. In Rose, C.L., C.A. Hawks, and H.H. Genoways (editors). *Storage of Natural History Collections: A Preventive Conservation Approach,* pp. 21-27. Society for the Preservation of Natural History Collections, x + 448 pp.

Access and Use

Ames, M. 1977. Visible storage and public documentation. *Curator* 20(1):65-79.

Orna, E. and C. Pettitt. 1998. *Information Management in Museums.* Gower Publishing Company Limited, 290 pp.

Richoux, J.A., J. Serota-Braden, and N. Demyttenaere. 1981. A policy for collections access. *Museum News* July/August, 43-47.

Stam, D. 1989. Public access to museum information: pressures and policies. *Curator* 32(3):190-198

Thistle, P. 1990. Visible storage for the small museum. *Curator* 33(1):49-62.

Risk Management

Cackett, S. 1992. Disaster planning. In Thompson, J.M.A. (editor). *Manual of Curatorship. A Guide to Museum Practice,* pp. 487-490. Butterworth-Heinemann, Oxford, vii + 756 pp.

Cassar, M. 1994. Preventive conservation and building maintenance. *Museum Management and Curatorship* 13(1):39-47.

Dorge, V. and S.L. Jones. 1999. *Building an Emergency Plan: A Guide for Museums and Other Cultural Institutions.* The Getty Conservation Institute, 272 pp.

Gallery Association of New York State. 1985. *Insurance and Risk Management for Museums and Historical Societies.* Gallery Association of New York State, 96 pp.

Griffith, E. 1995. Liability and risk management for museums. Pp. 277-283 in Fahy, A. (editor). *Collections Management.* Routledge, London and New York, xii + 304.

Hawks, C. and K. Makos. 2000. Inherent and acquired hazards in museum objects. Implications for care and use of collections. *Cultural Resource Management* No. 5:31-37. Available from www.cr.nps.gov/crm.

Heritage Collections Council. 2000. *Be Prepared: Guidelines for Small Museums for Writing a Disaster*

Preparedness Plan. Heritage Collections Council, Australia. Available from www.globalmuseum.org.

Liston, D. (editor). 1993. *Museum Security and Protection: A Handbook for Cultural Heritage Institutions.* Routledge, 208 pp.

Museums and Galleries Commission. 1995. Museum and gallery security. In Fahy, A. (editor). *Collections Management,* pp. 239-243. Routledge, London and New York, xii + 304.

Nelson, C. 1991. *Protecting the Past from Natural Disasters.* National Trust for Historical Preservation, 192 pp.

Suits, L.N. 1998. Hazardous materials in your collection. *Conserve O Gram* 2(10):1-4.

Waller, R.R. 1995. Risk management applied to preventive conservation. In Rose, C.L., Hawks, C.A. and H.H. Genoways (editors). *Storage of Natural History Collections: A Preventive Conservation Approach,* pp. 21-27. Society for the Preservation of Natural History Collections, x + 448 pp.

Intellectual Property

American Association of Museums. 1999. *A Museum Guide to Copyright and Trademark.* American Association of Museums, Washington, D.C., 225 pp.

Council on Library and Information Resources. *Collections Content and the Web.* January 2000. www.clir.org/pubs/reports/pub88/contents.html.

Malaro, M.C. 1998. *A Legal Primer on Managing Museum Collections.* Second edition. Smithsonian Institution Press, Washington, D.C., xx + 507 pp.

Shapiro, M., and B.I. Miller. 1999. *A Museum Guide to Copyright and Trademark.* American Association of Museums, Washington, D.C., 225 pp.

The National Initiative for a Networked Cultural Heritage (NINCH). www-ninch.org.

United States Copyright Office. *Copyright Law of the United States of America.* August 2001. www.loc.gov/copyright/title17.

World Intellectual Property Organization. www.wipo.int/index.html.en.

Zorich, D.M. 2003. *Developing Intellectual Property Policies: A How-to Guide for Museums.* Canadian Heritage Information Network, Ottawa. www.chin. gc.ca/English/Publications/developing_policies.html.

Cultural Property

American Association of Museums. 2001a. *Implementing the Native American Graves and Repatriation Act.* American Association of Museums, Washington, D.C., 250 pp.

American Association of Museums. 2001b. *Museum Policy and Procedure for Nazi-Era Issues.* American Association of Museums, Washington. D.C., 150 pp.

American Association of Museums. 1993. *Native American Collections and Repatriation.* American Association of Museums, Washington, D.C., 181 pp.

Burcaw, G.E. 1983. A museological view of the repatriation of museum objects. *Museum Studies Journal* 1(1):8-11

Department of the Treasury United States Customs Service. "Art and Cultural Property: Checking for Stolen Items." *Tools for the Trade 1*, no. 2. Second Quarter 1998: p.3.

King, Thomas F. 1998. *Cultural Resource Laws and Practice: An Introductory Guide.* AltaMira Press/ American Association for State and Local History, Walnut Creek, C.A., 384 pp.

Kino, C. 2003. Trading places: cultural property disputes are reshaping the art world—but how? Slate.com. www.slate.com/id/2086136.

O'Keefe, P.J. 1998. Museum acquisitions policies and the 1970 UNESCO Convention. *Museum International* 50(1):20-24.

Phelan, M. (editor). 1998. *The Law of Cultural Property and Natural Heritage: Protection, Transfer, and Access.* Kalos Kapp Press, 790 pp.

Meister, B. (editor). 1996. *Mending the Circle: A Native American Repatriation Guide.* The American Indian Ritual Object Repatriation Foundation, 167 pp.

Messenger, P.M. 1999. *The Ethics of Collecting Cultural Property: Whose Culture? Whose Property?* Second edition. University of New Mexico Press, 301 pp.

Simpson, M.G. 2001. *Making Representations. Museums in the Post-Colonial Era.* Revised edition. Routledge, London, xi + 336 pp.

Yeide, N.H. 2000. Behind the lines: lessons in Nazi-era provenance research. *Museum News* 79(6):50-53; 56-57

Yeide, N.H., K. Akinsha., and A.L. Walsh. 2001. *The AAM Guide to Provenance Research.* American Association of Museums, Washington. D.C., 304 pp.

Categories of Collections

Ainslie, P. 2001. A collection for the millennium: grading the collections at Glenbow. *Museum Management and Curatorship* 19(1):93-104.

Nicks, J. 1999. Collections management. In Lord, G.D. and B. Lord (editors). *The Manual of Museum Planning,* pp. 109-123. Second edition. AltaMira Press, Walnut Creek, CA., xvii + 462 pp.

Price, J.R. and G.R. Fitzgerald. 1996. Categories of specimens: a collection management tool. *Collection Forum* 12(1):8-13.

Stewardship

MacDonald, G.F. and S. Alsford. 1991. The museum as information utility. *Museum Management and Curatorship* 10:305-311.

Prioritization of Collections Care

Ainslie, P. 2001. A collection for the millennium: grading the collections at Glenbow. *Museum Management and Curatorship* 19(1):93-104.

Marquardt, W.H., A. Montet-White, and S.C. Scholtz. 1982. Resolving the crisis in archaeological collections curation. *American Antiquity* 47(2):409-418.

McGinley, R.J. 1992. Where's the management in collection management? In Rose, C.L., S.L. Williams, and J. Gisbert (editors). *Current Issues, Initiatives, and Future Directions for the Preservation and Conservation*

of Natural History Collections, pp. 309-333. Ministerio de Cultura, Madrid, Spain, 3:xxvii + 1-439 pp.

Michalski, S. 1994. A systematic approach to preservation: description and integration with other museum activities. In Roy, A. and P. Smith (editors). *Preprints of the Ottawa Congress, 12-16 September 1994. Preventive Conservation, Theory and Research,* pp. 8-11. International Institute for Conservation of Historic and Artistic Works, London, 244 pp.

Price, J.C. and G.R. Fitzgerald. 1996. Categories of specimens: a collection management tool. *Collection Forum* 12(1):8-13.

Thompson, R. 2000. The crisis in archaeological collection management. *Cultural Resource Management* No. 5:4-6.

Orphaned Collections

Lane, M.A. 2001. The homeless specimen: handling relinquished natural history collections. *Museum News* 80(1):60-63, 82-83.

Off-Site Storage

Ladden, P. 1988. Choosing off-site collection storage: problems encountered and solutions to consider. *Registrar* 5(2).

Digitization

IMLS. 2001. A framework of guidance for building good digital collections. *Institute of Museum and Library Services.* www.imls.gov/scripts/text.cgi?/pubs/forumframework.htm.

Jones-Garmil, K. (editor). 1997. *The Wired Museum: Emerging Technology and Changing Paradigms.* American Association of Museums, 250 pp.

Kenney, A.R. 2000. Mainstreaming digitization into the mission of cultural repositories. *In Collections, Content, and the Web,* pp. 4-17. Council on Library and Information Resources, Washington, D.C., 73 pp.

Reilly, B. 2000. Museum collections online. In *Collections, Content, and the Web,* pp. 40-41. Council on Library and Information Resources, Washington, D.C. 73 pp. www.clir.org/pubs/reports/pub88/coll-museum.html.

Spiess, K.P. and S.R. Crew. 2000. If you build it and they come, will they come back? *In Collections, Content, and the Web,* pp. 22-29. Council on Library and Information Resources, Washington, D.C. 73 pp.

Tooby, P. 2001. Preserving electronic records for posterity. *Envision* 17(4):6-7.

Ethics

American Association of Museums Committee on Ethics. 1978. *Museum Ethics.* American Association of Museums, 31 pp.

American Association of Museums. 2000. *Codes of Ethics and Practice of Interest to Museums.* American Association of Museums, Washington, D.C., 311 pp.

American Association of Museums. *Writing a Museum Code of Ethics.* Washington, D.C., 141 pp.

Andrei, M.A. and H.H. Genoways. 1997. Museum ethics. *Curator* 40(1):6-12.

Andrei, M.A. and H.H. Genoways. 1997. Codes of professional museum conduct. *Curator* 40(2):86-92.

Buck, R.A and J.A. Gilmore (editors). 1998. *The New Museum Registration Methods.* Washington, D.C.: American Association of Museums, xvii + 427 pp.

Carr, D. 2001. Balancing act: ethics, mission, and the public trust. *Museum News* 80(5):29-32; 71-81.

Duggan, A.J. 1984. Ethics and the curator. In Thompson, J.M.A. (editor). *Manual of Curatorship. A Guide to Museum Practice,* pp. 98-104. Butterworths, London, 553 pp.

Edson, G. (editor). 1997. *Museum Ethics.* Routledge, London, xxiii + 282 pp.

Goode, G.B. 1901. A memorial of George Brown Goode with a selection of his papers. *Smithsonian Annual Report for 1897, part II.* Washington, D.C., 515 pp.

Guy, M.E. 1990. *Ethical Decision Making in Everyday Work Situations.* Quorum Books, London, xx + 185 pp.

ICOM. 1997. ICOM Code of Ethics. In Edson, G. (editor). *Museum Ethics,* pp. 237-255. Routledge, London, xxiii + 282 pp. http://icom.museum/ethics-rev-engl.html.

International Committee on Museums. 1990. *Statutes and Code of Professional Ethics.* ICOM, Paris.

Macdonald, R.R. 1991. Developing a code of ethics for museums. *Curator* 34(3):178-186.

Rose, C. 1985. A code of ethics for registrars. *Museum News* 63(3):42-46.

Royal Ontario Museum. 1982. *Statement of Principles and Policies on Ethics and Conduct.* Royal Ontario Museum, 103 pp.

Schmidt, F. 1992. Codes of museum ethics and the financial pressures on museums. *Museum Management and Curatorship* 11:257-268

Laws and Legislation

Boyd, W.L. 1991. Museum accountability: laws, rules, ethics, and accreditation. *Curator* 34(3):165-177.

Jacoby, B.S. 1996. Caveat pre-emptor. *Museum News* 75(1):54-55; 57.

Leifer, J.C. and M.B. Glomb. 1992. *The Legal Obligations of Nonprofit Boards: A Guidebook for Board Members.* National Center for Nonprofit Boards, 58 pp.

Malaro. M.C. 1998. *A Legal Primer on Managing Museum Collections.* Second edition. Smithsonian Institution Press, Washington D.C., xx + 507 pp.

O'Keefe, P.J. 1998. Museum acquisitions policies and the 1970 UNESCO Convention. *Museum International* 50(1):20-24.

Phelan, Marilyn E. 1982. *Museums and the Law.* AASLH, Nashville., xi + 287 pp.

Phelan, Marilyn E. 1994. *Museum Law. A Guide for Officers, Directors, and Counsel.* Second edition. Kalos Kapp Press, xiii + 471 pp.

Shapiro, M.S. and B.I. Miller. 2000. Copyright in the digital age. *Museum News* 79(1):36-45; 66-67.

INTERNET RESOURCES

American Association of Museums:
www.aam-us.org

AAM Information Center:
www.aam-us.org/museumresources/ic/index.cfm

Getty Trust:
www.getty edu/research/
conducting_research/vocabularies/

Global Museum:
www.globalmuseum.org/

National Park Service Conserve O Gram series
www.cr.nps.gov/museum/publications/conserveogram/
conserv.html

National Park Service Museum Handbook
www.cr.nps.gov/museum/publications/handbook.html

The Council for Museums, Archives and Libraries:
www.resource.gov.uk/information/legacy/00legacy.asp

NETWORKING

American Association of Museums
www.aam-us.org

American Association of Museums Registrar's
Committee
www.rcaam.org

American Association for State and Local History
www.aaslh.org

Mid-Atlantic Association of Museums
www.cmiregistration.com/user/splash__org__231.htm

Mountain-Plains Museums Association
www.mountplainsmuseums.org

New England Museum Association
www.nemanet.org

Southeastern Museums Conference
www.semcdirect.net

Western Museums Association
www.westmuse.org

Museum-L
http://archive.comlab.ox.ac.
uk/other/museums/museum-l.html

NHCOLL-L
www.spnhc.org/nhcoll.htm

ABOUT THE AUTHOR

John E. Simmons has B.S. in systematics and ecology and an M.A. in historical administration and museum studies. He previously worked at the Fort Worth Zoological Park and the California Academy of Sciences. He is currently collections manager at the Natural History Museum & Biodiversity Research Center and director of the Museum Studies Program at the University of Kansas. Simmons also works regularly as a consultant and workshop presenter in the United States, Latin America, and Asia.

THINGS GREAT AND SMALL: COLLECTIONS MANAGEMENT POLICIES

INDEX